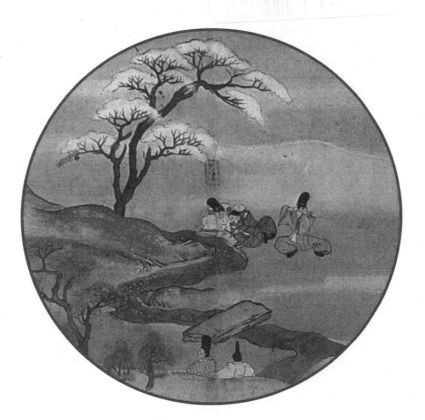

Sakuteiki

Visions of the Japanese Garden

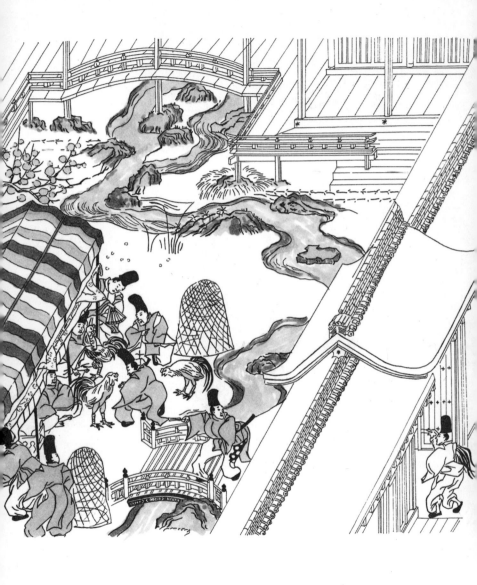

Sakuteiki

Visions of the Japanese Garden

A Modern Translation of Japan's Gardening Classic

Jirō Takei & Marc P. Keane

TUTTLE Publishing

Tokyo │ Rutland, Vermont │ Singapore

"Books to Span the East and West"

Tuttle Publishing was founded in 1832 in the small New England town of Rutland, Vermont [USA]. Our core values remain as strong today as they were then—to publish best-in-class books which bring people together one page at a time. In 1948, we established a publishing outpost in Japan—and Tuttle is now a leader in publishing English-language books about the arts, languages and cultures of Asia. The world has become a much smaller place today and Asia's economic and cultural influence has grown. Yet the need for meaningful dialogue and information about this diverse region has never been greater. Over the past seven decades, Tuttle has published thousands of books on subjects ranging from martial arts and paper crafts to language learning and literature—and our talented authors, illustrators, designers and photographers have won many prestigious awards. We welcome you to explore the wealth of information available on Asia at www.tuttlepublishing.com.

Published by Tuttle Publishing, an imprint of Periplus Editions (HK) Ltd.

www.tuttlepublishing.com

Copyright © 2008 Jiro Takei and Marc P. Keane
Front cover photo by Ben Simmons Photography

The Library of Congress has cataloged the hardcover edition as follows:

Takei, Jiro, 1930-
 Sakuteiki, visions of the Japanese garden : a modern translation of Japan's gardening classic / Jirō Takei and Marc P. Keane.
 xii, 247 p. : ill. (some col.) ; 24 cm.
 Notes: "Sakuteiki : translation and annotation": p. [149]-[206]. Includes bibliographical references (p. 236-239) and index.
 1. Sakuteiki. 2. Gardens, Japanese. 3. Landscape architecture--Japan.. II. Title.
 SB458 .T334 2001
 712/.2/0952 21
 2001046258

ISBN 978-0-8048-3968-6
ISBN 978-4-8053-1831-7 (for sale in Japan only)

Distributed by

North America, Latin America & Europe
Tuttle Publishing
364 Innovation Drive, North Clarendon
VT 05759-9436 U.S.A.
Tel: 1 (802) 773-8930
Fax: 1 (802) 773-6993
info@tuttle.com
www.tuttle.com

Japan
Tuttle Publishing
Yaekari Building, 3rd Floor, 5-4-12 Osaki
Shinagawa-ku, Tokyo 141-0032
Tel: (81) 3 5437-0171
Fax: (81) 3 5437-0755
sales@tuttle.co.jp
www.tuttle.co.jp

Asia Pacific
Berkeley Books Pte. Ltd.
3 Kallang Sector #04-01, Singapore 349278
Tel: (65) 6741-2178
Fax: (65) 6741-2179
inquiries@periplus.com.sg
www.tuttlepublishing.com

First edition
26 25 24 23 11 10 9 8 7

Printed in Malaysia 2311VP

TUTTLE PUBLISHING® is a registered trademark of Tuttle Publishing, a division of Periplus Editions (HK) Ltd.

The authors would like to thank the following students of the
Kyoto University of Art and Design who helped with the ink drawings
that appear in this book. All other ink sketches, and the addition of grey
tone to all, are by Marc P. Keane.

Nakamura Keiichi
 The Main Hall, p. 16
 Pure Land Garden, p. 91
 Building Gion, p. 97
 Taboo Plaques, p. 112
 Mitsukanae p. 161

Shibutani Shiho
 Higashisanjōdono, pp. 12-13
 Festivities in the Southern Court, pp. 26-27
 Senzai, p. 48
 Central Stairs, p. 154
 Garden Building Techniques, p. 157

Toba Makiko
 Garden Stream and Middle Gate, pp. 54-55
 Fudō Myōō and His Attendants, p. 101
 Aristocratic Life, pp. 120-121
 Suhama, pp. 170-171

Komatsu Yujiro
 Geomancy graphics, pages 68, 73, 79

CONTENTS

ACKNOWLEDGMENTS

First and foremost, I would like to offer my sincere thanks to the spirit of Dr. Okazaki Ayaakira, one of the greatest scholars in the field of landscape architectural history and my professor for the seven years I attended Kyōto University. My interest in landscape architecture, and of course in the Sakuteiki as well, came about as a result of his influence.

The Sakuteiki was written in the eleventh century and is thus rather difficult for us to read now, especially for young students of landscape architecture. Some twenty years ago, I decided to undertake a translation to modern Japanese to help those students with their studies, and some years after that, seeing the increase in interest from international students, I also decided to produce an English-language edition. I was fortunate at that point to meet Marc Peter Keane, and we immediately began work, spending in all more than two years working on the translation and annotations. I would like to express my sincere thanks to Marc for his encouragement throughout that time, without which I would have never been able to finish this work. I would also like to mention my gratitude to the Tuttle Publishing Company for taking on this work.

Last, I must not forget to thank my wife Eiko and daughter Emi for their continual help. Marc and I took over our living room every other Saturday for years at their expense. I hope to buy them a bigger house with the proceeds from this book.

—Jirō Takei

There are so many people who gave of their time and expertise, it is difficult to know where to begin. With regard to the life and times of Heian-period aristocrats, I would like to thank Royall Tyler for his answers to my endless e-mails, as well as all the staff at Kyotoshi Maizō Bunkazai Kenkyūsho and Uno Hideo at Kyōto Rekishi Shiryōkan. Regarding Buddhism, Mr. Masaki Atobe at the Koyasan Daigaku Toshokan deserves special thanks for unearthing the reference in the *Fudō Giki;* Hubert Durt and Robert Duquenne of the Hobogirin Kenkyūsho, Kyōto, generously gave of their time to explain so many aspects of Heian-period Buddhism; Jinhua Chen kindly took time from writing his own book to translate a section of the *Gion Illustrated Text [Gion zukyō];* Paola Di Fleece discussed aspects of esoteric Buddhism (even as she worked on an Italian translation of the Sakuteiki); and the Honorable Shincho Tanaka, head priest of Shimyōin, shared many personal insights from his position as the guardian of a Heian-period temple. Yamashita Shinichirō, of the Mokkan Gakkai, offered help with aspects of *mono imi* as did Wakasugi Junji of the Kyōto National Museum with Heian-period art. A special thanks goes to Antonino Forte, director of the Italian School of East Asian Studies, Kyōto, who kindly read the entire text and gave invaluable advice regarding Chinese matters. Many thanks are due to those who gave their expert editorial advice, Preston Houser, Winston Priest and Ann Rose, and of course, to John Einarsen, who gave form to our words. And finally, many, many thanks to Professor Jirō Takei, who offered me (and through this book now offers all of you, too) his knowledge of this ancient text.

—Marc Peter Keane

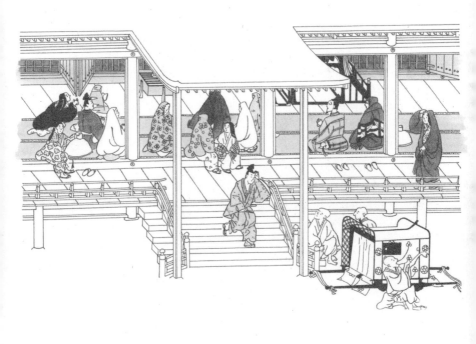

Sakuteiki

Visions of the Japanese Garden

祇園

Sakuteiki

Visions of the Garden

石をたてん事

Ishi wo taten koto

The Art of Setting Stones

LIFE IN THE HEIAN PERIOD

Ishi wo taten koto — "The art of setting stones."

With these words opens the oldest garden-making treatise in Japan—most likely the oldest in the world—best known by the name *Sakuteiki*, or *Records of Garden Making*.[1] Immediately upon reading this first line, we realize that the Sakuteiki will present us with a radically new view of gardening.[2] The expression *ishi wo taten koto* was used by the author of the Sakuteiki to define not only the placement of stones within the garden, but also the act of garden making itself. Although today there are many other words in Japanese to mean "gardening," such as *zōen* or *niwa zukuri*, both of which literally mean "build gardens," there was no such expression at the time the Sakuteiki was written. How fascinating to see that the simple act of standing a stone upright was so spiritually and aesthetically powerful (as with the dolmens of Stonehenge or Carnac), and so clearly central to the process of making a garden, that the act of setting stones became an appellation for gardening itself.

The importance placed on stones in Japan stems from several sources. The first is the ancient use of stones as prayer sites, especially those found naturally in the landscape, often stones that have

1. The Sakuteiki is the oldest treatise the authors know of that addresses gardening as an aesthetic art although there are older treatises that address agricultural-estate gardening, for instance, those of Pliny the Elder.

2. The expression *ishi wo taten koto* was written in various ways in the original text—石をたてんこと, 石を立てんこと, 石を建てんこと—all of which are pronounced the same way but have somewhat different meanings: "setting stones," "standing stones upright," or "building with stones." While "matters on setting stones" is the most literal translation of *ishi wo taten koto*, "the art of setting stones" is more inclusive and thus preferable.

a rounded form or a naturally upright appearance. It was believed that through the medium of the stone, gods could be induced to descend from their heavenly abodes to visit earth and bestow their blessings for good health and ample harvests on village communities. These sacred stones, called *iwakura,* are still actively incorporated in religious life even today. In later eras, the spiritual qualities inherent in sacred stones carried over into the use of stones in gardens. New meanings were added as well, meanings that were derived from cultural imports such as Buddhism and geomancy, the latter being an ancient Chinese method of geophysical divination. The author of the Sakuteiki clearly states that stones were a requisite part of gardening, going as far as saying, for instance, in chapter eight, "...stones are imperative when making a garden."[3]

In addition to the fact that the very word for gardening reveals the importance of stones, we also find another expression in the Sakuteiki of equal interest in this regard. In several places in the text, the author advises the reader to "follow the request of the stone," *ishi no kowan ni shitagahite.* In current design language we might interpret this to mean "pay attention to the individual characteristics of the stones" or even "follow the character of the stone when making design decisions." However, the word *request* reveals an important difference between the way we perceive gardens today and the way the writer of the Sakuteiki and his contemporaries did; for them, stones were animate, and the desires of stones warranted consideration. These two expressions regarding stones—the first showing that setting stones is the most central act of gardening and the second that stones were perceived as animate objects—both reveal that at the time the Sakuteiki was written gardens were perceived quite differently than they are today. This is what makes the Sakuteiki so appealing: it offers us a view into another society, at a time distant from our own, when people had distinctly different ways of understanding their world.

It is believed that the Sakuteiki was written in the mid to late eleventh century, during the Heian period (794-1184), an impor-

3. "... stones are imperative when making a garden" is *senzui wo nashite ha kanarazu ishi wo tatsu beki* 山水をなしては必石を立べき.

tant era in Japanese history since it marks a period of introspection when cultural attributes such as poetry, clothing styles, and so on, which had been imported from China and Korea over the previous centuries, were reexamined and transmuted into a clearly Japanese context. This is true of the gardens as well. The Sakuteiki offers the reader a vision of gardening from a society nearly 1000 years old. It also provides us with a rich source of information about the gardens of that time, insights that are pertinent not only to those who study historical records of gardening, but to anyone who is interested in simply perceiving what a garden *is.*

The Author and the Text

The oldest surviving version of the Sakuteiki was hand-written in flowing brushscript on two long scrolls. However, unlike the later *Illustrations of Gardening [Senzui Narabi ni Yagyōzu],*[4] the Sakuteiki contains no illustrative material. At some point after the Heian period, a set of these scrolls came into the possession of the Maeda family, wealthy provincial lords in what is today Ishikawa Prefecture, in central Japan. From the Maeda family, copies of the scrolls spread to other hands, and one such copy was acquired by the Tanimura family of Kanazawa City. Later, between the years 1779 and 1819 (the late Edo period by Japanese reckoning), the Tanimura scrolls were used in the production of the *Gunsho Ruijū,* a collection of historical literary works that contains more than 1800 scrolls.[5] One notable aspect of that collection is that it was published using block print rather than script, and at that time some of the alphabetic *kana* script used in the earlier scrolls was interpreted and printed as *kanji,* Chinese calligraphic script. It is not known how the Sakuteiki was referred to in the Heian period; there is no title on the Tanimura scrolls. During the Kamakura period, the text was referred to as the Secret Selection on Gardens *[Senzai Hisshō],*[6] and

4. Also pronounced *Sansui Narabi ni Nogata no Zu,* as in Uehara, *Zōen Daijiten,* (Tōkyō: Kajima Shoten, 1994)

5. *Gunsho Ruijū* 群書類従

6. *Senzai Hisshō* 前栽密抄

Figure 1: The Sakuteiki Scrolls

The Sakuteiki comprises two scrolls of text (no illustrations)
written in brushscript. The only extant copy is called the
Tanimura-bon after the family in whose possession it remains.
In addition, photographic copies have been made into scroll
form, such as this one held by Kyōto University.

at some point in the Edo period it became known as the Sakuteiki,
the name used in the *Gunsho Ruijū*.

The author of the Sakuteiki was long believed to be Fujiwara Yos-
hitsune, primarily because his sobriquet, Gokyōgokudono, is found
at the end of the *Gunsho Ruijū* text.[7] Further research, however, has
led to the now accepted theory that the author was in fact Tachibana
no Toshitsuna (1028-1094). During the Heian period, the Tachiba-
na family was listed as one of the Four Great Families, *shisei,* of Ja-
pan along with the Fujiwara, the Genji, and the Heike families, and
for this reason alone Toshitsuna would have had ample opportunity
to have spent time in and around gardens. Moreover, Toshitsuna
was the son of Fujiwara no Yorimichi (992-1074), who ruled Japan
as imperial regent for nearly half a century.[8] Besides being a power-
ful administrator, Yorimichi was also known as a builder of grand
palaces and is perhaps best known for the country retreat he built

7. Fujiwara no Yoshitsune (1169-1206) was a courtier and well-known poet of the
late Heian and early Kamakura (1185-1333) periods. Second son of imperial regent
Kujō Kanezane (1149-1207), Yoshitsune also served as regent after his father but is
best known for his contributions to poetry anthologies such as the *Shin Kokinshū*
(imperial anthology), and his own personal collection, *Akishino Gessei Shō*

8. Typical of the convoluted family lines of the Heian period, Toshitsuna is the son
of a Fujiwara but is himself a Tachibana.

for himself in Uji, south of Kyōto, which he turned into a temple in 1052. Miraculously, the central hall of that temple, Byōdōin, still exists to this day. Yorimichi also built an estate within the Heian capital called Kayanoin, not far from the imperial palace itself. It was four times the normal size of a high-ranking nobleman's estate. Ponds were placed on all four sides of the main hall, and a racetrack and horse-viewing grounds were also constructed on the property. Many of the festivities that took place at Kayanoin, as well as images of the gardens there, are recorded in paintings, perhaps the best known of which is *Koma Kurabe Gyōkō Emaki*, a lengthy scroll that depicts events at Kayanoin in 1024.[9] Paintings such as this give us a good idea of what an aristocratic estate looked like in the Heian period, and those images match quite well with the descriptions in the Sakuteiki. In fact, the author of the Sakuteiki mentions visiting Kayanoin during the construction of its gardens—another clue indicating Toshitsuna as author. That visit most likely took place in AD 1040 when Yorimichi was forty-nine and Toshitsuna was thirteen years old.

> With the building of the palace, Kayanoin, there was no one proficient in gardening, just people who thought they might be of some help. In the end, displeased with the results, Lord Uji took the task of designing the garden upon himself. I often visited the site at that time and was able to observe and study.
>
> XI. Miscellany (p. 192)

In his later years, Toshitsuna was appointed Fushimi Shuri no Daibu, head of a bureaucratic office in charge of construction and repairs of some imperial estates, which he held for twenty-four years. He is reputed to have taken part in making the gardens of many aristocratic families and was the owner of a magnificent garden as well. Although his main residence was Nishinotōintei in the Heian capital, he also possessed an estate in Fushimi, south of the city. *Shokuyotsugi*[10] relates the following encounter between Toshitsuna

9. Although *Koma Kurabe Gyōkō Emaki* depicts Heian-period scenes, the oldest extant scroll dates from the early fourteenth century.

10. *Shokuyotsugi* 続世継 also known as *Imakagami* 今鏡 is a record of historical facts compiled between 1025 and 1170.

and Emperor Shirakawa (1053-1129; r. 1072-86). The emperor requested that Toshitsuna name the best gardens of their time, to which he replied, "Finest of all would be Ishidadono. Second is Kayanoin." "Of course," interjected the emperor, "the third must be Tobadono," suggesting his own estate, which lay by the confluence of the Kamo and Katsura rivers south of the city. Toshitsuna, however, responded by naming his own estate in Fushimi, revealing not only that Toshitsuna was intimately involved with gardening at the highest level, but also that he was confident enough of his position in aristocratic society to contradict the emperor.

As the result of this long experience, and many "secret teachings," *kuden,* regarding gardening that he would have had access to, Toshitsuna is a very likely candidate as author of the Sakuteiki. It is not the focus of this work, however, to prove or disprove the authorship of the Sakuteiki. In fact, as noted in the footnotes of the translation, there may well have been several authors, or additions made to an earlier text by later owners of the scrolls. Most likely, if Toshitsuna did somehow note down his various experiences and the secret teachings that he had been party to, his writings were probably compiled into the form we now know as the Sakuteiki at a later date. Since the original name of the text and the authorship are unknown, the value to us in understanding the Sakuteiki lies not in pinpointing historical details but in understanding what the text reveals about the perception of gardening in the Heian period. Through that understanding, readers today can glean ideas that inform their own understanding of gardens—as visitors or as designers.

The Structure of the Heian Capital[11]

When the Heian capital, now known as Kyōto, was built in 794, it was the fifth large-scale capital to be built within just one hundred years, following Fujiwara, Heijō, Naniwa, and Nagaoka.[12] The proc-

11. For general information regarding life in the Heian capital around the time of the writing of the Sakuteiki, see Ivan Morris, *The World of the Shining Prince* (London: Penguin Books, 1997), and Rose Hempel, *The Golden Age of Japan* 794-1192, trans. Katherine Watson (New York: Rizzoli, 1983).

ess of rebuilding capitals in new locations ended with the construction of the Heian metropolis. The city was to remain as the imperial seat from its inception until 1868 when the imperial court was relocated to Edo (present-day Tōkyō).

The site for the Heian capital was reputedly "discovered" by a party of nobles during a hunting expedition; a relatively flat, open valley that sloped gently from northeast to southwest. Along with several major rivers there were many small brooks and springs, which proved both bane and boon. In the southwest area of the city, for example, groundwater proved to be in excess, with the result that those soggy areas never fully developed. In the northern parts of the city, however, especially the northeast, the abundance of water proved to be instrumental in the design of gardens that featured clear springs, meandering brooks, waterfalls, and ponds. The valley was surrounded on the east, north, and west by low mountains, yet opened broadly to the south. Besides the ready supply of water and physically protected situation, the environs of the site of the new capital were also found to have favorable geomantic conditions, the most basic requirement of which was the believed existence of Four Guardian Gods, *shijin*, in the surrounding landscape. It is recorded in *Shoku Nihonki*[13] that in the year AD 793, Emperor Kammu sent an expedition to survey the area then called Yamashiro no Kuni, and the report of the survey team includes the phrase *shijin sōō*, or "the four guardian gods are in balance." The four gods are the Blue Dragon, Scarlet Bird, White Tiger, and Black Tortoise.[14] The Blue Dragon was divined to the east of the proposed site for the capital in the form of the Kamo River; the Black Tortoise was divined as

12. In addition to these was the smaller-scaled Asukakyō capital, which was used from the mid-sixth to mid-seventh centuries, a short-lived capital built at Kuni (740-44), and many detached palaces such as Shigaraki no Miya.

13. *Shoku Nihonki* 続日本紀

14. There are several mythological birds associated with gardens in the Heian period, all of which are similar in appearance. The Scarlet Bird, *suzaku* 朱雀, which is the southerly of the Four Guardian Gods; the Phoenix, *hōō* 鳳凰, such as the one that adorns the Phoenix Hall of Byōdōin; the Waterfowl, *geki* 鷁, whose head is carved on the prow of the musicians' boats; and *garuda*, a bird seen paired with a dragon-like creature known as Kurikara Ryūō in paintings of Fudō Myōō.

a small hill known as Funaokayama that lay to the north; and the Scarlet Bird was divined as a large pond, Oguraike, in the south. Only the White Tiger was not clearly evident in the landscape and consequently was embellished by taking spring-waters from Konoshima jinja, a shrine just to the west of where the city would lie, and drawing them out in a long canal parallel with the western edge of the city. Even as the geomantic requirement of Four Guardian Gods was applied to the city as a whole, such symbology also became prerequisite for the design of the gardens within the city, and Heian-period gardens can be perceived as symbolic representations, on a reduced scale, of the larger world of the city and its environs.

The design of the Heian capital was based on that of Changan (present-day Xian), the capital of Tang-dynasty (AD 618-907) China, though it was built at a reduced scale. The whole city was laid out as a large rectangle, slightly longer north to south than east to west, covering some 2400 hectares (6000 acres) in all.[15] This large rectangle was divided by a grid of avenues that formed large blocks that in turn were subdivided so that a map of the whole appears like complex graph paper in which each square is subdivided again and again with smaller squares. The basic module of this system was a unit 120 meters square called a *chō*, the standard allotment for aristocrats of third rank or higher.[16] Within these rectangular plots the aristocrats built their residences, in what is now known as the *shinden* style.

Structure of Shinden Residences

Although the layout of aristocratic residences had many variations, they all adhered to certain basic rules. To begin with, situated roughly in the center of the property was the Main Hall, *shinden*, which

15. Heiankyō was approximately 4.5 kilometers east-west and 5.3 kilometers north-south. Ashikaga, *Kyōto Rekishi Atorasu*, 1994 p. 32

16. Third rank and above received one *chō* (14,692 square meters); fourth and fifth ranks, one half *chō;* six, seventh, and eighth ranks, one quarter *chō;* commoners, one thirty-second of a *chō (henushi);* and some residences, such as Fujiwara no Yorimichi's Kayanoin or the fictional Rokujō palace of the passionate prince in *The Tale of Genji,* were four *chō* in size. In comparison, the average urban resident these days lives on 100 square meters. See Kyōtoshi, *Yomigaeru Heiankyo* (Kyōto: Kyōtoshi, 1994), 20.

acted as both forum for political and social events, and private residence for the lord of the household. Annex Halls, *tai no ya*, were arranged to the east, west, and north of the Main Hall to provide living quarters for family and servants as well as places for storage, cooking, and the like. These auxiliary buildings were connected by roofed corridors, *suiwatadono* (referred to as Breezeways[17] in this book), that provided sheltered access amongst them. The rectangluar spaces enclosed between the various halls and the corridors that connected them were often used to create simple gardens that featured one species of plant. These spaces were called *tsubo* and were named after the plant they contained, so we find the Wisteria Court *(fuji tsubo)*, Paulownia Court *(kiri tsubo)*, and so on. Although *tsubo* gardens are well known from other literary sources, it is interesting to note that these smaller gardens are not mentioned in the Sakuteiki.

In the classic architectural form of *shinden* residences, directly to the east and west of the Main Hall were situated two Annex Halls from which long corridors, *chūmonrō*, led south to pavilions built in the garden. The roof of the corridors was raised halfway between the Annex Halls and the garden pavilions to create a gateway. In some cases those gates had doors, while in others only the raised roof itself emphasized the sense of threshold and passage. The garden pavilions were typically given names like Fishing Pavilion, *tsuridono*, and Wellspring Pavilion, *izumidono*. Just to the south of the Main Hall, and framed on the east and west by the long corridors, was a large flat area spread with sand that was used for gatherings of all kinds, from sporting events to formal dance performances. This area is referred to in the Sakuteiki as the Southern Court, *nantei*.[18] To the south of the Southern Court, and wrapping back around the pa-

17. *Suiwatadono*, literally "transparent crossing hall," refers to open-sided corridors, thus the translation "Breezeway."

18. *Nantei* is the Sino-Japanese pronunciation of the Chinese *nanting*, 南庭. In China, *ting* referred to a courtyard enclosed by architecture. In the Sakuteiki, the same character (also pronounced *niwa* in Japanese) was used to refer to the sanded area in front of the *shinden*, which was used for various events, a meaning quite similar to the Chinese *ting*. Although the ancient Japanese word *niwa* referred to places where events took place—such as *yuniwa*, purified places for performing religious rituals—and in that way is similar to *ting*, *niwa* also had the meaning of a broad, open place in nature, like the surface of the sea, which is quite different.

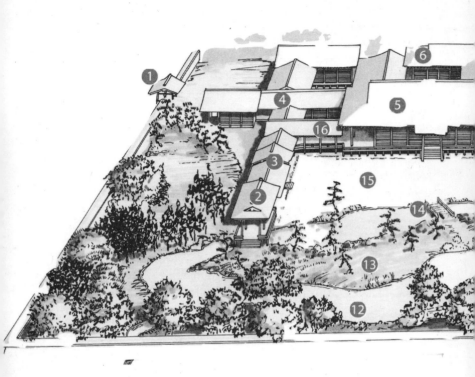

FIGURE 2: Higashisanjōdono

Heian-period *shinden* residences had many forms, some more or less classically symmetrical, others not so. Higashisanjōdono comes relatively close to the ideal form, although in this image (representative of its later years) the Western Annex Hall and Wellspring Pavilion are not fully developed. Located at the southeast corner of Nijō and Nishinotōin streets (see figure 29, p. 144), Higashisanjōdono was the official residence of regent families *(sekkanke)* from the middle of the ninth century onward. (Redrawn from *Ymnigaeru Heiankyō*, Tankōsha p. 47)

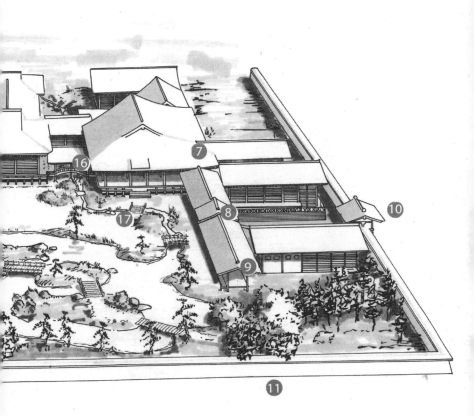

1. West Gate *(nishimon)*
2. Fishing Pavilion *(tsuridono)*
3. Corridor with Middle Gate *(chūmonrō)*
4. West Annex Hall *(nishi no tai)*
 (Not fully developed at this estate)
5. Main Hall *(shinden)*
6. Northern annex *(kita no tai)*
7. East Annex Hall *(bigashi no tai)*
8. Corridor with Middle Gate *(chūmonrō)*
9. Wellspring Pavilion *(izumidono)*

 (Not fully developed at this estate)
10. East Gate *(bigashimon)*
11. Earth Wall *(tsuijibei)*
12. Pond *(ike)*
13. Island *(shima)*
14. Curved Bridge *(sorihashi)*
15. Sand-covered Court *(nantei, niwa)*
16. Breezeway *(suiwatadono)*
17. Garden Stream *(yarimizu)*

vilions and corridors that projected into the courtyard from the annexes, was the garden proper, usually containing a pond with islands, some hillocks, and various plantings. This entire area, including both the Southern Court and garden, is the main focus of the Sakuteiki.

Shinden residences displayed an interesting combination of simplicity and ornament. Owing to limited resources, the volume of lavish materials—gold, silver, ivory, gemstones, and so on—which were available to the larger imperial societies of China or Rome, were unavailable to the Japanese court. Whatever their aesthetic preferences were, this alone would have prevented them from grandiose displays of decorative materials. It seems, however, that the simplicity of their residences may have been to some degree a matter of taste. The Heian-period aristocrats had a predilection for colors of the most refined and complex sort, the combining of which, such as in the twelve-layered costume some princesses wore, was judged as a sign of one's social refinement. Much of this use of rich color, whether it was brilliant gold foil or subtle plant dyes, was applied in microscale, for instance, to clothing, fashion accessories, scrolls, or screens. What is interesting is how differently they chose to color their larger living environments, both house and garden. Paintings of *shinden* residences show that at times the railings of the verandas, *kōran,* and the curved bridge leading to the middle island, *sori hashi,* were painted vermilion. The floors of some of the interior spaces and the screens, *misu,* used to separate rooms are at times depicted as being an azure green, like lapis lazuli. In a few rare cases, carpets with elaborate designs woven into them are shown in some rooms. But even in the cases where all of the decorative materials just mentioned are employed, as in the palaces depicted in the *Koma Kurabe Gyōkō Emaki,* the actual structure of the residence itself—the wooden structure, the roof of delicate cedar shakes, the floorboards on the verandas and in the rooms, the stairways, and corridors—are all untreated in any way. Whereas halls of state were painted with vivid combinations of green, yellow, and vermilion and roofed with green-glazed tiles, for their own residences, the nobles, from the emperor on down, all chose to build of untreated wood. This taste is revealed in the Sakuteiki as well, in the constant reminders toward naturalism in design.

The basic layout of the Main Hall of the *shinden* residence was like a set of boxes within boxes (see figure 3, p. 16). In the core was the *moya*, which contained two spaces: a walled room for sleeping, which had only one entry, and a second space that was opened to its surroundings to be used as a day-room. The *moya* was in turn surrounded by peripheral rooms collectively called *hisashi*. The *hisashi* were separated from the outdoors by sturdy hanging wooden-lattice panels, *shitomi*, lighter hanging reed screens, *misu*, and movable standing fabric screens, *kichō*. Surrounding the *hisashi* was a slim veranda, *sunoko*, located under the broad eaves of the roof but otherwise completely exposed to the elements.[19] The *sunoko* is mentioned in the Sakuteiki as a reference point by which heights in the garden could be set, for instance the water level of the pond, and it also appears in many paintings as a favored place from which to admire the garden.

The design *of shinden* residences as described above is idealized. In reality there were many variants, and by the mid-Heian period most residences did not maintain a perfectly symmetrical plan. One reason for this was the recurrence of fires that destroyed the residences. Forced to rebuild time and time again, the nobles decided, for reasons perhaps financial rather than aesthetic, to do without certain elaborations in the ideal plan. There are, however, three points that can be said to be universal. First, the plan was centered on a central Main Hall with outlying halls connected by roofed corridors, even if those were not symmetrically placed. Second, the design was based on rectilinear forms: the surrounding earthen wall that enveloped the whole property; the north-south, east-west alignment of all the buildings;[20] even the design of each simple, box-like architectural unit. In contrast to the architecture,

19. In later years *moya*, "mother house," would be pronounced *omoya* and would refer to the main building of a residence in deference to sub-buildings, which were called *hanare*. *Hisashi* would come to mean the eaves of a roof, and *sunoko* would apply to a slatted wooden deck used where water is prevalent.

20. Although Heian was almost perfectly aligned with the cardinal points, it in fact had a westerly divergence of some 13' 54". See Tsuji Atsushi, cited by Hida Norio, *Teien Shokusai no Rekishi: Heian Jidai no Shokusai*, part 1 (Tōkyō: Nihon Bijutsu Kōgei, 1990-91), 37. At present, the magnetic declination in Kyōto is 6' 22' to the west. See *Kyōto Shigaizu* (Kyōto: Kyōtoshi Keikaku Kyoku, 1994).

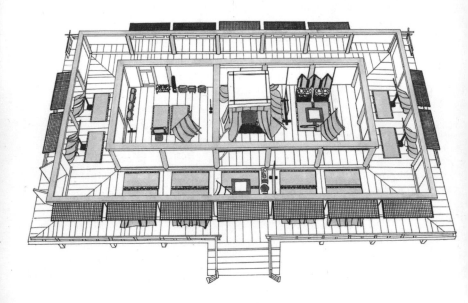

FIGURE 3: The Main Hall, *Shinden*

The Main Hall of aristocratic residences was the center of court life and directly related to the sand-covered court to its south. The central rooms, *moya*, were reserved as bedroom and living room for the master of the house; the rooms that surrounded the *moya* had various functions and were collectively referred to as *hisashi*; the *hisashi* were separated from the outdoors by movable shutters *(to* or *shitomi)*; the outdoor veranda that surrounded the building was called the *sunoko* and was used as a benchmark for setting heights when making gardens. (Redrawn from *Yomigaeru Heiankyō,* Kyōto City Publication, p. 125)

the gardens were entirely organic in their design. This brings up the third and perhaps most important point: *shinden* architecture was garden-oriented. In fact, the buildings of the Heian period served in many ways as stages offering advantageous views of the garden.

The Southern Court and Garden

The Southern Court immediately south of the Main Hall was flat, open, and spread with sand or fine gravel to make it usable for large gatherings. The ornamental garden was built to the south of that court, as well as to the southeast and southwest of the property. In rare cases, when the property was inordinately large, there are records of gardens in all four directions from the Main Hall. The Sakuteiki dictates that the Southern Court should be eighteen to twenty-seven meters in depth from the Main Hall to the pond. We can judge from this and other sources that for a property of one *chō*, the Southern Courts ranged from one thousand to more than two thousand square meters in size, or roughly a quarter to a half of an acre, while the ornamental garden may have been about three thousand to five thousand square meters, or roughly an acre to an acre and a quarter in size.[21] We can see in contemporary paintings, and find recorded in chronicles of the time, a great diversity of events taking place in this open area. *Nenjū Gyōji Emaki,* a scroll from the twelfth century depicting annual festivities in aristocratic households, for example, shows formal processions, dances, archery, cockfights, cherry viewing, and even at times men carrying torches, implying nighttime festivities as well.

Another use of the garden revealed in contemporary paintings is boating. There were three types of boats, the best known of which are those that had their prows carved in the shape of the heads of dragons or waterfowl. These boats were used to convey musicians and their instruments around the pond, creating a glorious spectacle for people of higher rank, who sat in the Southern Court or on

21. Sizes are based in part on a plan-view drawing of a typified imperial palace presented in *Kyō, Gosho Bunka e no Shōtai* (Kyōto: Tankō Mukku, 1994), 83, which represents a large-scale version of a *shinden* palace.

the veranda of the Main Hall observing the festivities. These boats were not used, however, for touring the garden. For that purpose there were two others types: one was an open boat with a narrow prow and the other was covered with a curved, Chinese-style roof and had a boxlike stern.[22]

There were as many styles and forms of garden as there were garden owners, but just as there were certain standard components to the architecture of the time so too were there standard components to the gardens which should be introduced briefly at this point. From images passed on to us in contemporary literature, including the Sakuteiki, as well as from paintings and archeological digs, we realize that the gardens often contained stones, diverse plantings, well-springs, ponds, islands, streams, bridges, and waterfalls.

As mentioned above, stones were the most fundamental element of garden design and served a number of purposes: structure, such as footings for building or ramparts to stabilize island banks; aesthetics, as when they were placed in flowing water to create certain visual effects; allegorical motifs, in which case the stones were seen as being representative of famous natural scenes or Buddhist deities; and for the effects they were believed to have on the geomantic balance of the entire property (a subject we shall go into in depth in the following chapter on geomancy). The garden stones we find depicted in paintings of Heian-period gardens are often complexly shaped. The Sakuteiki refers to these as "stones with corners" *(kado aru ishi, ishi kado art)*, implying that angular or complexly shaped stones were considered to be attractive. Evidence from archeological digs on Heian-period gardens confirms that rough-textured stones were used, but the specific undulating form often depicted in paintings is rarely found and may have been a painterly conven-

22. Dragon-head and Waterfowl-head boats are *ryūtō bune* 龍頭船 and *gekisu bune* 鷁首船, respectively. Dragons are said to be strong in water and waterfowl are strong against the wind, thus the two were carved on the prow to act as charms against trouble on a voyage. The waterfowl, *geki*, is described as a heron-like bird in Japanese dictionaries, but it looks more like a rooster in the paintings. Some examples can be found in *Nihon no Emaki*, vol. 9, *Murasaki Shikibu Nikki Ekotoba* (Tōkyō: Chūōkōronsha, 1987; 1988), 30-31, 40-41, 66-67, and *Nihon no Emaki*, vol. 18, *Koma Kurabe Gyōkō Emaki* (Tōkyō: Chūōkōronsha, 1988; 1993), 50-52.

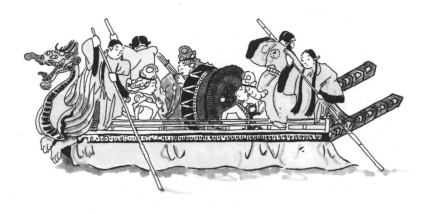

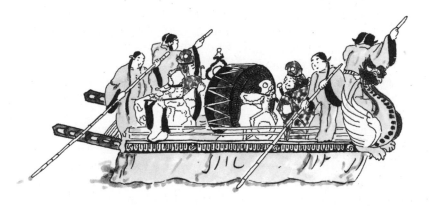

FIGURE 4: Musicians' Boats

Dragon-head boats *(ryūtō bune)* and Waterfowl-head boats *(gekisu bune)* were used exclusively to carry performers during festivities. It is unlikely the boats actually traveled around the pond, but rather floated slowly, lending an elegant atmosphere to the garden. The musicians in the Dragon-head boat are playing the drum *(taiko)* and flutes *(sho* and *hichiriki)* and wear red costumes representing the "left." The musicians in the Waterfowl-head boat are playing the drum, flutes *(hichiriki* and *yokobue),* and chime *(kane),* and wear green costumes representing the "right." (Redrawn from the *Komakurabe* scroll, Chūōkōronsha, p. 50-51)

tion of the time. The mountains that border the eastern side of Kyōto, called Higashiyama, are to a large extent composed of a type of granite that is formed primarily of three minerals: white feldspar, gray quartz, and black mica. When this granite is exposed on the surface and weathers, it quickly decomposes, forming the white sand that can be found in the rivers flowing out of that mountain. Assumedly, that is the same white sand that was used for surfacing the Southern Courts or for building promontories, *sūsaki shirahama*, and sandbars, *shirasu*, in the ponds and streams of the gardens. To the north of Kyōto, however, is a range of mountains called Kitayama, which yields a different kind of stone now called Kitayama-ishi that is composed of chert.[23] Unlike the granite or basalt boulders found in Japan, which form generally rounded shapes as they tumble along in rivers, chert is created in sedimentary layers of different hardness that degrade into more complex shapes as they erode.

Plantings were also important to the Heian-period garden designer and had far more diversity at that time than is commonly associated with Japanese gardens. We find for, instance, a wide variety of perennial grasses and flowers that have almost entirely disappeared from the palette of Japanese gardeners these days. The Southern Court, however, had almost no plantings in it since they would interrupt the free use of the space. Here plantings were usually limited to a few trees placed near the verandas of the various halls and occasionally tufts of wild grasses or meadow flowers planted to accent the edges of the Southern Court or the stream that passed along the eastern edge of it. In the case of the imperial hall of state, Shishinden, two trees were planted in the Southern Court for specifically symbolic reasons, one on each side of the central stairs that led up to the Main Hall. To the west was a citrus tree called *tachibana*, and to the east was a cherry, *sakura*. The evergreen citrus tree symbolized things eternal, while the deciduous cherry evoked the image of things evanescent; *Yang* and *Yin* in the garden.[24]

23. Chert is a form of sedimentary rock that has undergone changes subsequent to its initial formation and is thus called a diagenetic rock. The main constituent material of cherts is extremely fine-grained quartz. See R. V. Dietrich and Brian Skinner, *Gems, Granites and Gravels* (Cambridge: Cambridge University Press, 1990), 67-68, 161-3.

Water was easily available in the Heian valley, found either flowing freely from springs or by digging down to access groundwater (at times no more than a meter). Easily obtainable, it is no wonder that water in gardens was a common occurrence. The Sakuteiki describes wellsprings in some detail, recording technical data regarding the location of the source of the water, the way to artificially improve water flow, and the means of drawing water from natural or artificial wellsprings in underground wooden box-conduits that were reinforced against leakage with clay (see figure 5, p. 22). In addition to water that could have been drawn into the property from rivers flowing nearby, wellsprings provided a source of water for the garden streams and ponds.[25]

Ponds and islands seemed to have been almost requisite elements, and they are found in most paintings and literary references to Heian-period gardens. It was not, however, sufficient to just dig out a hole to create a pond. Rather, by carefully detailing the edges of the pond, as well as the stones and plantings around them, garden designers created a whole palette of water scenes, for instance, rocky seashores *(ara iso)*, cove beaches *(suhama)*, and wetland scenes *(numa ike)*, each of which differs from the other in the details of its design.

Islands also had many forms, such as the Mountain Isle, Meadow Isle, and Forest Isle. Naturally they were designed as scenery, but they also served to hold temporary stages, called *kari itajiki*, for musical performances. In the scroll *Nenjū Gyōji Emaki*, as well as

24. Formally, the trees planted in front of the imperial hall of state were called *sakon no sakura* (left-close cherry) and *ukon no tachibana* (right-close citrus). Originally the tree used in the Southern Court was a plum, not a cherry, and then in 834, during the reign of Emperor Ninmei, a cherry was planted for the first time. See Wybe Kuitert, *Japanese Flowering Cherries* (Portland, Timber Press, 1999), 44. Alternatively, the scroll *Kasuga Gongen Kenki Emaki*, vol. 1 (in vol. 13 of *Zoku Nihon no Emaki*, ed. Komatsu Shigemi, 18-19), shows a residence with a pine and cherry (or plum), and the *Nihon no Emaki*, vol. 8, *Nenjū Gyōji Emaki*, ed. Komatsu Shigemi (Tōkyō: Chūōkōronsha, 1987, 1993), 6-7, shows an example of two cherries.

25. As an example of the former, *The Tale of Genji* ("Hahakigi" chapter) relates how Ki no Kami, a member of Genji's retinue, had dammed a river called Nakagawa to bring its cool waters into his garden. Nakagawa is an appellation for Kyōgokugawa, a river that ran along Higashi Kyōgoku Ōji, the road delineating the eastern edge of the Heian capital. See Abe Akio et al., *Nihon Koten Bungaku Zenshū*, vol. 12, *Genji Monogatari* (1) (Tōkyō: Shōgakkan, 1972), 168.

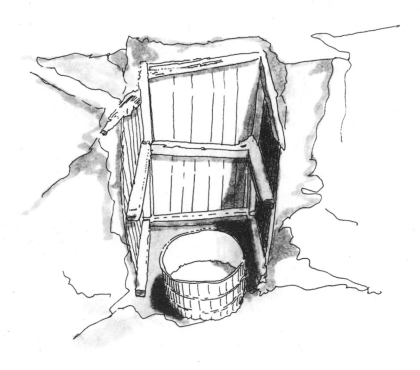

FIGURE 5: Heian-period Wellspring

The Sakuteiki describes how a wellspring should be created by digging a hole over a natural spring, lining it with wooden boards to prevent collapse, and then tamping clay around the outside to prevent leaks. This Heian-period well box excavated in the Nishijin district of Kyōto shows exactly that form. (Redrawn from site photos, Kyōtoshi Maizō Bunkazai Kenkyūsho)

in *Koma Kurabe Gyōkō Emaki*, the flame-like crest of a large drum called *dadaiko* and a festival tent made of brightly colored, striped cloth can be seen on the central island of the pond.[26] There were often several islands within larger ponds, and the Sakuteiki relates how it would be possible to connect two islands with a temporary stage if there was not enough room on one to accommodate the performers' activities on only one island.

> On the back side of this island a place for musicians should be prepared, as large as twenty-one to twenty-four meters across. The front of the island should remain plainly visible in front of the musicians' area and so, if there is not enough room on the central island, another island may be constructed behind it, and a plank deck constructed to connect the two.
>
> II. Southern Courts (p. 153)

It was not, however, imperative to have a pond, and the Sakuteiki also mentions a garden style with only a Winding Stream.

> In the case where there is no garden pond, but only a Garden Stream, Meadow scenes should be built in the Southern Court and used as the theme for the design of the garden.
>
> VIII. Garden Streams (p. 180)

Ideally, the flow of water was made to enter the property from the north, flow to the east of the Main Hall through a winding stream called a *yarimizu*, pass in front of the Middle Gate that acted as the eastern entry to the Southern Court, and then into the elongated pond in the south, central part of the garden area. From there the water would flow to the southwest and out of the property (the path of the water had geomantic implications, which will be discussed at length later on). The edges of the stream and pond were accented with boulders and tufts of meadow grasses and flowers. The riverbed, as well as the bottom of the pond, was lined with clay to prevent leakage and embedded with small stones, which would help prevent erosion from moving water, the effects of fish digging around for food, or boatsmen prodding with their poles. The streams

26. The *dadaioko* can be seen in *Nenjū Gyōji Emaki*, (8), 10, and *Koma Kurabe Gyōkō Emaki*, 50-51. (See figure 6, pp. 26-27.)

were made to flow languidly, just enough to keep the water moving or gently push fallen cherry blossoms along, and the Sakuteiki suggests a slope of three percent as being just right.

> With regard to the slope of a waterway, and the manner in which water will be made to flow, a fall of nine millimeters over thirty centimeters . . . will make for a murmuring stream that flows without stopping.
>
> VIII. Garden Streams (p. 175)

As a result of the extensive use of water in the gardens, we also find numerous bridges. The *yarimizu* is often shown crossed by a small bridge made simply by laying down a large, reasonably flat, natural stone. The bridge where the *yarimizu* passes in front of the eastern Middle Gate, however, was usually made of cut stone or wood, and shaped with a slight upward curve. A smaller bridge was built in front of the western Middle Gate, where there was a small drainage ditch that followed along the buildings and corridors. A large, curved bridge connected the Southern Court to the central island in the pond. At times the railings of this bridge were painted a bright vermilion color, a custom left over from the Asuka and Nara periods, when Chinese style was still considered high fashion. If there were other islands in the pond they were connected to one another, and to the shore, by means of flat bridges.[27]

Waterfalls are common in Japan because of the large amount of rain that falls here combined with the steep geological formations that comprise most of the country. Waterfalls are mentioned in many ancient records as prayer sites and places of pilgrimage as well as being places of scenic beauty. Certainly at the time the Sakuteiki was written, there was a widespread knowledge of, and an abiding interest in, waterfalls. The Sakuteiki describes their construction in detail, discussing ways to construct a wide variety of fall patterns. Moreover, the text also reveals that the Heian aristocrats perceived

27. Although none of these wooden bridges is extant, whether they were curved or flat can be deduced from paintings as well as from the placement of the footings, some of which remain preserved in the mud of the pond bottom. Flat bridges have even spacing between the footings, while curved bridges have footings spaced closer toward the ends than in the middle.

an allegorical aspect to waterfalls, perceiving in them the visage of Fudō Myōō, a Buddhist deity.

Lives of the Aristocrats

The population of Japan at the time of the Sakuteiki may have been around seven million. Of these, perhaps 100,000 people lived within, or were based in, the Heian capital itself. Among the residents of Heian, who were referred to as *kyōko*, roughly 10,000 would have been aristocrats—those whom the Sakuteiki describes as owners and builders of gardens.[28] Other written material from the Heian period, such as *The Tale of Genji*, *The Pillow Book*, and *The Gossamer Years*, offers highly detailed descriptions of court life, and from these and other sources we get a picture of a close circle of highly cultured, interrelated families who spent a good deal of their time either in aesthetic pursuits (including romance, which was an aesthetic pastime in that day) or vying with one another for power positions at court. The worldview presented in these books is intensely introverted. The Heian capital seemed to represent all that was good in the world, and aristocrats of standing who lived there referred to themselves as *yoki hito*, the "good people."[29] The small town of Fushimi, for instance, which lies just a few kilometers south of the Heian capital, was considered to be the hinterlands, and a posting as governor of the southern island of Kyushu was tantamount to exile.

This introversion can be seen in the Sakuteiki as well. In later years, a gardening technique developed that is now known as *shakkei*, or borrowed scenery, by which a distant view was incorporated into a garden in a painterly manner. There were tremendous opportunities for this in the Heian capital. The land was relatively flat, affording good views of the surrounding hills, and since the residences of

28. Sources for population figures: *Kokushi Daijiten* (Tōkyō: Yoshikawa Kōbunkan, 1986), 811. Heian figures are from *Kyōto Daijiten* (Kyōto: Tankosha, 1984), "Heiankyō." Heian figures are from *Kyōto Daijiten*, Tankōsha, *Heiankyō*. Population figures from before the national survey of 1721 (then 26 million people nationally) are estimations at best, with the Heian, Kamakura, and Muromachi periods proving particularly intractable.

29. Morris, *World of the Shining Prince*, 80.

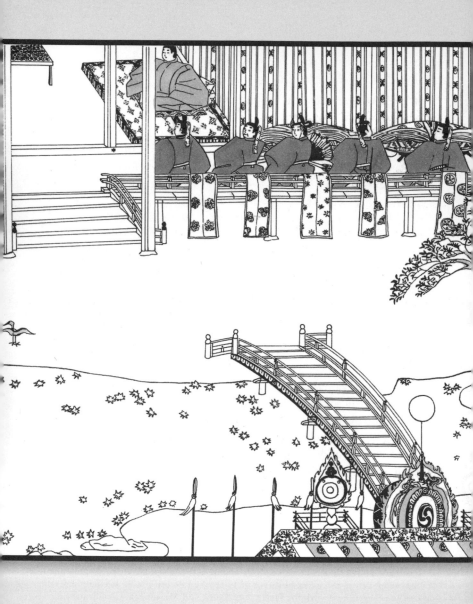

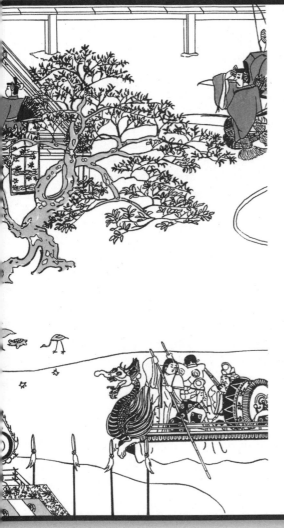

FIGURE 6:
Festivities in the Southern Court

On the island in the foreground
is the musicians' stage *(gakuya)*,
including a cloth tent, decorative
halberds, one large drum *(dadaiko)*
and two smaller ones *(shōko)*.
Performances by elaborately
dressed musicians on the island,
as well as on boats on the pond,
were intended to create the correct
atmosphere at formal gatherings.
In the background, gentlemen
sit on the veranda *(sunoko)* of the
Main Hall *(shinden)* with the
multilayered dresses of princesses
poking out from below the
curtains in front of them. A large
Japanese maple frames the corner
of the veranda, its fallen leaves
floating on the surface of the pond.
The cranes and turtle by the
shoreline are images of felicity
rather than actual garden pets.
(Redrawn from *Komakurabe* scroll,
Chūōkoronsha, pp. 50-51)

the nobles were spread out, only of one story, and surrounded by a relatively low property wall, they would have had a virtually un-interrupted view of their surroundings. The long, serpentine ridge of mountains on the eastern or western flanks, the layered ranks of mountains that climb ever higher toward the north, and especially Mount Hiei, which sits prominently in the northeast, should all have been visible from any garden. Of course, the Main Hall faced south, so the primary view would have been mostly of the South-ern Court, one's own garden, trees in the southern neighbor's rear garden, and the sky, but from any of the garden pavilions, from a boat on the pond, or from a vantage point on one of the small hill-ocks in the garden, the views of the surrounding natural world must have been spectacular.[30] It is possible that the edges of the property were completely surrounded by tall and dense, old-growth trees that blocked the view, but there is little evidence of this in paintings, and archeological digs do not turn up massive root pockets along the edge of the properties. The fact that the Sakuteiki makes no note of views outward from the garden whatsoever may well be more indicative of the introverted nature of Heian society in general than the actual appearance of the gardens.

Another aspect of Heian culture that was central to the lives of the aristocrats is poetry. Unlike the authors of other books from that period—for instance, Murasaki Shikibu, the purported author of *The Tale of Genji*—the author of the Sakuteiki never breaks into poetic verse, and while in *Genji* we find imagery from the garden used to make allegorical inferences about the emotional state of the characters in the tale, the author of the Sakuteiki does not present the garden in these sorts of poetic terms. This is especially surpris-ing since in biographical records the name Tachibana no Toshitsuna is as associated with poetry and music as it is with gardens. Only

30. In the *Hōgen Monogatari* 保元物語, a passage relates that it was possible to spy down on Takamatsudono by climbing a tree on a hill in the Higashisanjōdono. The two residences were directly next to each other; the latter was a large, *two-chō* site on the corner of Nijō and Nishinōtoin, and the former, a smaller one-*chō* property, just at the corner of Aneyakōji and Nishinotōin (see figure 29, p. 144). One scene in the scroll *Nenjū Gyōji Emaki* shows just such a tree-covered hill to the west of the Western Annex Hall. See Komatsu, *Nihon no Emaki mono Zenshū*, (8), 99.

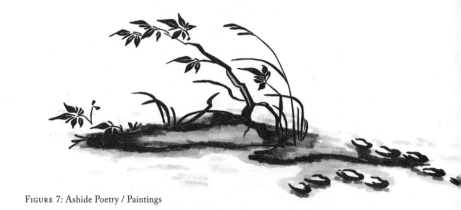

FIGURE 7: Ashide Poetry / Paintings

Ashide were paintings that concealed short messages or that were overwritten with longer poems. The landscape images were usually undulating shorelines and soft, flowing plantings: wisps of grasses or sensuous pine trees. The Reed Style *(ashide no yō)* of gardening mimicked this painting style. The looped line in the center is an abstracted version of the character meaning "water." The poem inscribed over this painting has been eliminated for clarity (Redrawn from Wakan Rōeishu, Kyōto National Museum)

in a few places is the prevalence of poetry in Heian court society revealed in the Sakuteiki. One such place is chapter five, "Styles of Gardening," in which we find the Reed Style, *ashide no yō*. *Ashide* does not refer to a natural scene; instead it is the name for a type of calligraphic poetry, a game of sorts, in which a painter created a scene of an undulating shoreline or a meadow in wispy, flowing brushstrokes, with tufts of grasses or reeds here and there, and maybe a few curvaceous tree trunks for effect. Within the flowing lines of the painted landscape, poems or individual characters were skillfully inserted, half-hidden in the landscape among the plantings. The Sakuteiki shows us that the classic image of an *ashide* poem— tufted grasses and an undulating ground plane—was so commonly understood that it could be used as a tacit model for garden design.

> In the Reed Style, hill-forms should not be too high. A few stones should be set along the edge of Meadows or on the water's edge; next to those, some grass-like plants such as grass bamboo or tall field-grasses should be planted. Plums, willows, or other such trees with soft and gentle forms can also be planted according to one's taste.
>
> V. Gardening Styles (p. 163)

Besides the mention of *ashide,* other sections of the Sakuteiki also reveal how Heian nobles thought in literary terms. First, a small note in chapter eleven states that ponds can be built in the form of *kana* script. *Kana* is a syllabic script developed by the Japanese to compensate for limitations in the imported Chinese script, *kanji,* in expressing their own language. In chapter twelve, we find a certain amount of wordplay introduced into garden design. The fact that the words *willow* and *dragon,* for instance, can both be pronounced *ryū* allowed for an association between willow trees and Dragon Gates. Likewise, the words *catalpa* and *bosom,* both of which can be pronounced *kai,* associated catalpa trees with gates of ministers of state who were supposed to "take the people of the land to their bosom." Also in chapter twelve is advice against planting trees in certain positions (on axis with a gate or in the center of a square-shaped property) which would evoke an image of *kanji* with pejorative meanings.[31] In these examples we see that word play, certainly an essential element of the poetry of the day, was used to impart geomantic or social significance to elements of the garden. Still, as a whole, the Sakuteiki does not offer a poetic vision of the garden and may differ in that way so strongly from the three texts mentioned above in that the author of the Sakuteiki was a man while the other texts all were written by women.

Designers and Builders of the Gardens

The Sakuteiki was intended to reinforce oral teachings, known as *kuden,* a term that implies a secret teaching that an apprentice would receive from his master. In the Heian period a formal apprentice system like the one that developed during the late medieval and Edo periods was not in existence yet. There were, however, those people who by virtue of their age and experience in garden making were held to be masters, described in the Sakuteiki as "skilled ones of old," *mukashi no jōzu.* The designers of the gardens were primarily members of the aristocratic class who supervised the building of their own gardens and advised others on their gardens as well. There

31. See footnotes 123-125 on page 197.

is one scene in *The Tale of Genji,* in a chapter called "Matsukaze,"[32] in which the protagonist, Genji, a young prince of the highest rank, is seen robe discarded, personally supervising the repair of a winding stream that runs underneath one of the Breezeways. This kind of work, however, was not done professionally and there was no professional gardening class during the Heian period that would be the complement of the *uekiya* and *niwashi* of later years.[33] By the mid to late Heian period there were also Buddhist priests involved in garden building, known collectively as *ishitateso,* literally stone-setting priests, though in fact the expression "stone-setting" was simply a euphemism for "garden making." Many of these priests, though not all of them, were associated with Ninnaji temple, and they may have been involved in both the design and construction of gardens, depending on their rank. Two such *ishitateso* who are mentioned in the Sakuteiki are En'en Ajari, referred to as a great master of gardening, and Renchū, who apparently committed a taboo in his work.

In addition to aristocrats and priests, there were several branches of the government that were involved with gardens. The bureaucratic system of government during the Heian period was based on a Chinese system called *ritsuryō* (Ch. *lu ling),* which had been imported to Japan in the late seventh century. Both *ritsu* and *ryō* mean "orders" or "decrees," but in practice *ritsu* stood for the system of punishments to be meted out against those who digress from the rules, while *ryō* dictated administrative regulations. At the core of the system were eight ministries, four under the supervision of the Controllers of the Left, *sabenkan,* and four under the Controllers of the Right, *ubenkan.* One of the responsibilities of the Controllers of the Left was the Interior Ministry, within which was the Bureau of Geomancy, located in a building just south of the imperial residence within the palace.[34] In a society that placed so

32. In Edward Seidensticker's translation of *The Tale of Genji* (Tokyo and Rutland, Vermont: Charles E. Tuttle Co., 1976), "Matsukaze" is called "The Wind in the Pines."

33. *Uekiya* and *niwashi* are terms for professional gardeners; the former was coined in the Edo period and the latter in the Meiji period.

34. Controller of the Left, *saben kan* 左弁官; Controller of the Right, *uben kan* 右弁官; Interior Ministry, *nakatsukasa shō* 中務省; Bureau of Geomancy, *onyō ryō* 陰陽寮. The Controllers were responsible to the Minister of the Left *sadaijin* 左大臣 and Minister of the Right, *udaijin* 右大臣.

much importance on physical positioning as representative of social hierarchy, it is informative to see that this Bureau was located as close to the main southern gate of the imperial palace as possible. Geomancy is an ancient means of divination, and the Bureau of Geomancy was responsible for astronomical and meteorological divination, administering calendars, timekeeping, and divination of future events. Geomancy was also applied to garden design as well as garden maintenance, and some of the tasks assigned to members of the Bureau of Geomancy may well have been directed toward imperial gardens. For instance, the bureau may have been called on to design, or approve the design of, a garden with regard to the placement of stones and flow of water, both of which were believed to affect the geomantic balance of a household. They may have also approved the schedule of maintenance work, especially earthwork, which was taboo at certain times (see chapter on taboos).

One of the four agencies under the auspices of the Controllers of the Right was the Imperial Household Ministry, which was responsible for all matters concerning the wellbeing of the imperial family. Within this ministry there were eighteen bureaus, at least five of which had certain responsibilities related to gardens.[35] The most important among these would have been the Bureau of Gardens, which was responsible for the maintenance of imperial gardens and grounds as well as the vegetable fields and orchards used by the imperial household.[36] The Bureau of Carpentry had responsibility for construction and repairs of all imperial buildings, so this would naturally include garden pavilions and perhaps garden fences and the like. The Bureau of Earthworks was responsible for such work as plastering, rooftile production, and lime production

35. Within the Imperial Household Ministry, *kunai shō* 宮内省, were the Bureau of Carpentry, *moku ryō* 木工寮; Bureau of Earthworks, *dokōshi* 土工司; Bureau of Festivals, *uchi no kanimori no tsukasa* 内掃部司; Bureau of Gardens, *enchi shi* 園池司; Bureau of Geomancy, *onyō ryō* 陰陽寮; Bureau of Household, *tonomoryō* 主殿寮.

36. As early as the Nara period, *Shoku Nihongi* 続日本紀, a record of ancient events, mentions the *enchi no shō* 園池正, who is the head of the *enchi shi*, and describes his duties as including the administration of all imperial garden ponds 諸苑池, vegetable crops, and orchards. Hiromasa Amasaki and Jirō Takei, *Teianshi wo Aruku* (Kyōto: Shōwadō, 1998), 30.

and thus may have been involved in the construction of certain aspects of the garden such as earthen walls. The Bureau of Household Affairs dealt with sundry aspects of daily life, including maintenance of imperial carriages, household curtains and blinds, and candles and lamps; it also had the responsibility of keeping the garden clean. The fifth agency related to gardens was the Bureau of Festivals, which made preparations for festivals and ceremonies, many of which required the use of the garden, especially the flat portion of the garden spread with white sand that adjoined the southern façade of the Main Hall.

Part of the *ritsuryō* system, but under neither the Controllers of the Left nor the Right, was a branch called *kyōshiki* that was responsible for, among other things, the maintenance of the capital's trees. Passages in *Engishiki*, a text from the early tenth century that details the *ritsuryō* bureaucracy, mention that the responsibilities of the *kyōshiki* included planting and caring for the vast colonnades of willows along the central north-south avenue, Suzaku ōji, noting that there should be "...four men to protect the willows of Suzaku..." as well as men to "...plant willows in the *ten-chō* area around (the imperial garden) Shinsen'en."[37]

With regard to the actual builders of the gardens, little is recorded of the individual men who labored to construct the gardens. Whereas the imperial household had various government bureaus to support it, other aristocrats had to draw from their own household staff, as well as from serfs, *domin*, who worked on their outlying manors, *shōen*, for the construction and maintenance of their gardens. For instance, in the same scene of *The Tale of Genji* mentioned above, where Genji is personally supervising garden work, the actual cleaning is being performed by serfs who, having heard of his arrival, gathered from his nearby manors. There was no gardening profession; however, those members of an estate staff who cared for the garden were called *komori* or Tree Guardians.

37. *Kyōshiki* 京職 was the bureau of the *ritsuryō* government in charge of administration, litigation, taxes, transportation, etc. *Engishiki* 延喜式 is a record, compiled between 927 and 967, of annual ceremonies and rituals performed by the imperial household. As cited in Hida, *Heian Jidai no shokusai* (1), 37-38.

FIGURE 8: Purification Ceremony

This scene depicts an aristocratic residence during an annual purification ceremony called *minazuki-barae* 水無月祓, 六月祓 or *nagoshi no barae* 夏越の祓. The central act of the ceremony, which was (and still is) performed on the last day of the sixth month, was passage through, a purifying

hoop made of miscanthus reeds, *chi no wa* 茅の輪. At shrines, the hoop is large enough to walk through, but in this scene, in the upper left, a woman and infant are having a hoop passed over them as an act of purification. The two men sitting and talking in the upper right corner are

inside the Eastern Annex Hall, which is connected to the Main Hall by a curved, bridge-like Breezeway, *suiwatadono*. From under the Breezeway flows the Garden Stream, *yarimizu*. To the left of the stream, walking toward the stone bridge, is a *Yin Yang* practitioner, *onyō ji*, and behind him, next to the plum and pine trees, is the temporary altar he has set up to perform his incantations. Behind the desk is a circular mat where he sits (facing south), and on the altar are set eight small wands, *beigushi*. While *minazuki-barae* finds its basis in Shinto belief, the incantations of the *onyō ji* were based in Chinese geomancy. (Redrawn from *Nenjū Gyōji Emaki*, Chūōkōronsha, pp. 48-49)

Visions in the Sakuteiki

The Sakuteiki is a technical journal, written for a select group of people who were involved in garden making. At least a third of the text is made up of concise, technical advice on how to lay out or construct various elements of the garden. We find, for instance, the following:

> When designing the Southern Courts of aristocratic residences, the distance from the outer post of the central stair roof to the edge of the pond should be eighteen to twenty-one meters.
>
> II. Southern Courts (p. 152)
>
> The surface of the pond should be twelve to fifteen centimeters beneath the bottom edge of the veranda of the Fishing Pavilion.
>
> III. Ponds and Islands (p. 156)
>
> If the waterfall is 90 to 120 centimeters tall, then it should be made of mountain stones with rough surfaces.
>
> VII. Waterfalls (p. 166)
>
> The technique for keeping water from leaking from the sides and bottom of a wellspring is as follows . . .
>
> XIII. Wellsprings (p. 199)

Amazingly, for the most part, the same rules and techniques, or variants of this explicit gardening information, are still employed today by traditional gardeners and garden designers. Because of the straightforward nature of this body of technical information, there is no need to embellish it further with commentary and explanations. Beyond this straightforward technical advice, however, the Sakuteiki reveals four ways in which gardens were perceived during the Heian period—that is to say four threads of allegorical meaning that were woven into the gardens by their designers and perceived in the gardens by the aristocrats who lived with them—and this is where the Sakuteiki becomes truly interesting for both professionals and laypeople alike. Many of us nowadays have been influenced by philosophies of modern art movements that divorce form from meaning, allowing form to exist for its own sake. It is perhaps a little difficult for us to comprehend a mentality, like that presented in the Sakuteiki, that necessarily links meaning and form, but it is a difficulty that makes an understanding of such a text all the more relevant because it suggests a new way of thinking.

The first and most obvious of these four interpretations are the images of nature we find throughout the Sakuteiki. We see that the garden was envisioned as a conglomerate of "vignettes" of the natural world. The second set of meanings imparted to the garden relate to ancient Chinese geomancy. In this case the garden is perceived as modulating geomantic forces that can affect the larger household either positively or adversely, depending on whether the components are correctly designed or not. These references are less common than nature images, but it is clear that they form a fundamental basis for garden design. The third interpretation of the garden seen in the Sakuteiki relates to Buddhism. Certain elements of the garden were considered representative of Buddhist deities, and well-known Buddhist allegories were used as the basis for the design of the gardens themselves. Lastly, the complex system of taboos that so heavily influenced every aspect of aristocratic life in the Heian period is also evident in gardens as presented in the Sakuteiki. By examining each of these interpretations, we hope to set the stage for a deeper understanding of this ancient treatise as well as to offer, to gardeners and garden designers alike, possibilities for enhancing their own work.

生得の山水

生得の山水

Shōtoku no senzui

Nature

NATURE

Select several places within the property according to the shape of
the land and the ponds, and create a subtle atmosphere, reflecting
again and again on one's memories of wild nature.
I. The Basics (p. 151)

Paying keen attention to the intricacies of nature is one of the un-
derlying themes in the Sakuteiki, the importance of which is made
evident throughout the text but nowhere more clearly than in
the opening lines shown above. The word used for nature in the
Sakuteiki is *shōtoku no senzui*, in which *senzui* means "mountain-wa-
ter" and *shōtoku* means "natural constitution" or "innate disposition."
This phrase appears three times in the Sakuteiki, once in the above
quotation and again twice at the end of chapter eleven. *Senzui*, which
in later years would be pronounced *sansui*, has various meanings and
usages. Taken most directly, it refers simply to mountains and water.
It can also imply a landscape that contains mountains and water, as
in the expression *sansuiga*, which refers to paintings, primarily from
medieval periods onward, of natural landscapes depicting mountains
and rivers or mountains and the sea. *Senzui* can also mean "nature."
In that case, out of the vastness of nature, mountains and water
have been chosen as representative elements, fusing them into a sin-
gle icon that represents the whole. According to Chinese geoman-
tic thought, rigid and stable mountains are considered to be *Yang*
elements, while fluid and everchanging water is *Yin*. We see that
mountains and water were chosen not only for their ubiquitousness
in the landscape (at least in the part of China where this terminol-
ogy originated), but these words also represent what was perceived
as the two most fundamental building blocks of the natural world.
Senzui can also mean "garden," as in *karasenzui (karesansui* in later
eras), a style of garden that includes no water in its design. In this

last expression we see that garden designers, envisioning their creations as a distillation of the natural world, took the very word that meant "nature" as an appellation for their work. The word *distillation* is also very important, since the gardens were not designed to be nature parks or botanical gardens in which nature is re-created in full, but rather as works of art that extract a certain aesthetic essence from nature. This need for distillation when designing an artificial landscape was also stressed in the opening of the Sakuteiki:

> Visualize the famous landscapes of our country and come to understand their most interesting points. Re-create the essence of those scenes in the garden, but do so interpretatively, not strictly.
>
> I. The Basics (p. 152)

The idea that nature is to be used as a model for garden design but not to be copied in its entirety is expressed again at the end of chapter eleven:

> A certain person once said that man-made gardens can never exceed the beauty of nature. Travel throughout the country and one is certain to find a place of special beauty. However, there will surely also be several places nearby that hold no interest whatsoever. When people make gardens they should study only the best scenes as models. There is no need to include extraneous things.
>
> XI. Miscellany (p. 191)

The author of the Sakuteiki advises the readers to make a study of nature as a basis for garden design but also suggests that this knowledge must be applied in an artistic and interpretive manner. The word used in the Sakuteiki to describe this feeling is *fuzei*, which is written with two characters meaning "wind" and "emotion." When *fuzei* is used in reference to a physical situation it can best be translated as the "spirit of the place" or "subtle atmosphere"; when it is applied to a designer's personal sensitivity toward design, "taste" would be more suitable. In keeping with the aesthetics of the time, the taste that was preferred was one of refined elegance, and *fuzei* came to connote that as well. It is interesting to note that despite the importance of nature as a model for garden design, the author of the Sakuteiki found it necessary to stress that a study of nature alone would not suffice to make one a garden designer. At

the end of chapter eleven we find an instruction that states there are other things besides nature study that are imperative for an understanding of garden design:

> To make a garden by studying nature exclusively, without any knowledge of various taboos, is reckless.
>
> XI. Miscellany (p. 192)

Nature in the Heian Period

Even though the author of the Sakuteiki stressed that the study of nature needs to be tempered by a knowledge of taboos, nature was still a primary source for imagery in garden design; but what was "nature" as the Heian aristocrats knew it? The world they immersed themselves in, as we have seen, was relatively limited in a physical sense. They confined themselves as best they could to the precincts of the capital, at times taking short sojourns into the surrounding area, usually nothing more than several kilometers in any direction: plant collecting in Saga, just a short ride by horse to the northwest; east over the hills to visit temples in what is now Shiga prefecture; or south to Fushimi or Uji. The stories they were familiar with, as recorded in poetry or told by travelers, extended their understanding to include the environs of the ancient capital of Nara, the Inland Sea, the Japan Sea, and some outer provinces. We know that certain relatively distant scenes were replicated in abstract form in Heian-period gardens, for instance the famous landscape of the Pine Isles in Matsushima Bay (in northern Honshu near the city of Sendai) which Minamoto no Tōru re-created in his garden, even going to the extent of boiling salt water on the edge of his pond to capture the right *fuzei*. Still the natural world the aristocrats were most familiar with would have been that which directly surrounded the Heian capital, an environment which had in fact been altered by human intervention for quite some time. Long before Emperor Kammu decided to build the Heian capital in that valley, there were people dwelling there: among them, the Hata clan in the west, the Kamo clan in the north, and the Yasaka clan in the east. These families were skilled at various crafts, such as silk weaving and pottery, and also were adept at civil engineering, especially controlling wa-

terways for agriculture. We can expect therefore that the landscape had been altered for agricultural purposes, though not on a massive scale, even before the imperial city was moved to that location.

What most dramatically reshaped the landscape was timber felling for colossal construction projects related to the construction of more than five capital cities within one hundred years. The requisite halls of state, imperial and aristocratic residences, and large-scale temples required enormous volumes of large-girth timber. In addition, timber was felled in order to build housing and workspaces for the nonaristocratic population, which in volume would have been even greater than that required for the needs of the upper echelon, though the quality and size of timber required were on a lesser scale. Furthermore, brush and forest undergrowth—everything from fallen leaves and branches to small trees—would have been collected for use as fuel. By AD 800, the entire region from south of present-day Osaka to north of Lake Biwa, including all the surroundings of the Heian capital, had been stripped of its old-growth forests.[1] Since there was no active attempt at replanting forested areas, the secondary growth that naturally filled in after logging would have included faster-growing deciduous trees, in fact many useful plants such as chestnut and oak which would provide food and fuel. In areas where the soil was not particularly fertile perhaps red pine trees would have been the predominant infill.[2]

The result is that the landscape around the capital would have not been a vision of wild nature. With purportedly hundreds of thousands of conscripts working to build the Heian capital in the space of a few years, the impact of the construction alone must have been enormous. After those initial scars healed, however, and certainly by the time the Sakuteiki was written, the surrounding hills would have recovered a secondary-growth forest, but that forest would have been composed of smaller trees and more deciduous

1. Conrad Totman, *The Green Archipelago* (Berkeley: University of California Press, 1988), frontispiece, map 2.

2. In fact, we see an increase in pines replacing primal forest as a result of human influence beginning as early as the Jomon period, in other words, more than 2500 years ago. Hida, *Heian Jidai no Shokusai* (1), 36.

species, making it altogether lighter in feeling than the original. Perhaps in areas near the capital, the forest would have even appeared somewhat park-like because of the constant gathering of fallen material and undergrowth by the general populace for firewood and other sundry purposes. The flat land between the capital and the hills would have been at least partially filled with rice fields and dotted with occasional farming hamlets and agricultural manors *(shōen)* owned by aristocrats. Buckwheat was most likely raised in slash-and-burn patches on slopes that were too steep for rice or vegetables, and meadows still existed in outlying flatlands or in small valleys found between the mountains. The existence of meadows is revealed in certain historical records such as one that relates that during a hunting trip taken in 796, Emperor Kammu visited Ōharano, Murasakino, Hino, Kitano, and Kurusuno, in which the suffix *no* means "meadow."[3]

Plants in the Heian Gardens

The plantings used in Heian-period gardens were more varied than those usually associated with Japanese gardens of later eras, especially the ascetic "dry" gardens, *karesansui*, of the middle ages. Of particular note is the ample use of herbaceous plants—grasses, vines, and meadow flowers—which are all but absent from Japanese gardens nowadays. In the *Pillow Book*, written by Sei Shōnagon in the late tenth century, 121 plant names are mentioned. Although the variety of plant species used in the garden would slowly decrease toward the end of the Heian period, at the time of the Sakuteiki they were still diverse.[4] Not all gardens were the same, and some owners would have pushed the ornamental garden back in favor of

3. Ōharano 大原野, Murasakino 紫野, Hino 日野, Kitano 北野, and Kurusuno 来栖野. Buckwheat pollen has been found preserved in the deep mud of Midorogaike pond in northern Kyōto. Emperor Kammu's hunting trip is recorded in the *Nihon Gōki* 日本後紀, a record of events from Emperor Kammu to Emperor Junna completed in 840. Ibid.

4. This and other information on plants in Heian-period gardens is drawn in part from Hida, *Heian Jidai no Shokusai* and from *Kyōto no Teien: Iseki ni Mieru Heian Jidai no Teien*, vol. 5 of *Kyōtoshi Bunkazai Bukksu* (Kyōto: Bunka Kankō Kyoku, 1990).

a large open space for holding festive events, while others would have preferred the enclosure of trees. *Eiga Monogatari,* for instance, records that in 1016 the Sanjō palace was used as a temporary imperial residence, *satodairi,* and goes on to describe that residence as having "no pond nor garden stream, but with plants in abundance, and tall groves of trees."[5]

Judging from a combination of references in literature, depictions in paintings, and archeological finds, we can see that certain plants were favored by Heian gardeners. Of the evergreens, pines, both red and black, were found planted on garden islands, along pond edges (especially when the pond was evoking the image of a seashore), and as single specimen trees close by the Main Hall. Although we know that evergreen oaks were used in the gardens, the fact that they do not show up in paintings of the area around the Main and Annex Halls implies, most probably, that they were used in the rear of the garden as background plantings.

Of the deciduous trees, the most highly featured were plums (often red-flowering varieties called *kōbai)* and cherries, which were given center stage in the Southern Court, close to the Main Hall; willows (especially weeping willows), planted near water, at the pond edge, or on an island; and Japanese maples, used both near the Main Hall as specimen trees and in the general planting, often as part of an "autumnal scene." Larger deciduous trees, as with the larger evergreens, were probably used in the rear of the garden. These included Asiatic nettletree and Japanese hackberry. Unlike modern Japanese gardens, Heian-period gardens used fruiting trees such as persimmon, pear, and peach as well as chestnut and other nut-bearing trees.

Bamboos, especially fine bamboos such as *kuretake,* were used in the gardens, and they are often shown planted in boxes with open grillwork sides that were placed either in front of the Main Hall or in one of the small courtyard gardens. Grass bamboo was also used,

5. The *Eiga Monogatari* 栄華物語 is a historical record that centers on the splendorous life of Fujiwara no Michinaga (966-1027). The reference to a garden with no pond comes from scroll number twelve. As cited in Hida, *Heian Jidai no Shokusai* (4), 26.

and the Sakuteiki suggests planting it in clumps by stones along the water's edge. It seems that larger-scale bamboo was not planted in the garden, but it was used in garden construction to form underground pipes for waterworks and as a level-measuring device, split in half and filled with water.

Shrubs commonly used include bushclover, the large mounded form of which was used sometimes beside the central stairs that led into the Main Hall or along the open corridors that bordered the Southern Court, as well as the pendulous yellow-flowered *yamabuki*. Another Heian-period shrub, one that is still very popular, is the Satsuki azalea, which is often seen in gardens nowadays trimmed tightly into mounded forms. In the Heian period it was called *iwatsutsuji*, Rock azalea, and was undoubtedly not trimmed, since fine metal gardening tools were not developed until the following, medieval period.

The prolific use of flowers and meadow grasses distinguishes Heian-period gardens from modern Japanese gardens, in which those kinds of plants are almost nonexistent. Among those used in the Heian period we find Japanese pampas grass, Chinese bellflower, and plantain lily, all of which are used to create the feeling of a meadow, for instance along streams in the garden. Regarding the planting of herbaceous plants, *Sansuishō,* an edited version of the Sakuteiki from the Kamakura period, mentions that the taller varieties should be planted at the back of the garden, near the large earthen walls, while the shorter ones should be set out in front.[6] This common-sense directive presents us with an image of herbaceous plants laid out in

6. *Sansuishō* 山水抄 is an edited version of the Sakuteiki written by Keisan Hōin 慶算法印 in the early thirteenth century. The *Sansuishō* contains basically the same material as the Sakuteiki, but rather than order it into ten to fifteen subgroups, it breaks the information into three scrolls each with a title: *Twenty-eight Items Regarding Setting Stones* [*Tateishi Shisai Nijuhachi Kajō* 立石子細廿八箇条], *Twenty-seven Items Regarding the Circumstances of Making Waterfalls and Streams* [*Tatetaki Ryusui Shidai Nijūshichi Kajō* 立滝流水次第廿七箇条], and *Thirty-one Secret Teachings Regarding Setting Stones and Plantings* [*Tateishi Kuden Sanjūichi Kajō Narabini Senzai no Koto* 立石口伝三一箇条並前栽事]. The sections on construction (*Zōsaku no Koto* 造作ノ事) and plantings (*Senzai no Koto* 前栽事) found in the *Sansuishō* are new additions not found in the Sakuteiki. See Osamu Mori, *Sakuteiki no Sekai* (Tokyo: Nihon Hōsō Shuppan Kyōkai, 1986), 192-8.

massed, layered plantings, not unlike an English perennial border, at least in theory. Another popular flower was the chrysanthemum, which was grown in beds, perhaps out of sight in the rear of the property, and then transplanted into the Southern Court when they were ready to bloom. As shown in the thirteenth century painting *Koma Kurabe Gyōkō Emaki*, though, they were planted directly into the ground rather than being set out in pots. Groundcovers included moss, *koke*, and lawn, *shiba*.

Last among the types of plants used in the garden were the water plants. Irises of several types were planted both on the edge of ponds and along streams, as were tall reeds. While irises are still quite popular in larger stroll gardens or in the ponds of some shrines, reeds are essentially unused in gardens today. Lotus were also planted in Heian-period ponds but this may have been specifically associated with gardens that were attempting to evoke a Pure Land theme (see the chapter on Buddhism). Lotus are associated with Buddhism in general and appear in paintings of the Pure Land of Amida Buddha, which show a lotus-filled lake traversed by a curved bridge that connects the world of mortal man with that of Amida's paradise.

The plants that were used in the gardens were perhaps transplanted from garden to garden as they are now, but it is also very likely that they were collected from the wild as well—something that rarely happens these days. *Kanke Bunsō*, a record from the late ninth century, mentions an imperial edict to replace a dead cherry tree by moving a tree from the mountains; and *Midō Kanpakuki*, the diary of Regent Fujiwara Michinaga, has an entry from 1012 that reads: "At times light rain falls. Some people of the house have left for Saga [a few kilometers northwest of the capital] to collect plants."[7] It seems that plant collecting was a pastime of some aris-

7. "Moving plants" is expressed as *yamaki wo utsushite* 山木を移して; "collecting plants" as *senzai wo hori* 前栽を堀り. *Kanke Bunsō* 菅家文草 is a collection of Chinese-style poetry compiled in the year 900 by Sugawara no Michizane; the reference to replacing cherries is in scroll five. *Midō Kanpakuki* 御堂関白記 is the diary of Fujiwara Michinaga, compiled between 995 and 1021; the reference to aristocrats collecting from the wild comes from the sixth day of the ninth month, Chōwa Gannen (1012). As cited in Hida, *Heian jidai no Shokusai* (4), 20.

tocrats, or their servants, but undoubtedly the time and freedom of movement that would allow for this depended on one's rank.

Small meadow plants were not the only transplanted flora, however. A passage in *Bunka Shūreishū*, a compilation of Chinese-style poems made for the Emperor Saga in 818, refers to "old pines" in the imperial garden, Shinsen'en, and yet at that date the garden was only twenty years old.[8] Shinsen'en is thought to have been built on the site of a natural, spring-fed pond, and there may have been old pines existing around it. On the other hand, it is also possible that the pines were transplanted into the garden to create an atmosphere of age and solemnity. Similarly, *Kokon Chomonjū*, a Kamakura-period anthology, records that "Fujiwara no Tadahira was very fond of *natsume*. Finding a splendid specimen in the garden of a high-ranking aristocrat, he had the tree pollarded and, under his personal supervision, replanted it to the western side of the Northern Annex Hall at Kazanin."[9] In order to warrant having all its branches cut back for transplantation, the tree must have been large indeed. In fact, chapter six of the Sakuteiki also has a remark regarding the use of old trees.

> The trees need not be too tall, but they should be old, splendid in form, and laden with deep green needles. (p. 165)

The Heian period lasted for 400 years, and many things about the society changed over that time, not least of which were the gardens. The early Heian period is marked with a conscious mimicking of Chinese culture, a characteristic carried over from the previous Nara period. For instance, Shinsen'en, the imperial garden built at the very beginning of the Heian period, is recorded as having had as its central pavilion a building called Kenrinkaku. *Kaku* is a suffix for Chinese-style buildings which are recorded in the Sakuteiki as

8. *Bunka Shūreishū:* 文華秀麗集.

9. *Kokon Chomonjū* 古今著聞集 is an anthology of popular stories, completed in 1254. Fujiwara no Tadahira 藤原忠平 (880-949), was the Minister of the Left under Emperor Daigo. As cited in Hida, *Heian jidai no Shokusai* (1), 38; (4), 20.

Natsume, is jujube in English. Pollarding is a gardening technique by which all branches are cut back to the trunk; Jp. *oroshi eda.* Kazanin 花山院 was a place on eastern Ichijō Street.

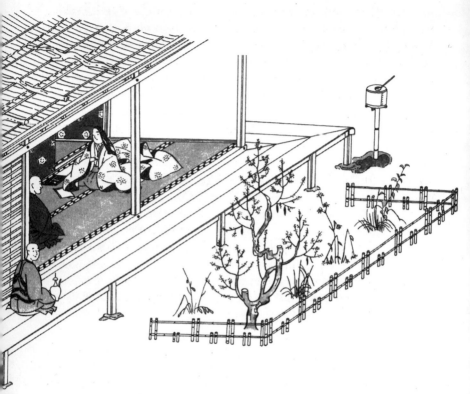

FIGURE 9: *Senzai*

A poetic fascination with the natural world on the part of Heian-period nobles lead them to collect their favorite plants from the wild and place them in the garden. The part of the garden containing the plants, and the plants themselves, were both referred to as *senzai*. *Senzai* literally means "front planting" and also referred to the part of the garden close to the residence, as in this scene. While the plants were usually more integral with the garden, here, at the residence of the priest, Myōe Jōnin 明恵上人, we find a small plot separated from the main garden by a low bamboo fence. The plot is just outside his chambers, created as if to keep a set of favorite plants close at hand. The collection is mostly various autumn grasses, now withered because it is very early spring, revealed by the budding blossoms on the plum tree. Four cocoons *(minomushi)* also hang on the tree. At the corner of the veranda, a water basin and dipper on a pole were used for handwashing, for instance after using the toilet. (Redrawn from *Kasuga Gongen Kenki Emaki* (2) pp. 29-30)

having deep eaves and thus being enjoyed for their cooling effects.[10] This affection for Chinese things would soon be replaced by a more self-conscious attitude, a kind of cultural nationalism that led to the development of many Japanese arts that deviated from their Chinese predecessors. So it was with the garden. This change can also be seen in garden plantings in some ways. Both chrysanthemum and bamboo were used in the early Heian period with the tacit realization that they were Chinese plants; but over the course of time, as the plants became naturalized and the cultural focus shifted, interestingly enough, the same plants became images of Japan.

Also indicative of this shift in attitude is the development of the *senzai*, a new concept in gardening.[11] *Senzai* literally means "foreplantings" and referred to that part of a large garden that was in the foreground, close to the veranda of a residence. In Heian-period texts, *senzai* also has the specific meaning "plantings" as well as the broader meaning of "a garden with many plantings." In terms of the garden, *senzai* referred to a place within a garden where the bounty of the Japanese landscape was evoked through a variety of plantings. A scene in the scroll *Kasuga Gongen Kenki Emaki* shows a small rectangular *senzai*, enclosed by a simple bamboo pole fence, adjacent to a private room (see figure 9, p. 48). The garden contains just five plants—a plum and some herbaceous plants—but just one of each species, as if the garden was meant for viewing a collection of favorite plants. One recurring incorporation of the natural landscape into the garden was the meadow scene, especially the autumn meadow, *akino*. We can easily imagine the grasses of the meadow, tinged bronze and crimson by an early frost, which were the inspiration for that gardening style.

Another hint at naturalism in the use of plants in Heian-period gardens is given by Sei Shōnagon in her *Pillow Book* when she

10. Kenrinkaku 乾臨閣, and other Chinese-style buildings in Shinsen'en, are recorded in the *Shūgaishō* 拾芥抄, a record of customs written in the late Kamakura period. The first mention of Shinsen'en, however, occurs in the *Nihon Kiryaku* 日本紀略 on the nineteenth day of the seventh month, in the year 800, just six years after the founding of the capital itself. Ibid., 37-38.

11. Iwanami *Kogo jiten* states that *senzai* was pronounced *sensai* in the Heian period. Hida, *Heian Jidai no Shokusai* (4), 25.

praises the beauty of wisteria vines blooming in the pine trees of the garden. Whereas in modern Japanese gardens wisteria are grown on trellises or pergolas, and deliberately stripped off trees whenever they try to grow up them, Sei Shōnagon presents an image of the opposite. In the wild, of course, wisteria naturally climbs on trees, and in Sei Shōnagon's garden, pines may have been chosen in particular because their open branching would have allowed the flowers of the vine to be shown to the best advantage.[12] In short, the plantings of Heian-period gardens reflect the general nature of the gardens themselves—naturalistic, somewhat uncontrolled, and abundant.

Examples of Nature in the Sakuteiki

Nature as presented in the Sakuteiki is a combination of images of the partially man-altered environment that surrounded the Heian capital as well as wilder scenes from further afield. The act of examining those natural scenes in order to understand and incorporate them into the garden is referred to in the Sakuteiki as "studying," *manabu* or *manabi*. By the time of the writing of the Sakuteiki, however, many natural scenes had already been developed into stylized forms called *yō* or "styles."[13] References to nature fall into several categories that generally parallel the chapters of the text. The first of these is gardening styles, including the Ocean Style, Broad River Style, Mountain Torrent Style, and Wetland Style, in which we see various natural scenes used as motifs for garden design.[14] In describing each style, the author displays a clear understanding of the workings of the natural world, but perhaps he is most confident with the design of waterways. Take for instance the following passage from the chapter on gardening styles regarding the Broad River Style, which reveals how well the author comprehended how the shape of a river will affect flow speeds and how that in turn will control sedimentation:

12. Ibid., 21.

13. *Manabu* can mean both "study" and "employ," and so we find the word used in reference to "studying a natural scene" as well as "employing a stylized form."

14. The last gardening style mentioned in the Sakuteiki, the Reed Style, is not based on a study of nature but on a form of calligraphy. See figure 7 and text, pp. 29–30.

Water flows more rapidly through narrow channels; where the river broadens it will relent. At this point a sandbar should be created. A Middle Stone should be set at the head of such a sandbar and if such a stone is set, there is all the more reason to create a sandbar downstream from it. (p. 162)

The next set of references to nature appears in the chapter on islands, which include the following styles: Mountain Isle, Meadow Isle, Forest Isle, Rocky Shore Isle, Cloud Type, Mist Type, Cove Beach Type, Slender Stream, Tide Land, Pine Bark. Each style is an attempt to distill some aspect of the way islands appear naturally in order to evoke that image in the garden. The first four styles are relatively literal representations of islands found in nature: the Mountain Isle has a hill, the Meadow Isle has grasses growing on it, and so on. Some of the island styles, however, required a more interpretive approach to their design. Creating a Tide Land Style island, for instance, in a pond that has no actual tidal movement, or creating a Mist Type island when the mist itself cannot be controlled, required the designer to become an artist.

The Tide Land Style should appear like a beach at ebb tide, half exposed above water and half below, so that the beach stones are partly visible above the water. No plants are needed. (p. 166)

The Mist island, when seen from across the pond, should appear as trailing mist in a light green sky, in two and three layers, fine, indefinite, here and there disconnected. Again, no stones, no trees. Only a white sandy beach. (p. 165)

Waterfalls are next among the images taken from nature. The styles proposed in chapter seven are Twin Fall, Off-Sided Fall, Sliding Fall, Leaping Fall, Side-Facing Fall, Cloth Fall, Thread Fall, Stepped Fall, Right and Left Fall, Sideways Fall. All of these types of waterfalls can be found in nature but, of course, rarely in such an idealized form as the author of the Sakuteiki suggests. Nonetheless, the author displays a sensitivity to how water flows over stones to create various effects: slipping smooth and clear over the surface of the stones (Sliding Fall), leaping out away from the surface of the stone and crashing down below (Leaping Fall), or perhaps the most elegant of all, falling in long, thin slivers carved off from the stream as it flows

over the ragged edge of a stone (Thread Fall). In addition, the author eventually goes beyond merely commenting on the design of the waterfall itself and turns his attention to describing how the setting of the waterfall can create a feeling of mystery in the garden:

> . . . waterfalls appear graceful when they flow out unexpectedly from narrow crevices between stones half hidden in shadows. At the source of the waterfall, just above the Waterfall Stone, some well-chosen stones should be placed so that, when seen from afar, the water will appear to be flowing out from the crevices of those boulders, creating a splendid effect, (p. 169)

This is repeated again in chapter eleven:

> It has been said that waterfalls should not be built in the shade of trees in the mountains, but this is not true. A waterfall that is seen splashing out from the darkness of the trees is truly fascinating, as is often seen in old gardens. (p. 189)

The chapter on Garden Streams is another place in the Sakuteiki where nature is revealed as a basis for garden design. The first part of the chapter is devoted to the geomantic implications of water in the garden, and examples of that way of thinking will be given in the following chapter on geomancy. The following passages from the middle of the chapter, however, reveal a careful study on the part of the author of the way in which water flows in natural stream beds. The reader is encouraged not to simply place stones randomly in a stream but rather to consider how stones affect the flow of water with their own form, and in turn, how water so affected will act when it strikes another stone further downstream:[15]

> The first place to set a stone in the Garden Stream is where the flow bends sharply. In nature, water bends because there is a stone in the way that the stream cannot destroy. Where the water flows out of a bend, it flows with great force. As it runs diagonally, consider where the water would strike an obstacle most powerfully and at that point set a Turning Stone. (p. 176)

15. In *The Tale of Genji*, (" Otome," " The Maiden") we find a passage that mentions that stones were placed in the *yarimizu* of a garden specifically to enhance the sound of the running water: *yarimizu no oto masarubeki iwao tatekuwae* 遣水の音まさるべき巌たて加え Abe et al, *Nihon Koten Bungaku Zenshū* (14), 72.

And again at the end of the chapter:

> In the areas where the Garden Stream runs shallow, if a stone with a sharply toothed surface and wide bottom is placed crosswise in the flow, and another stone set facing this is placed just downstream, then water that flows over the top of the second stone should turn white with foam. (p. 180)

Much of what is written in the Sakuteiki regarding the use of stones in the garden is related to geomantic, Buddhist, or technical issues. The following passages, however, show us that the placement of stones in the garden was also based on observance of nature. It would appear from the way the author writes that he actually went out into nature and based his writing on his observations there. The text implies that the author had taken excursions in the mountains and meadows as well as to the seashore:

> The stones of steep mountain cliffs rise in the angular manner of folding screens, open shutters, or staircases. (p. 182)

> The stones at the base of a mountain or those of a rolling meadow, are like a pack of dogs at rest, wild pigs running chaotically, or calves frolicking with their mothers. (p. 182)

> Rocky shores are interesting to look at, but, since they eventually fall into desolation, they should not be used as models for gardening.
> XI. Miscellany (p. 189)

Nature is also presented by the author as a healing or ameliorating force. In the following passage, for instance, we are reminded that stones are supposed to be used in the same position in which they were created. It says that taking a stone that was upright in the mountains and using it upside-down in the garden was taboo, but, if the stone had tumbled off the mountain of its own accord, due to the effects of erosion or perhaps an earthquake, and most importantly, if some time had passed during which the stone weathered and settled into its new environment, then the new position of the stone would not be taboo.

> According to a man of the Sung Dynasty, stones taken from mountains or riverbanks have in fact tumbled down to the base of a mountain or valley floor from above, and in doing so the head and base of

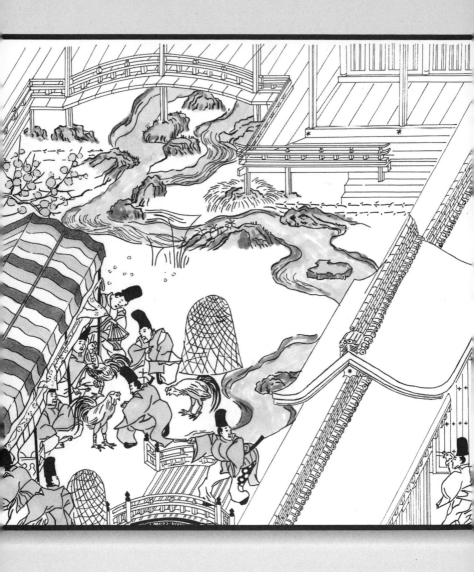

FIGURE 10:
Garden Stream and Middle Gate

The corridor *(chūmonrō)* with the Middle Gate *(chūmom)* in the foreground runs from the Eastern Annex Hall, partially visible above, to a pavilion in the garden off the bottom of the page. This corridor could be closed with shutters, while those at other residences had open sides. To the left of the gate is the Southern Court *(nantei)* which is being used for a display of fighting cocks. Adjacent to the gate is a bridge across the Garden Stream *(yarimizu)* that flows out from under the Breezeway *(suiwatadono)* at top (north). Just where the stream bends, a Turning Stone *(meguri ishi)* has been placed to make the stream flow in an interesting manner, exactly as prescribed in the Sakuteiki. So too are the angular stones used as pedestal stones for the posts of the verandas. (Redrawn from *Nenjū Gyōji,* Chūōkōronsha, p. 17)

the stone have become reversed. Some are upright while others lie flat. Still, over time they will change color and become overgrown with moss. This weathering is not the work of man. Because the stones have weathered naturally, they can be set or laid in the garden as they are found in nature without impediment.

XI. Miscellany (p. 189)

We can see that Heian-period gardens were naturalistic in their overall design, and that to some degree direct observations of nature were made by garden designers on trips through the countryside. Undoubtedly some nature imagery was also drawn from the large body of existing nature poetry, rather than from direct observation, although the Sakuteiki makes no direct reference to this process of understanding. No matter the source, it can be said that the palette used for garden design comprised elements of the natural world: mountains and hill forms, rivers, ponds, islands, and meadow scenes. On one level this can be seen as an aesthetic, a particular taste of the Heian-period aristocrats, but there is a hint in the last passage quoted above that implies that the use of nature as a motif for garden design (and perhaps a reason why nature imagery was such a fundamental theme of the Heian period in general as well) was based on the widespread belief that there was something inherent about the natural world that was wholesome and correct. Things as they appear in the natural world were believed to express an innate balance, a propriety, a kind of healthfulness. It followed that to use those elements in the garden in the same way they were found in nature was a means to bring nature's innate balance into one's household; conversely, to use elements of nature in a way that was contradictory to the way they were found naturally, for instance to use stones upside down or run water in the wrong direction, was tantamount to disrupting the balance of nature. Observing nature as a basis for garden design, therefore, was not just a point of aesthetics, it was an attempt to harmonize one's household with the life forces of the surrounding environment through the design of the garden.

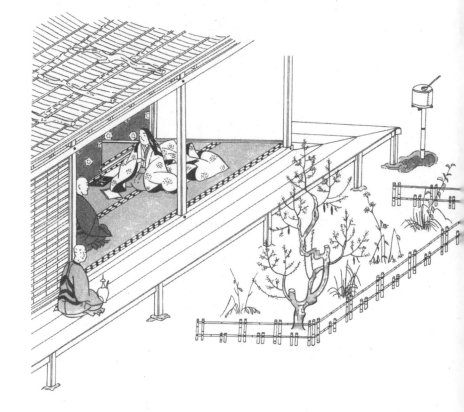

四神相應

Shijin sōō

The Four Guardian Gods in Balance

GEOMANCY

When one is trying to select a site with correct geomantic conditions, remember that the place on the left side where water runs from is called the Land of the Blue Dragon.
VIII. Garden Streams (p. 173)

Throughout the Sakuteiki the author makes references to the Blue Dragon in the east and the White Tiger in the west, usually in connection with the proper direction for water flow within the garden. There are other references as well to the use of specific species of trees in particular magnetic directions and to placing stones of a particular color in the east or the west. The meaning of these statements may appear somewhat cryptic at first, but in all cases the author has based his instructions on the principles of geomancy. Geomancy, recently popularized as *feng shui (fūsui* in Japanese), is a catchall expression for a complex group of interrelated concepts that originated in ancient China and were used to explain the existence and inner workings of all manner of phenomena. These explanations include how the natural world works as well as divinations to guide man's machinations within that world. Examples of the former are explanations for the cycles of the seasons, periodic changes in climate, and such fundamental aspects of mortal life as birth, growth, and death. Examples of the latter were primarily commentaries made in regard to the acts and policies of the leaders of nations, in particular, emperors and their courts. In short it was believed that all actions were interrelated and that the actions of powerful people, such as the emperor, could affect the natural environment. Conversely, it was believed that disruptions in the natural world could be interpreted as reactions on the part of nature against inappropriate political policies, and consequently divinations took on the color of national policy making. Divinations were used to

guide an extremely wide variety of activities including how to build (anything from a house to a city), when and where to move, when to marry or give birth, even how to rule a nation. In fact, much of the development of geomantic thought in China's classical period is related to social power and took the form of political critique of otherwise unassailable emperors.

As mentioned, geomancy is an amalgamation of many different schools of thought, a concept that is certainly as true today as it was at the time of the writing of the Sakuteiki. In fact, by the time geomantic thought was first imported to Japan from China, many hundreds of years before the Sakuteiki was written, it was already an admixture of several different theories. Of these there are three that are pertinent to an understanding of gardens as described in the Sakuteiki: *Yin Yang* (Theory of Mutual Opposites), *Yi* (Theory of Changes), and *Wuxing* (Theory of Five Phases).[1] For the purposes of this book, we have chosen to use the Chinese terms *Yin Yang* and *Yi,* and the English term "Five Phases."

The Sakuteiki shows that these theories were applied to garden design at least with regard to the movement of water through the gardens and to the placement of stones and plants within them. At times geomancy is specifically mentioned by the author of the Sakuteiki as a guide for garden design, and in other cases we can perceive geomantic concepts only by inference after coming to an understanding of the basic mechanisms of the various theories.

Historical Development of Geomancy
The Early Years—*Yin Yang* and *Yi*

Although the early historic development of geomancy is the stuff of legend, we can reason that at a time before the evolution of cities, towns, or villages, before the knowledge of agriculture compelled ancient peoples to settle down in one place at all, those peoples lived as an integral part of the landscape; not observing it objec-

1. Ch. *yin yang,* Jp. *in yō* (ancient *on yō* or *on myō)* 陰陽; Ch. *yi,* Jp. *eki,* 易; Ch. *wuxing,* Jp. *gogyō,* 五行.

tively, they were simply a part of it. They knew how to read the land, how to scent it out for its secrets, where to find water and food, shelter from wind and rain. Beyond these basic necessities, the Chinese people of antiquity also sensed in the landscape something more ephemeral: a vaporous element that seemed to flow throughout and connect all matter. They called this *qi* (pronounced "chee"), or life energy. In Japan this force is referred to as *ki*.

Traditional lore attributes the origins of geomantic theory to Fu Xi, one of China's legendary cultural heroes, who some five thousand years ago perceived in mystic visions the basic icons that would develop into advanced geomantic theories.[2] *Ki* energy was the basis for what Fu Xi discovered in his visions, and eventually these concepts, which were originally developed intuitively, were organized intellectually into manageable systems. The most basic of these is the *Yin Yang* system, which describes the genesis of *ki* and its most elementary derivative forms. *Yin Yang* theory provides the foundation for *Yi* theory, which evolves from basic *Yin Yang* tenets to provide more complete explanations for the complexity of the natural world as well as the operation of human society. The Five Phase theory is based in the basic substances of the natural world rather than its energies, and although it began as a separate theory, it was integrated with *Yin Yang* and *Yi* at a later stage.

According to legend, what Fu Xi is said to have discovered in his vision is a set of icons inscribed on the back of a dragon-horse rising from the Yellow River. Known as the River Diagram, *He Tu*, the icons depict basic geomantic principles in a series of dots and lines. In fact, the earliest depictions of the River Diagram date from later eras, and what the original form was is not clear. The concepts that Fu Xi promulgated were later recorded in a treatise known as *Yijing*, the Book of Changes. The Chinese word *Yi* can be loosely interpreted to mean "divination," thus a literal translation of *Yijing* would be the "Classic Text of Divination"; but the standard English title emphasizes change, or mutation, which is the conceptual

2. Information on the history of geomancy is drawn, in part, from Richard Wilhelm, *I Ching*, trans. Cary Baynes (Princeton: Princeton University Press, 1950).

core of the *Yijing*. The basic elements described in the text, which were proposed as being the building blocks of all phenomena, were postulated as being in a state of constant flux, perpetually mutating into one another. In the *Yijing*, these basic elements are represented by two icons, a solid line (—) and a dashed line (– –), which are in turn built up into stacks of three lines (solid, dashed, or a combination of both) that form eight new icons called trigrams (Ch. *gua*, Jp. *ke)*. See figure 11, page 68.

Yi theory is noted in historical texts as having existed as early as the Xia and Shang dynasties, together stretching from approximately 2000 to 1000 BC, at which stage the theory was most likely based on only the eight original trigrams. Over the centuries, *Yi* theory was modified by many people, of whom four are of note: Wenwang, first emperor of the Zhou dynasty (1100-256 BC), whose addition was to increase of the number of icons from eight trigrams to sixty-four hexagrams; Zhougong, Wenwang's son, who added interpretive text related to each line of the hexagrams; Kongzi (Confucius), who wrote, or inspired his disciples to write, detailed commentaries that appear at the end of the text; and Zou Yan, who introduced the principles of *Yin Yang*.[3] Perhaps the best way to consider this long, half-legendary, historical development is to understand that Fu Xi represents an immediate, mystical perception of the natural world; Wenwang and Zhougong symbolize an intellectualization of that understanding; and Kongzi personifies the application of that understanding to social organization. The version of the Yijing that was imported to Japan and became the basis for the knowledge of geomancy is the result of the accumulative changes made by all of the above people.

The Early Years—Five Phases and the Five Phase Encyclopedia

The Five Phase theory developed separately from the *Yin Yang* theory and was integrated at a later date. The Five Phases are Wood,[4]

3. The main text of the *Yijing*, and the older commentaries, do not use the words *Yin* or *Yang*. Ibid., lvi.

Fire, Earth, Metal, and Water but were not always in that order; we will discuss that development below. The Five Phases are also sometimes referred to as Five Elements, but we prefer the translation "Phases," partly because it is closer to the original word, meaning "movement," but also because it better represents the process-oriented nature of the system. The Five Phases, like the basic elements of *Yi* theory, are not perceived as fixed elements but rather as having the ability to ameliorate and create each other. Rather than being envisioned as fixed substances, they should be understood as points, or events, along a cyclic flow.

The earliest mention of the Five Phases is believed to be in the *Book of History [Shujing],* an ancient Chinese collection of historic writings purportedly complied by Confucius, although the information contained within is reputedly much older.[5] One of the many scrolls that make up the *Book of History* is a volume called the "Hong Fan," in which we find the following passage regarding the Five Phases:[6]

> The Five Phases are one. The first is water, the second is fire, the third is wood, the fourth is metal, and the fifth is earth. It is said that water flows down, fire destroys with its blaze, wood can be straight or curved, metal is malleable, and earth nurtures seed to harvest.[7] Five tastes: water causes a salty taste, fire makes things bitter, wood makes for an acid taste, metal yields a spiciness, and earth is sweet.

4. The character for this Phase can be understood to mean either "wood" (as in the building material) or "plants" (as in a living tree). The usual translation, which we will use here is "wood," and the Phase itself has properties related to both dead and living wood.

5. *Shujing* is the oldest of the Chinese classics. Modern scholarship has placed most of the records contained in the *Shujing* near the first millennium BC, though formerly a much greater age was ascribed to the earliest of them. How old is not clear, but Wilhelm notes 1000 BC or older. Wilhelm, *I Ching,* xlviii.

6. The "Hong Fan" (Jp. *Kōhan* 洪範) is part of the *Book of History* (Ch. *Shujing,* Jp. *Shokyō* 書経; alternatively Ch. *Shangshu,* Jp. *Shōsho* 尚書).

7. In this passage the five phases are referred to in the following manner: Water as "wet down" 潤下 Ch. *run xia, Jp. junka;* Fire as "blaze up" 炎上 Ch. *yan shang,* Jp. *enjō;* Wood as "bent straight" 曲直 Ch. *qu zhi,* Jp. *kyoku choku;* Metal as "obey leather" 従革 Ch. *cong ji,* Jp. *jūkaku;* Earth as "earn millet" 稼穡 *Ch. jia ji,* Jp. *kashoku.*

Water, fire, wood, metal, and earth were presented as the Five Phases, but various tastes were also associated with them because of their particular attributes, and even as there were associative tastes, so there were other elements that were similarly related to the Phases. One of these associations, also recorded in the "Hong Fan," relates to the nature of emperors. It states that rulers of nations can be divined as possessing one of five qualities, or virtues, as they are called. It was proposed that if a ruler behaved in a manner suiting his virtue, all other matters would also correctly transpire. The positive and negative aspects of the administration of a ruler were believed to have an immediate influence on natural phenomena. In addition, it was believed that rulers must conduct a benevolent method of administration, adapted not only to their aforementioned virtue, but also in accordance with the season. This does not refer to actual annual seasons but rather reveals an attentiveness to the cyclical nature of sociopolitical developments. As in Ecclesiastes, "For everything its season and for every activity under heaven, its time."[8]

As with the successive additions to *Yi* theory, there were also many alterations made to the theory of Five Phases. The resulting divergent geomantic theories were unified into the single theory by Zou Yan in the third century BC. Zou Yan proposed that the nature of earth was the most important and placed it as the top of the hierarchy of the Five Phases. He thus reversed the order found in the *Book of History*—namely, Water, Fire, Wood, Metal, Earth—and further switched Metal and Wood so that Zou Yan's newly organized Five Phases read Earth, Wood, Metal, Fire, and Water. Zou Yan also directly linked magnetic directions and seasons with the Five Phases, coupling wood with east and spring; metal with west and autumn; fire with south and summer; water with north and winter. The most important element, earth, was related to the "center" and to a subseason called *doyō* in Japanese.[9]

8. *The New English Bible* (Oxford: Oxford Press, 1970).

9. *Doyō* 土用 is a four-part sub-season that divides the other four seasons. Each *doyō* period lasts eighteen days and is named after the season it follows, so that, for instance, autumn *doyō* refers to the eighteen days between autumn and winter.

The next important figure in the history of the Five Phases is Xiao Ji, who was born during the Liang dynasty. Xiao Ji compiled the Five Phase theory into the form that was introduced to Japan, a text known as *Wuxing dayi*, the *Five Phase Encyclopedia*.[10] *The Five Phase Encyclopedia* was brought to Japan soon after it was completed and as such, it must have been viewed as a document of cutting-edge technology. The use of the Five Phases in ancient Japan, including of course its application to gardening, was based on the *Five Phase Encyclopedia*.

Knowledge of geomancy seems to have arrived in Japan rather early on. *The Chronicles of Ancient Japan [Nihon Shoki]*, a record of Japan's prehistoric legends and early imperial history compiled in AD 720, mentions a priest named Kanroku as the initial bearer of geomancy to Japan.[11]

A priest from Paekche named Kanroku arrived and presented, by way of tribute, books of Calendar-making, Astronomy, and Geomancy, and also books on the art of invisibility and magic. [12]
Tenth Year of the Empress Suiko (AD 602), Winter, 10th Month

Paekche was one of three kingdoms on the Korean peninsula and the source of much of the Chinese culture that flowed into Japan at that time. The *Ancient Chronicles* do not specifically mention the *Five Phase Encyclopedia*, but they do state that in the following year the system of ranks in the imperial court was formalized. There are twelve steps in that ranking system, the names of which seem to be drawn from the *Five Phase Encyclopedia*.[13]

10. *Wuxing dayi* 五行大義, the *Five Phase Encyclopedia*, is known as *Gogyō Taigi* in Japan.

11. *Kanroku* is the Japanese pronunciation of the Korean *Gwanreug* 觀勒 (Aston gives *Kwal-leuk).*

12. Paraphrased from W. G. Aston, *Nihongi, Chronicles of Japan from the Earliest Times to A.D. 697*, vol. 2 (Tokyo: Charles E. Tuttle Company, 1972), 126. In the text the term *geography*, encompassing the meaning "geomancy," was used.

13. The twelve ranks are *dade* (Jp. *daitoku* 大德), *shaode* (Jp. *shōtoku* 少德), *daren* (Jp. *daijin* 大仁), *shaoren* (Jp. *shōjin* 少仁), *dali* (Jp. dairei 大礼) *shaoli* (Jp. *shōrei* 少礼), *daxin* (Jp. *daishin* 大信), *shaoxin* (Jp. *shōshin* 少信), *dayi* (Jp. *daigi* 大義), *shaoyi* (Jp. *shōgi* 少義), *dazhi* (Jp. *daichi* 大智), and *shaozhi* (Jp. *shōchi* 少智), in which *da* means "greater" and *shao* means "lesser." In fact, the *Wuxing dayi* (Jp. *Gogyō Taigi)* states that

The *Nihonkoku Kenzaisho Mokuroku,* a national record of written works from the Heian period compiled about 891, lists the *Five Phase Encyclopedia* among a total of 919 works related to Five Phase theory, which means that they were part of the collection of the imperial court at that time. In addition, we find references to the *Five Phase Encyclopedia* in several other Heian-period texts: *Guketsu Getenshō,* compiled in 991 by Prince Tomohira (967-1009); Seiji Yōryaku, compiled in about 1002 by Koremune Kotosuke; and *Hokuzanshō,* compiled by Fujiwara no Kintō (966-1041).[14]

As mentioned above, the importance of geomancy during the Heian period is revealed in the existence of a governmental department called the Bureau of Geomancy, *onyō ryō,* which was part of the Interior Ministry, itself governed by the Controller of the Left. The *onyō ryō* was responsible for astronomy, meteorology, calendars, time keeping, and divination of future events. This bureau was introduced as part of the *ritsuryō* system in pre-Heian times and was an import from Tang-dynasty China. The men who worked in the Bureau were known as *onyō ji,* and Sei Shōnagon also mentions apprentices ("enviably bright young lads") who helped the *onyō ji* with their work. There were resident professors, *onyō hakase,* as well, whose job it was to educate regarding geomancy.[15] The political system before the introduction of the *ritsuryō* system was based on an ancient system of clans, *uji,* and families that supplied services, *be,* to the ruling

there are "Five ways of heaven, five hills on earth, five sounds in music, five tastes, five colors, and five ranks among men. Therefore, there are twenty-five levels of men between heaven and earth." Those twenty-five are broken into five categories of five types each. The ranks *dade* and *shaode* are found in the second highest category while the other ten ranks (greater and lesser *ren, li, xin, yi, zhi*) compose the middle grade. Shohachi Nakamura, *Gogyō Taigi,* vol. 2 (Tōkyō: Meiji Shoin, 1998), 202.

14. *Guketsu Getenshō* 弘決外典妙 is a Japanese collection of nonreligious writings quoted by the Tang priest Zhanran 湛然 (711-782), known as Tannen in Japan. *Seiji Yōryaku* 政治要約 is a record of legislation from the middle of the Heian period, including court rituals, regulations, and bureaucratic duties. *Hokuzanshō* 北山抄 is a record of court rituals and government proceedings that is one of the primary sources for understanding mid-Heian-period court life. Hokuzan (also pronounced Kitayama) is where the compiler, Fujiwara no Kintō, lived in retirement in his later years.

15. *Onyō ji* were so well known they became part of common language, as in the expression *onyōji minoue shirazu*—"the Master of Divination knows not his own future"—meaning we see easily in others what we cannot fathom in ourselves.

class. Because of this foundation, the government departments, even under the *ritsuryō* system, tended to gravitate toward family-run bureaus. In the case of the Bureau of Geomancy, it was the Abe and Kamo families that became most clearly associated with the service, and they are thus known as *onyō ke*, literally *Yin Yang* Families. The original purpose of having the Bureau of Geomancy as part of the *ritsuryō* system was to provide advice to the government on matters of geomancy pertaining to the well-being of the state. By the time of the writing of the Sakuteiki, however, it appears that the *onyō ji* were just as likely to be performing divinations of a private nature for the aristocratic class as they were for the state.

The Theories: Yin Yang, Yi, and Five Phases
1. *Yin Yang*—Theory of Mutual Opposites

Yin and *Yang* are the binary elements of *ki* (life energy), but the *Yin Yang* theory begins by proposing a primordial time before the development of *ki*, a state called *wu ji* (Jp. *mu kyoku*), literally "nonpolarity," in other words a time of no separation between things; all is one, one is all (see figure 11, page 68). At some point in the deep past, the primordial unified state of *wu ji* divided in an instantaneous flash as profound as, and in many ways strikingly similar to, the Big Bang proposed by Western cosmological theorists. Created from that division was a binary condition known as *tai ji* (Jp. *tai kyoku*) or "extreme polarity." In *tai ji*, all manner of things were believed to be composed of two mutually opposed yet interdependent elements, collectively known as *liangyi* (Jp. *ryōgi*), which could be loosely translated as "the Dual Matters." Separately, the two elements are known as *Yin* and *Yang*. In Japanese, *Yin* and *Yang* are now pronounced *in* and *yō* respectively, but at the time of the Sakuteiki were pronounced *on* and *yō* (or *on* and *myō*). *Yin* traditionally represents negative energy while *Yang* represents positive energy, but in fact almost all manner of things were perceived as being a result of the interrelated effects of the two energy fields while very little was believed to be composed of purely one or the other. For instance, *Yin* and *Yang* are never seen to represent Man and Woman but rather what were perceived as masculine or feminine aspects of

FIGURE 11: Development of *Yin Yang* Theory and *Yi* Theory

The chart flows from bottom up, the way steam rises from the earth. It begins with a state of Nonpolarity (Jp. *mukyoku)* and develops into Extreme Polarity (Jp. *taikyoku),* from which appear *Yin* and *Yang. Yin* and *Yang* each have an ascending (moving) and diminishing (still) aspect, which give rise to the Four Forms *(shishō).* The Four Forms in turn also have dual aspects, which yield the Eight Trigrams, which in turn have Eight Forms associated with them, as well as directions according to the Earlier and Later Heaven Circles.

The names of the icons are as follows: Single line (—) *Ch. yao* Jp. *kō* Trigrams (such as ☰) Ch *gua;* Jp. *ke* 卦 or *shōseike,* 小成卦; Hexagrams (such as ䷀) Jp. *taiseike* 大成卦.

phenomena (both of which could be contained in men or women). As shown in the diagram, *Yang* was represented by a solid line (—) and *Yin* by a broken line (– –), perhaps the world's first binary digital system. In Japanese these basic binary icons are called *kō*.

Yin and Yang are each seen as further dividing into two subforms resulting in four forms of energy. *Yin* subdivides into *Old Yin* and *Young Yang*, while *Yang* subdivides into *Old Yang* and *Young Yin*.[16] "Old" refers to a climaxing state and "Young" to an incipient state, revealing that the energy states are not perceived as static but rather are always in the process of creation or dissolution. Interestingly, the basic elements do not separate exclusively into variants of themselves—*Yin* does not separate into Old and Young *Yin* but rather Old (climaxing) *Yin* and Young (incipient) *Yang*, the same is true in reverse with *Yang* energy. In other words, each element is perceived as having an aspect of its own nature climaxing (the Old) as well as an aspect about to evolve into the nature of its complementary element (the Young).

It was at this stage that a separate geomantic theory, that of the Five Phases, was integrated in an attempt to unify the two, much as present-day proponents of the unified field theory attempt to bridge the gap between quantum mechanics and general relativity. We will examine the Five Phase theory in some detail below, but first, to continue with the *Yin Yang* theory, the Old and Young energies are now represented by sets of icons that have two bars each. Since the icons are seen as representative of energy, and, since energetic things rise (as in the example of steam), the sets of bars are read from the bottom up. For instance with the icon for Young *Yang*, we see a *Yin* dashed-bar with a *Yang* solid-bar on top. Read from bottom up we see *Yin* turning into *Yang*.

The four energies each divide again, ending up with a set of eight energies. In order to represent these eight new energy forms, the bars were built up into sets of three to make trigrams, *gua* (Jp. *ke* or *shōseike)*, with each one representing a different specific quality. A full set of eight *gua* is referred to as *bagua* (Jp. *hakke)*, and it forms

16. *Old Yin, laoyin* (Jp. *rōin,* 老陰); *Young Yang, shaoyang* (Jp. *shōyō,* 少陽); *Old Yang, laoyang* (Jp. *rōyō,* 老陽); and *Young Yin, shaoyin* (Jp. *shōin,* 少陰).

the basis of a type of geomantic divination called *Yi* (Jp. *eki)*, which we will discuss further on.

Example of *Yin Yang* in the Sakuteiki

Sending Water to Fire
There is also a theory of sending water from north to south because north is the Water direction while south is that of Fire. In other words one should send *Yin* in the direction of *Yang,* and thus by facing the two forces against each other, create a state of harmony. Considered in this way, the notion of sending water directly from north to south is not without merit indeed.

VIII. Garden Streams (p. 174)

In this case, the terms *Yin* and *Yang* are clearly stated and the theory is easily understood; water and fire are commonly understood to be representative of *Yin* and *Yang.* What is interesting, however, is that whereas fire and water would normally be perceived as opposites (and "sending water to fire" would seem the source of an imbalance) the Sakuteiki proposes this as a means to achieve harmony in the garden. This is understood from the *Yijing* in the line "rain brings moisture, the sun brings warmth," both of which are required for seeds to germinate and grow, showing that "Water and Fire do not combat each other."[17]

2. *Yi*—Theory of Changes

Yi is a continuation or extrapolation of *Yin Yang* theory. *Yi* is usually translated as "divination" but since divination is possible with the Five Phases and *Yin Yang* as well, that translation becomes confusing and hereafter we will simply use the term *Yi*. Various forms of *Yi,* known collectively by their Japanese name, *Eki,*[18] are practiced in Japan even to this day to situate residences or plan personal and business schedules.

17. Wilhelm, *I Ching,* 265, 267.
18. The Chinese word *Yi,* of *Yi* theory and *Yijing,* is one and the same as the Japanese word *Eki:* 易.

Yi theory begins with the eight trigrams which are named after natural phenomena, namely: Earth, Mountain, Water, Wind, Thunder, Fire, Lake, and Heaven. The original arrangement of the trigrams, considered to be very ancient, is called the Earlier Heaven Circle. The eight trigrams are arranged in a circle but are perceived as pairs of complementary opposites: Heaven and Earth, Mountain and Lake, Thunder and Wind, Water and Fire. Another arrangement of the trigrams, ascribed to Wenwang, is known as the Later Heaven Circle. This arrangement stresses the cyclical flow of energy through the circle. It is likened to an annual cycle in nature, commencing in the east at Thunder (Arousing; spring), moving south to Fire (Clinging, meaning "bright light"; summer), west to Lake (Joyous, as in "joyful harvest"; autumn), and north to Water (Abyss, or death; winter). The cycle completes at Mountain where Stillness implies resurrection and the recommencement of the cycle.

The eight trigrams were considered insufficient for emulating all the vagaries of the natural and social worlds, so they were multiplied by combining two trigrams into double sets called hexagrams, or *taiseike* in Japanese. An explanation for the choice of six lines as the preeminent form is given in the Commentaries of the *Yijing:*

> (The ancients) determined the Tao of Heaven and called it the Dark and the Light. They determined the Tao of Earth and called it the Yielding and the Firm. They determined the Tao of Man and called it Love and Rectitude. They combined these three fundamental powers and doubled them; therefore in the *Book of Changes* a sign is always formed by six lines.[19]

Hexagrams can be used to make sets of ten (Jp. *jikkan),* twelve (Jp. *jūnishi)* or sixty-four (Jp. *rokujūyonshi)* icons, and each of those sets is applicable to a different kind of divination.

There are nearly eighty places thoughout the Sakuteiki in which we find references to directions. Most references concern the direction of the flow of water. At times, however, the directions are referred to in the text by their usual names—southwest, northeast,

19. Wilhelm, *I Ching,* 264. Capitalization added for emphasis. Notice that the expressions *Yin* and *Yang* are not used yet.

and so on. There are also times when expressions such as Sheep Monkey (southwest), Dog Boar (northwest), Cow Tiger (northeast), and Tiger (west) are used. The use of animal names to refer to directions derives from the divination system called the Twelve Branches, *jūnishi*. The names are Mouse, Cow, Tiger, Rabbit, Dragon, Snake, Horse, Sheep, Monkey, Rooster, Dog, and Boar.[20] There are numerous explanations for the choice of the number twelve, including a link with Jupiter, which revolves around the sun every twelve years, as well as the fact that twelve stages would fit well with both annual agricultural cycles and with directional divisions.[21] The *kanji* applied to the *jūnishi* are not the same ones normally used for the twelve animals' names nor are they original. The original characters were rudimentary glyphs that described twelve stages in the growth of plants—information that would be considered basic knowledge for survival in an agricultural society.

There is another system of divination based on ten divisions and called the Ten Stems, *jikkan*.[22] These ten elements were extrapolated by taking the Five Phases—Wood, Fire, Earth, Metal, and Water—and assigning each one both a *Yin* and a *Yang* nature. In this case, *Yang* is represented by the character for *older brother* and named *"e"* and *Yin* is represented by the character for *younger brother* and named *"to."* The resulting *Yin* Wood, *Yang* Wood, *Yin* Fire, *Yang* Fire, and so on, become the Ten Stems.[23] Furthermore, the Ten Stems and the Twelve Branches were combined to create sixty new icons that were then used to record historical changes

20. The Twelve Branches are assigned the following names: Mouse *(ne 子)*, Cow (*ushi* 丑), Tiger (*tora* 寅), Rabbit (a 卯), Dragon (*tatsu* 辰), Snake (*mi* 巳), Horse (*uma* 午), Sheep (*hitsuji* 未), Monkey (*saru* 申), Rooster (*tori* 酉), Dog (*inu* 戌), Boar (*i* 亥). See figure 12, p. 73.

21. Jupiter's circumnavigation of the sun takes 11.86 years.

22. The systems of ten and twelve together are referred to as the Ten Stems Twelve Branches, *jikkan jūnishi* or *eto*. The initial use in China of the Ten Stems may have been to count the days in one month (three weeks of ten days each) while the Twelve Branches were used to name the months themselves.

23. The Ten Stems are *Yang* Wood (*kinoe* 木の兄, 甲), *Yin* Wood (*kinoto* 木の弟, 乙), *Yang* Fire (*hinoe* 火の兄, 丙), *Yin* Fire (*hinto* 火の弟, 丁), *Yang* Earth (*tsuchinoe* 土の兄, 戊), *Yin* Earth (*puchinoto* 土の弟, 巳), *Yang* Metal *(kanoe* 金の兄, 庚), *Yin* Metal (*kanoto* 金の弟, 辛), *Yang* Water *(mizunoe* 水の兄, 壬), *Yin* Water (*mizunoto* 水の弟, 癸).

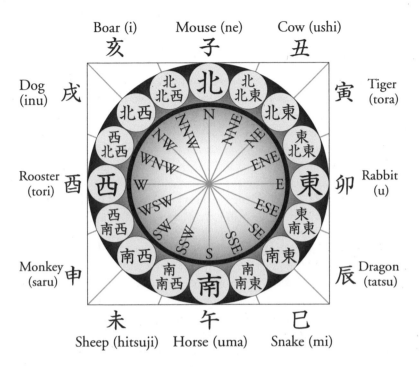

FIGURE 12: The Twelve Branches

In the Sakuteiki, directions are sometimes referred to by cardinal names such as northeast and southwest and sometimes by their associated animal—Cow Tiger *(ushi-tora,* NE), Sheep Monkey *(hitsuji-saru,* SW), and so on—a system called the Twelve *Branches, jūnishi.* These were used in combination with *Yin Yang* and the Five Phases to divine auspicious and inauspicious days and directions, a system that was introduced to Japan in the early seventh century.

over a long period of time, for instance cycles of agriculture, as well as to attempt to divine far into the future.[24]

Examples of *Yi* in the Sakuteiki

There are many theories that attempt to explain the flow of water in Heian gardens, which generally begins in the north, flows clockwise through the garden, and exits in the southwest. These theories include the rotation of the earth (the sun appears to move to the west) and the general landscape formation of Kyōto, which falls off to the south and west causing water to flow naturally in that general direction. The Sakuteiki, however, provides another explanation for this phenomenon that is based on *Yi* theory, and we will examine how it addresses three aspects of water flow: the positioning of the water source, a general westward flow of water in the garden, and water leaving the garden from the southwest quadrant. It must be remembered that, at a most fundamental level, land is perceived to be infused by energy, *ki*. Mountain forms (which in the garden could be boulders, artificial hills, or even pavilions) possess a different energy than flat areas, and the placement of mountain forms was believed to affect the balance of energy in the garden. Water was also believed to contain energy, and the energy of quickly flowing water, such as streams or waterfalls, was seen as different in quality than that of still, pooling water. Flowing water was perceived to modulate, gather, and disperse energy, thus the much-repeated line in the Sakuteiki: "The waters from the Blue Dragon will wash all manner of evil off to the Great Path of the White Tiger."

The Position of the Water Source

When one is trying to select a site with correct geomantic conditions, remember that the place on the left side where water runs from is called the Land of the Blue Dragon. Similarly, water should run from the east of the Main Hall or outer buildings, then turn

24. A full calculation of the set of Ten and Twelve Branches would yield 120 combinations, but if the duplicates are removed the result is 60 (i.e., using only A-B instead of A-B and B-A).

south and finally flow out to the west. In the case of water that flows from the north, the stream should first be brought around to the east and then caused to flow to the southwest.

VIII. Garden Streams (p. 173)

The movement of change in *Yi* is usually perceived in a clockwise direction.[25] When we look at all sixty-four hexagrams together, we see that *Yang* originates in the north (actually just west of true north), and as we move around the compass, through the east to the south, we find that *Yang* gradually gives way to *Yin*, which becomes dominant just east of true south. The flow continues around west and then back to north, where it starts all over again. The inception point is clearly near true north and follows through in a clockwise manner, explaining the last line in the previous passage: "In the case of water that flows out from the north, the stream should first be brought around to the east."

There is also material in the *Yijing* that suggests that the source of water should be in the east rather than the north, which also fits geomantic theories. First of all, according to the cyclic flow of the Later Heaven Circle, the east is the source point. Also, in the arrangement of the Twelve Branches as well as the Four Guardian Gods, the east is represented by the Dragon. Dragons are considered to be related to "sources," which is revealed in the hexagram for Dragon,(☰), which begins with all *Yang*, a sign of Spring, the source of new things.

Westward Flow of Water in the Garden

According to the scriptures the proper route for water to flow is from east to south and then toward the west. Flowing from west to east is considered a reverse flow, thus a flow from east to west is standard practice.

VII. Garden Streams (p. 173)

In the Earlier Heaven Circle, west is associated with the trigram Water (☵) while in the later Heaven Circle the trigram for west

25. The flow of the Circles can be read counterclockwise as well as in linked pairs. For instance, in the Earlier Heaven Circle, Mountain and Lake are positioned opposite each other but in nature are related in that "wind blows from mountain to lake, and clouds and mist rise from lake to the mountain." Wilhelm, *I Ching*, 266.

is Lake (☱). The hexagram that represents west shows Water over Water (☵). In all we see that the west is a place of waters and a general movement from the east, which is a place of "sources," to the west, the realm of Water, fits the nature of the theory.

Water Flowing to the Southwest

The waters of the pond and Garden Streams should flow out of the garden to the southwest...

III. Ponds and Islands (p. 156)

The place where water flows out of a pond should be in the southwest.

XI. Miscellany (p. 190)

On the most basic level we can see that the flow of energy is clockwise, moving from north to east to south to west and then back toward north again. Starting at a high point in the north, if water was caused to flow any further in a clockwise direction than the south-west, it would be required to flow uphill, an impossibility, which demands that the flow be exited from the garden somewhere around the southwest. Looking at it another way, because southwest falls directly between Sheep (☶) and Monkey (☷) directions, the expression Sheep Monkey comes to mean "southwest." Examining the hexagram for Sheep we find Mountain (☶) under Sky (☰). Mountain has the property of stopping, which could send the water out of the garden there. Also, the Sheep hexagram has a visual aspect like a grand two-storied gate, the likes of which were found in imperial cities, providing a gateway for water to exit through. In the hexagram for Monkey we find Earth (☷) under Sky (☰). In this we see the pure *Yin* of Earth is blocked from movement by the pure *Yang* of Sky that sits over it. Water, a *Yin* element, prevented from further movement by a cap of *Yang,* flows out of the garden at that point.

3. Wuxing—Theory of Five Phases

The Five Phases are Wood, Fire, Earth, Metal, Water. As mentioned earlier, they are referred to as Phases rather that elements because they are not perceived as fixed substances but rather as points along a cyclic flow. Each Phase is associated with a cardinal direction,

color, season, and so on, as shown in the chart on page 78. While the associations are fixed, there are two separate systems for arranging the order of the Five Phases as well as how they will relate to one another, namely, the Five Phase Creation theory and the Five Phase Control theory as shown on page 79.[26]

According to the Five Phase Creation theory, each of the five elements is seen as creating the next in the cycle. Wood is considered the point of departure and the order is Wood, Fire, Earth, Metal, and Water. This yields a cyclic flow of creation as follows: Wood produced Fire, Fire produces Earth, Earth produces Metal, Metal produces Water, Water produces Wood. The explaination is that if wood is heated, then fire will result; when the fire is burned down, what is left is ash, which is perceived as a form of earth; from earth metals can be extracted in the form of ore; the cool surface of metal will cause water to appear as condensation; and water nurtures the growth of trees, which are the source of wood.

In the case of the Five Phase Control theory, Wood is still the point of departure but the order of the phases changes to Wood, Earth, Water, Fire, and Metal. The cyclic flow is that Wood controls Earth, Earth controls Water, Water controls Fire, Fire controls Metal, and Metal controls Wood. In explanation, Wood (in the form of living plants) shrouds Earth with its growth, Earth impedes the flow of Water, Water extinguishes Fire, Fire will make Metal malleable, Metals are used to cut down plants and shape Wood. In the Sakuteiki we see these concepts being used as a model for garden design.

Examples of Five Phase Theory in the Sakuteiki

Control Theory

Earth is lord, water servant. If earth permits it, water will flow, but if earth prevents it, it will not. Seen another way, mountain is lord

26. The Five Phase Creation Theory is *gogyō sōshō setsu* (literally, Five Phase Mutual Birth Theory) and the Five Phase Control Theory is *gogyō sōkoku setsu* (literally, Five Phase Mutual Victory Theory). *Sōshō* can also be pronounced *aioi*, a word that describes two trunks growing from the same root. *Gōkoku* is commonly translated as "rivalry."

Five Phase Theory

PHASE	Wood	Fire	Earth	Metal	Water
DIRECTION	East	South	Center	West	North
COLOR	Blue	Red	Yellow	White	Black
EMPEROR	Taikō	Entei	Kōtei	Shōkō	Sengyoku
SEASON	Spring	Summer	Doyō	Autumn	Winter
PLANET	Jupiter	Mars	Saturn	Venus	Mercury
GUARDIAN GOD	Blue Dragon	Scarlet Bird	Yellow Dragon	White Tiger	Black Tortoise
TASTE	Acid	Bitter	Sweet	Spicy	Salty

FIGURE 13: The Five Phases

Each of the Five Phases *(gogyō)* is associated with certain qualities.
In the Sakuteiki, we find that these associations were used as the
basis for making decisions related to garden design. The connection
between Dragon-East-Blue and Tiger-West-White, for instance,
informs the warning not to use large white stones in the east (see
translation, p. 187).

CONTROL CYCLE

FIGURE 14: Five Phase Cycles:

As implied in the word *phase*, the Five Phases are not static elements, but rather are in a state of constant flux, changing into or ameliorating one another. These charts depict the Five Phase Creation Theory *(gogyō sōshō setsu)*, and the Five Phase Control Theory *(gogyō sōkoku setsu)*.

and water the servant, while stones are the lord's counsellors. Water thus flows in accordance with the nature of the mountain. However, if the mountain is weak, it will be destroyed by water without fail, like a servant opposing a lord. The mountain is weak where there are no stones to lend it support, just as the lord is weak when he lacks supporters. Therefore, the mountain is complete when it contains stones, even as the lord rules by the support of his servants.

VIII. Garden Streams (pp. 175)

In this passage we see the Five Phase Control theory being used as an underlying model for garden design. The theory says that Earth controls Water (Earth impedes the flow of Water), and the Sakuteiki reflects this with "Earth is lord, water servant. Thus if earth permits it, water will flow, but if earth prevents it, it will not." In Confucist manner, the Sakuteiki correlates the actions of nature with that of political rulers, expressing a contentious situation in the garden (water eroding the mountain) in terms of discord in society (servant opposing the master).

Colors and the Control Theory

Do not set a white stone that is bigger than those around it in the easterly direction or harm will come to the master of the house. Likewise, in all other directions, be careful not to set stones that are of "controlling" colors nor ones that are larger than the other stones there.

X. Taboos (p. 187)

As we have seen, the east is associated with the color blue and the Wood Phase, while the west is related to the color white and the Metal Phase. According to the Five Phase Control theory, Metal controls Wood; therefore, a white stone, as representative of the Metal Phase, set in the easterly direction, being the domain of the Wood Phase, is a controlling element in that region and thus the source of imbalance. The Sakuteiki offers the same advice for the other directions, warning against setting a particularly large stone of a controlling color in other directions. This would imply not placing particularly large blue stones in the center, yellow ones in the north, black ones in the south, or red ones in the west.

Colors and the Control Theory

It is said that in old gardens, when there was a stone that caused evil of its own accord, if stones of a controlling color were intermingled nearby, the evil would stop.

XI. Miscellany (p. 191)

According to the Five Phase Control theory, setting blue stones would act to control yellow stones, yellow stones control black stones, black stones control red stones, red stones control white stones, and white stones control blue stones.

Four Guardian Gods

Perhaps the most often encountered aspect of Heian-period geomancy is the Four Guardian Gods, *shijin*. Achieving a harmonic balance of all four, *shijin sōō*,[27] was a fundamental purpose for using geomancy. This was applied to the macroscale, such as urban design, as well as the microscale, for instance, private gardens. The principles of the Four Guardian Gods came to Japan as part of the Five Phase Theory, and the two concepts are so entirely interwoven that it makes sense to present them together. The Four Gods are each associated with a direction and a color, and so we find the Blue Dragon *(seiryū)* in the east, the Scarlet Bird *(suzaku)* in the south, the White Tiger *(byakko)* in the west, and the Black Tortoise *(genbu)* in the north. It is possible that the original image for the Scarlet Bird could have been the Paradise Bird from New Guinea, which lies to the south of central China where geomantic thought was developed. It is interesting to note that the White Tiger is native to India, which lies somewhat westward from central China, so there seems to have been some historical accuracy in the tales that undoubtedly provided the source for the gods' images.

Genbu is translated as "Black Tortoise," but it usually is depicted as a tortoise with a snake's neck and head. Snakes and tortoises are both animals with a water nature, and it was said in ancient times that tortoises were all female and snakes all male, thus the *Genbu* implies a fusion of male and female imagery. There is an explana-

27. *Shijin sōō*, or the "four guardian gods are in balance."

tion for the disposition of the Four Guardian Gods in the "Yueling," which is the Monthly Commands chapter of the *Liji*, the *Book of Rites*.[28] On the imperial banner, the gods are positioned so that the Phoenix is in front, Tortoise behind, Dragon to the left, and Tiger to the right, showing that the banner icons were drawn as seen from the emperor's south-facing point of view. The arrangement is also good from the standpoint of military planning as well: Quick-moving, mobile Phoenix in front; stable, armored Tortoise to the rear; and the powerful, flexible Tiger and Dragon on both flanks. The figure shown here is a rubbing from a Jin-dynasty (265-420) grave of the Four Guardian Gods arranged in the cardinal directions and divided into separate areas by diagonal lines. It appears that the Dragon and Tiger are placed in reverse of their normal positions, but in fact this image is drawn as if the viewer were facing south and heavenward.

The passage from the Sakuteiki below describes the Four Guardian Gods and their relation to plants in the garden. The basic concept is geomantic and thus Chinese in origin, but the substitution of trees for the standard elements required for harmonic balance is a Japanese development and may well be linked to native Shinto belief in the spiritual power of plants. The reason for the particular choice of species, and the numbers of trees to be used, remains unclear.

> One should plant trees in the four cardinal directions from the residence and thereby evoke the presence of the Four Guardian Gods—so it is written. The flow of water to the east of the house is the Blue Dragon. If there is no water there, then plant nine willow trees instead. The Great Path to the West is the White Tiger. If there is no Great Path, then plant seven catalpas in its place. The pond to the south is the Scarlet Bird. If there is no pond, then plant nine katsura trees there. The hill to the north is the Black Tortoise. If there is no hill there then plant three cypress trees. Those who follow these rules will create places encompassed by the Four Guardian Gods and be blessed by ascending careers, personal wealth, good health, and long lives.
>
> XII: Trees (p. 192)

28. Ch. *Liji Yueling*, Jp. *Raiki Gatsuryō* 礼記月令

Figure 15: The Four Guardian Gods: *Shijin*

This image of the Four Guardian Gods was
meant to be seen looking up from below.
From that point of view, the Four Gods align
with their traditional directions. (Redrawn
from rubbing of Jin-dynasty grave carving.
Collection of author.)

Westerly Flow of Water Cleanses Gardens

... the waters from the Blue Dragon will wash all manner of evil off to the Great Path of the White Tiger.

VIII. Garden Streams (p. 173)

Why the Sakuteiki states that the waters of the Blue Dragon have the power to wash off evil toward the White Tiger may also be explained according to the ancient text *Huainanzi,* which precedes the *Five Phase Encyclopedia* by about 600 years. The *Huainanzi* states that there are eight winds, one for each forty-five degrees of the compass. The two winds that blow from the east toward the south (thus, generally, westerly), called *qingmingfeng* and *mingshufeng,* are both said to have the power to cleanse all manner of things.[29]

There were various theories—*Yin Yang, Yi,* Five Phases—and numerous interpretations of each; undoubtedly as many interpretations as there were practitioners. It is unlikely that many Heian-period aristocrats had a deep knowledge of the inner workings of geomantic thought; rather, they relied on geomancy experts to elucidate the secrets of the inner sanctum or simply proceeded by hearsay rather than strict dogma. Like the author of the Sakuteiki, however, at least some aristocrats had an interest in and an understanding of geomanctic rules and, when they built gardens or when they spent time enjoying them, they undoubtedly examined them for their geomantic nature. Was the direction of the stream laid out properly? Were stones of various colors set in proper order or were their energies clashing with one another? In chapter five, Gardening Styles, the author writes: "It is amusing to see ignorant people attempt to critique a garden according to a certain style." We can easily imagine the same comment about the geomantic qualities of the garden as well, with each visitor throwing in his or her own opinion about what was well done or what might be out of balance.

29. The *Huainanzi* 淮南子 (Jp. *Enanji*), was written around 120 BC. It contains a discription of eight winds, *bafeng* 八風 (Jp. *bappū*), each of which blows in a different direction. *Qingmingfeng* 清明風 (Jp. *seimeifū*) blows from east to southeast, and *mingshufeng* 明庶風 (Jp. *meishofū*) blows from southeast to south. Both of these winds were said to have the power of cleansing; thus, a flow from east through southeast to south may have been seen as a cleansing motion.

As mentioned in the previous chapter regarding nature, Heian aristocrats believed that there was an inherent balance in nature. Likewise, they were also convinced that there was a balance of life energies that was described by the tenets of geomancy. A garden that followed those tenets would accordingly provide a safe haven for those who lived within it, while one that ignored the principles of geomancy, or mistakenly violated them, was believed to cause havoc with the mortal lives of those who lived within the field of effects of the garden. When Heian-period aristocrats viewed their gardens, they did not do so with an eye only to aesthetics, seeking pleasure in a painterly scene, but rather were to some degree also able to read the garden for its geomantic messages.

佛法東漸

Buppō tōzen

The Eastward Flow of Buddhism

BUDDHISM

... the idea that all water should run to the east stems from the
concept of the Eastern Flow of Buddhism. If this is true, it follows
that such noble places are not appropriate for mere residences.
VIII. Garden Streams (p. 175)

The historical Buddha, Siddhārtha Gautama, lived and preached
in northern India in the sixth or fifth century BC. He is known
as Śākyamuni, meaning "Sage of the Śakya clan."[1] His teachings
of the true nature of life, which are the foundation of Buddhism,
spread from India through China to the Korean peninsula, from
where they eventually entered Japan, a generally eastward move-
ment that was supposedly predicted by the Buddha himself. In Ja-
pan this is known as the Eastward Flow of Buddhism, *buppō tōzen.*
The Sakuteiki refers to this as being a model for the eastward flow
of water in gardens. In fact, in most Heian-period gardens, water is
caused to flow in a generally westward direction, and the eastward
flow is cited as being appropriate only for places that are holy and
not for secular residences.

It is recorded in the *Nihon Shoki [Ancient Chronicles of Japan]*,
that the teachings of Buddhism were first brought to Japan by
priests from the Korean kingdom of Paekché, in the year AD 552.[2]
Buddhism did not seek to eliminate the native gods of Japan but
instead existed communally with them. This was exemplified by
one of the most popular Buddhist sects of the Heian period, the
Shingon sect founded by the priest Kūkai (also known as Kōbo

1. In Japanese Śākyamuni is pronounced Shakamuni; Śakya is Shaka.
2. There is some disagreement over this exact date and it must be remembered
that the *Nihon Shoki* is an official record and Buddhism was probably known of unof-
ficially for some time before that date.

Daishi), which went so far as to directly associate Buddhist deities with native Japanese gods, proposing that the latter were simply manifestations of the former. Partly because of this supplicant, harmonic nature, Buddhism grew rapidly in Japan as both as a religion and a sociopolitical force.

During the time when the imperial capital was seated at Heijōkyō, known now as the Nara period (710-94), six main sects of Buddhism developed; these sects, in many ways, set the foundation for all later Buddhism in Japan. There were two aspects that typified those sects and the religious tenor of the era in general: first, their scholastic nature and second, the interdependency between the religious sects and the *ritsuryō* government system.[3] The differences among the various sects were mainly intellectual or philosophical; all of the sects promoted a religious dogma that was not aimed at personal salvation of individuals but rather was given over to professional debates among learned priests. The government was directly involved in religion, even going so far as to choose the head priests of the different sects. This involvement proved a two-edged sword, allowing for the mutual growth and stability of both government and religion and then, as the level of corruption in both organizations rose, their mutual decline.

One of the reasons often cited for the move of the imperial capital away from Heijōkyō (now known as Nara) north to Nagaoka, and then to Heian (now known as Kyōto), was an attempt on the part of the imperial household to remove itself from the intrigues of the well-established Buddhist temples of Heijōkyō. The initial plan of Heian, in fact, allowed for only two Buddhist temples within the city precincts, and these were situated at the extreme opposite end of the city from the imperial palace (see figure 28, pp. 142-43). Buddhism as a religion was, however, still a link to powerful new ideas, and it was widely supported by the Heian aristocrats,

3. This and other information on Nara-period and Heian-period Buddhism was drawn in part from Daigan Matsunaga and Alicia Matsunaga, *Foundation of Japanese Buddhism*, vol. 1 (Los Angeles and Tokyo: Buddhist Books International, 1974) and Nobuyuki Kawasaki and Kazuo Sasahara, ed., *Shukyoshi* (Tokyo: Yamakawa Shuppansha, 1974).

including the successive emperors. By the time of the writing of the Sakuteiki, several new sects had developed and become influential in the lives of the nobles of the Heian capital. One of these was the previously mentioned Shingon sect, which was based at temples in the south of the city. The other was the Tendai sect, the head temple of which was (and still is) Enryakuji, located near the top of Mount Hiei, a prominent mountain that sits just northeast of Heian.

Unlike Buddhism of the Nara period, which was heavily connected to the *ritsuryō* government system, religious sects that developed during the Heian period ministered to, and were supported by, the aristocracy. Unlike the scholastic nature of Buddhism during the Nara period, the focus of Heian-period Buddhist sects was on the salvation of individuals. Toward the end of the Heian period, and certainly in the medieval periods that followed, those individuals included commoners: farmers, craftsmen, and merchants. In the early Heian period, however, as well as in the middle of the era when the Sakuteiki was written, individuals attended by the Buddhist religion were mainly aristocrats whose interest in Buddhism was decidedly nonscholastic. Part of their interest was political. As the *ritsuryō* government system weakened, aristocrats began to ally themselves with the next-strongest organizations, which were the Buddhist temples, and by doing so, bolstered their own position in Heian society. The aristocrats also enjoyed the pomp and circumstance of esoteric Buddhist rituals, since the silken garb and gilded utensils made the rituals sumptuous and appealing to the senses. To a great degree, Heian-period Buddhism (or more properly, Buddhist practice as performed by Heian aristocrats) was an aesthetic undertaking. Surely there was also earnest belief, but it seems that the boundaries of that belief were vague, and concepts of geomancy and local taboos strayed easily into the realms of religion, and vice versa. One aspect of Buddhism, however, which was taken seriously by the aristocrats, was its role as protector. In the Nara period, and early Heian period as well, Buddhism was seen as the protector of the state, but as the *ritsuryō* system gradually declined in favor of strong aristocratic households, Buddhism came to be seen as the protector of individuals and families of the aristocratic class.

In addition to the Tendai and Shingon sects, another sect that

existed during the Heian period, but which did not reach wide-spread acceptance until the following Kamakura period (1185-1333), was the Amida sect whose central deity, Amida Buddha, is believed to preside over a paradisiacal land known as the Western Pure Land, *Saihō Jōdo*.[4] The image of this paradise as recorded in paintings from the Heian and Kamakura periods—the architecture of Amida's palace, the layout of the palace grounds, the pond that lies in front of it, the boats in that pond, and the curved bridge that crosses over it—are all precisely the same as the images we find in paintings of the residences and gardens of Heian aristocrats. This striking similarity gave rise to the belief that during the Heian period, some gardens were created as earthly examples of Amida's Pure Land. This type of garden is now referred to as a Pure Land garden, *jōdo teien*. It is interesting to note, however, that despite the connection revealed between Amida's paradise and garden design in other sources such as Heian-period paintings, there is no mention at all of Amida or the Pure Land in the Sakuteiki.

Another Buddhist concept that was very apparent in the literature of the Heian period was impermanence, *mujō*. Birth, growth, death, rebirth—the natural world in a constant state of flux. Frequent epidemics, earthquakes, fires, floods, and other vicissitudes of the time certainly would have encouraged this particular worldview. In addition, there was a growing mindfulness, just around the time of the writing of the Sakuteiki, of a Buddhist concept called the Latter Days of Buddhist Law, *mappō*. After the death of the historical Buddha, time was believed to move in three stages, the last of which was *mappō*, which was prophesied to be a degenerate age.[5] Furthermore, *mappō* was expected to commence in AD 1052 when Tachibana no Toshitsuna, the purported author of the Sakuteiki, was an impressionable twenty-four years old. While we know that

4. Amida 阿弥陀 is the Sino-Japanese expression for two Sanskrit names, both of which refer to the same deity: Amitāyus, Lord of Everlasting Life, and Amitābha, Lord of Everlasting Light. The Pure Land is properly *Saihō gokuraku jōdo* 西方極楽浄土, the Western Paradise Pure Land.

5. The three stages are: True Law, Skr. *saddharma*, Jp. *shōbō* 正法; Imitative Law, Skr. *saddharma pratirūpaka,* Jp. *zōbō* 像法; and End of Law, Skr. *saddharma vipralopa,* Jp. *mappō* 末法.

FIGURE 16: Pure Land Garden

Jōruriji is a temple in the south of Kyōto Prefecture that has a classic Pure Land garden. A hall with nine Amida sculptures enshrined sits to the west of a pond symbolizing Amida's Western Paradise. The pagoda (shown above), in which Yakushi Buddha is enshrined, sits to the east of the pond and symbolizes Yakushi's Eastern Land of Pure Lapis Lazuli. (Redrawn from photo by author)

mujō and *mappō* were concerns of the Heian period, again, we see no reference to them in the Sakuteiki, and like the absence of poetic comment or any mention of Amida's Pure Land, it shows that the gardens of the Heian aristocrats were highly complex creations. There was no one uniform style that was consistent to gardens throughout the capital, implying that different designers held different images of what a garden was.[6] There are four ways in which Buddhism is, however, revealed as a model for gardening in the Sakuteiki: The first is the Eastern Flow of Buddhism mentioned above; the second is the story of Gion Shōja, known more widely in the West as the Jetavana; the third relates to the Buddhist deity Fudō Myōō; and the fourth to Buddhist Trinities.

Gion Shōja

> In order to create the appropriate solemnity in a noble's residence, build mountains in the garden such as those seen in the *Gion Illustrated Text*.
>
> <div align="right">I. The Basics (p. 152)</div>

The *Gion Illustrated Text* mentioned in the passage above was edited in AD 667 by the Tang-dynasty priest Daoxuan (596-667), who is known as Dōsen in Japan. Daoxuan was the founder of the Southern Mountain branch of Vimaya, *Nanshanlü*, and is well known for his writings. Among those writings was the *Gion Illustrated Text*, referred to as *Qiyuan tijing* in China and *Gion zukyō* in Japan, which describes an ancient Indian monastery called Jetavana-vihāra in Sanskrit and Gion Shōja in Japanese.[7] When Daoxuan was alive,

6. The lack of any reference in the Sakuteiki to poetic sensibilities or Buddhist concepts such as *mujō* and *mappō* may also be simply because they were too common to warrant mention.

7. The *Gion Illustrated Text* (Ch. *Qiyuan tijing;* Jp. *Gion zukyō)* is included in the Buddhist Canon, *Taishō Shinshū Daizōkyō,* 大正新脩大蔵経; Vol. 45, No. 1899. The illustration of Gion (figure 17, pp. 96-97) is from another text by Daoxuan called the *Illustrated Text on the Ordination Platform Instituted in Guanzhong* (Ch. *Guanzhong chuanli jietan tujing* 關中創立戒壇圖經), also to be found in the Canon: *Taishō Shinshū Daizōkyō,* 大正新脩大蔵経; Vol. 45, No. 1892. For further reading on this, see Antonio Forte, *Mingtang and Buddhist Utopias in the History of the Astronomical Clock* (Rome: Istituto Italiano per il Medio ed Estremo Oriente, 1988).

more than one thousand years had already passed since the construction of the Jetavana, and the story of the garden, not to mention the garden itself, was undoubtedly shrouded in mystery.

The Sakuteiki refers to creating mountains in the garden, "even as those seen in the *Gion Illustrated Text.*" Mentioned especially in the *Text* is Xumishan, Mount Sumeru, the mountain proposed by Hindu and Buddhist religions as being the central axis of the cosmos.[8] The following passages illustrate the descriptions of mountains as found in the *Gion Illustrated Text.*[9]

Within the eastern and western annex palaces, there are magnificent trees, which grow luxuriantly in winter and summer. The shade of the trees is so heavy they completely block the sun. Under the roof of the palace there are two fragrant mountains, which were built in the past by the Dragon King, Pibojieluo.[10] Though it is the height of Mount Ghanda,[11] in the eyes of ordinary people, it does not look higher than four meters.[12] It is shaped exactly like Mount Sumeru; the lower half being made entirely of gold and silver. On the top [of the mountain] is a huge pond with animal heads on its four sides, making it look like Lake Anavatapta[13] and its sides are decorated with four treasures. There are trees, flowers, and fruits on the mountain including *zitan, niutou,* and *chenshui.*[14] The flowers are shaped like cartwheels, and in the eyes of ordinary people they are no larger than coins, and flower beautifully on the six monthly Days of Fasting.[15] All of the water flows underground and disappears. All

8. Xumishan, Mount Sumeru, is known in Japanese as Shumisen 須弥山.

9. These two sections of the *Gion Illustrated Text [Gion Zukyō]* were translated by Chen Jinhua specifically for this book. The original is found in *Taishō Shinshū Daizōkyō,* Vol. 45, No. 1899, p. 887 a12-21 and p. 888 c22-27.

10. Dragon King Pibojieluo; 毘婆竭羅, perhaps Pibhakara.

11 Mount Ghanda; Ch. Banshanwang 半山王.

12. The length "four meters" is expressed as "one *zhang* 丈 and two *chi* 尺," a *chi* being a tenth of a *zhang*. During the Tang dynasty, there were two standards for the unit of *zhang*—300 or 360 cm—thus the length mentioned could be anywhere from 3.6 to 4.32 meters.

13. Lake Anavatapta, Sanskrit for the "Lake of No Heat," is associated with images of Sumeru. One of the two lakes in front of Mount Kailas (an "earthly" Sumeru in western Tibet) is named Mānasarovara, Tibetan for Anavatapta.

14. *Zitan* 紫檀 (*Pterocarpus indicus), niutou* 牛頭 (unidentifiable), and *chenshui* 沈水 (unidentifiable).

15. The six monthly days of fasting, *posadha,* are the 8th, 14th, 15th, 23rd, 29th, and 30th days of the month.

FIGURE 17: Gion Monastery

The great monastery park called Jetavana (J. Gion) was built in India at the time of the historical Buddha in the sixth or fifth century BC. It certainly did not look anything like the very Chinese version depicted in this drawing, which even includes a Temple of Yin Yang, a concept that never existed in India. Nevertheless, this is the image that came to Japan, included with a sutra called *Illustrated Text on the Ordination Platform Instituted in Guanzhong (Gusnzhong chuanli jietan tujing* 關中創立戒壇圖經 開中創立戒壇図経 *kaichū sōritsu kaidan zūkyō)* completed in 667 by the priest Daoxuan, who also authored the *Gion Illustrated Text.* The map included with the *Gion Illustrated Text* is not extant. *(Taishō Shinshū Daizōkyō,* 45, No. 1892)

the trees on the mountain are capable of preaching *dharma*. The nine dragons that dwell beneath the mountain issue fragrant clouds and savory, clean water.

On the top level of the western mansion in the front palace are sixty-four Mount Sumerus, all of which are decorated green, white, and blue. The shores of the seas surrounding the mountains are made of seven treasures. On the central mountain there are eight billion mansions made of pearls and each mansion is [decorated] with the pictures featuring the [Śākyamuni] Buddha attaining the way, subduing deities and devils, turning the *dharma-wheel,* and entering *Parinirvāṇa.*[16] On each of the Mount Sumerus[17] there are one hundred thousand Buddha Kingdoms, while at the top of the central mountain there is a great treasure mansion.

The story of Jetavanavihāra, or simply Jetavana, is familiar among Buddhists. It relates that in India, at the time that Śākyamuni was still preaching sermons, there was a wealthy merchant from Śrāvastī by the name of Sudatta. He was known to be a great philanthropist, and his generosity toward the poor and homeless gained him the name Anāthapindada, which means "he who gives to the needy." Sudatta became a follower of the Buddha after hearing him preach at the Bamboo Grove in Rājagrha. Sudatta wished for Śākyamuni and his disciples to come to Śrāvastī to visit and preach, so he invited them to spend the rainy season there, an offer they accepted. Realizing that he must now provide them with a suitable monastery to reside in, Sudatta set out to find an appropriate spot in his home district. In searching for land, he came across a pleasure garden owned by Prince Jeta, son of King Prasenajit of Śrāvastī, and thinking it would be the ideal spot, he offered to buy the land. Prince Jeta, unaware of Śākyamuni's importance and thus uninterested in letting go of the land, suggested the inconceivable—that the price of the garden would be to cover the ground of the entire garden with gold coins. Taking this suggestion seriously, Sudatta prepared his whole fortune and had his servants begin to cover the ground of the garden. This act of faith and devotion so impressed Prince Jeta, that he

16. These were four important stages in the life of the Śākyamuni.
17. Mount Sumeru is here expressed as Mountain King, Ch. Shanwang 山王.

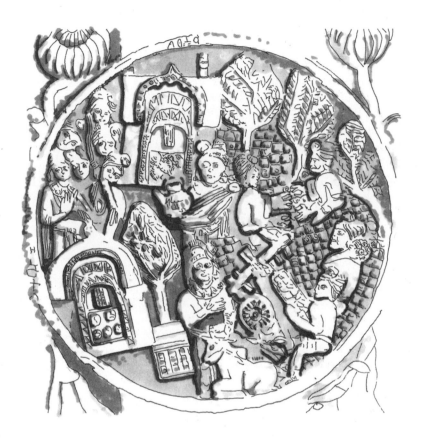

FIGURE 18: Building Gion

When Anāthapindada, the wealthy Indian merchant, wanted to build a monastery for the Buddha, he asked Prince Jeta to sell him part of his private park. Jeta answered that the price would be to cover the ground with gold. This relief, which depicts Jeta's park being spread with gold tablets, comes from a medallion carved into a stone fence at Barhut, c. 150 BC. (Collection of the Indian Museum, Calcutta)

not only agreed to sell the land for the purpose of building a monastery but he also agreed to help with the project and contributed all the gold Sudatta had laid in the garden as a gift toward the building of a monastery for the Buddha. So goes the story of the Jetavana.

To understand the passage referring to Jetavana that follows, it is first necessary to introduce the Japanese names of the characters in the story. Prince Jeta is Gida Taishi, or simply Gida. Sudatta is Sudatsu, and Sudatta's nickname as a philanthropist, Anāthapindada, is Gikkodoku. The Sakuteiki uses Kodoku Chōja, Kodoku being a shortened version of Gikkodoku, and *chōja* meaning "person of wealth." The suffix *on* in Gikkodokuon means *garden,* a word that is pronounced *en* in modern Japanese.[18] The passage in the Sakuteiki is as follows:

> Trees express the solemnity of man and Buddha. For this reason, when Kodoku Chōja, the wealthy merchant, decided to build the splendid monastery Gion Shōja with the intent of giving it to Sākyamuni as a gift, he was troubled when placing a value on the trees. At the suggestion of Gida Taishi, Kodoku Chōja gathered up his gold and spread it evenly across the entire garden and, having bought the garden for the price of that gold, he presented it to Sākyamuni. Gida said, "It is not right for me to accept money for these trees" [and so he donated all the gold toward the building of the monastery]. For this reason that place is called Giju Gikkodokuon, "Kodoku's garden made with Gida's trees."
>
> XII. Trees (pp. 193)

Whereas most versions of this tale relate that Sudatta was trying to buy the land, the story as recorded in the Sakuteiki focuses on the trees instead. Both Gida Taishi and Kodoku Chōja are bargaining over the cost of the trees, not the land, and it is the trees that show up in the Japanese name for the monastery, Giju Gikkodokuon, "the garden Kodoku made with Gida's trees." Trees and park-like images often appear in Buddhist parables. Sākyamuni, for instance, is said to have reached enlightenment while meditating under a bo tree *(Ficus religiosa),* and the *nehanzu* paintings that depict the Buddha's death, or more aptly put, his realization of nirvana, show him and

18. Anāthapindada is Gikkodoku 給孤独 in Japanese, which translates literally as "Giver *(gi)* to children with no parents *(ko)* and eldery with no offspring *(doku).*"

his disciples surrounded by a grove of trees. The section of the *Gion Illustrated Text* quoted earlier (p. 93) expresses the luxuriousness of Gion in terms of trees and plants (as well as splendid buildings and mountains), and it seems that trees in Heian-period gardens were used in order to impart a solemn, religious atmosphere on the garden and on the household in general.

Fudō Myōō

> Always be aware of waterfalls, for although Fudō Myōō takes many forms, the most fundamental of all these are waterfalls.
>
> VII. Waterfalls (p. 173)

In the pantheon of Buddhist deities, the supreme deities are called Tathōgatas, or Buddhas, which means Enlightened Ones. In Japan, Buddhas are known either as *butsu* or *nyorai*. For instance the historical Buddha, Śākyamuni, is known also as Shaka Nyorai. Another Buddha is Dainichi Nyorai (Mahāvairocana tathāgata), the Universal Buddha, who is perceived as being one with the universe and the pinnacle of the pantheon of deities. In addition to Buddhas, there are other deities that act as assistants to Buddhas in their work as saviors of unenlightened souls. Of these there is a class called *myōō (vidyārāja)*, which derive from incarnations of the older Brahman god, Siva. Among the *myōō*, meaning Brilliant Kings, the different types of which number five or sometimes eight, is one that is known as Fudō Myōō. Fudō means "Unmoving," thus Fudō Myōō is often translated as "The Immovable One," but the essence of the word Fudō might better be expressed as "unswayable," "steadfast," or "unbendable." This is reflective of Fudō Myōō's character—an enormously fierce deity who will not be swayed from his task of purging the world of evil. Fudō Myōō (hereafter Fudō) corresponds to the Indian deity Acalanātha, originally an ancient Hindu deity who was appropriated as a guardian of esoteric Buddhism in India sometime around the seventh century AD.[19] Unlike most Buddhist deities, which are painted or sculpted so as to appear the epitome of

19. This and other following information on Fudō from Kyōto National Museum, *Gazō Fudō Myōō* (Kyōto: Dōbōsha Shuppan, 1981).

calm, Fudō are depicted as being fierce in visage, with bulging eyes and fangs. In their left hand they hold a rope, *kongōsaku,* which they will use to bind and subdue earthly passions and carnal desires. In their right hand they hold a well-honed sword, *gōma no riken,* with which they cut out and annihilate evil spirits.

Fudō is believed to be a manifestation of the Universal Buddha and is associated with esoteric Buddhist sects such as Shingon and Tendai. The popularity of these two sects during the Heian period to some degree explains the popularity of Fudō and is the basis for that image in particular being incorporated in the Heian-period gardens. Another point, however, is that the same logic that envisioned fiercesome Fudō as a subduer of evil also presumed that Fudō could be evoked to subdue one's enemies. Fudō, therefore, was seen as a protector of the state and was actively used in such rituals during the early Heian period. As the strict Chinese *ritsuryō* system of government was gradually replaced by a system in which powerful regents from private families controlled the reins of power, Fudō's role similarly shifted from protector of the state to protector of individuals. Perhaps this then provides the fundamental reason for Fudō in particular being associated with gardens during the Heian period. Garden design was, to some degree, perceived as a means of creating a balanced, protective environment within which a household existed. The placement of stones and flow of water were designed to enhance that environment geomantically, and undoubtedly Fudō, in the form of waterfalls, was seen primarily as a protective element in the garden.

> Fudō Myōō has vowed that "all waterfalls over 90 centimeters in height are expressions of my self." Needless to say, those of 1.2 meters, 1.5 meters, 3.0 meters, or even 6.0 meters are also symbolic of Fudō.
>
> VII. Waterfalls (p. 172)

The relationship suggested between Fudō and waterfalls is an elusive one because it is not specifically recorded in Buddhist texts. Moreover, Fudō is usually associated with the element of fire, not water. Most paintings depict the deity sitting on a stone pedestal or a mountain precipice with a glory of flames rising from behind to form a brilliant backdrop. As mentioned above, Fudō uses his sword and rope to achieve his ends, but fire is also one of Fudō's tools for

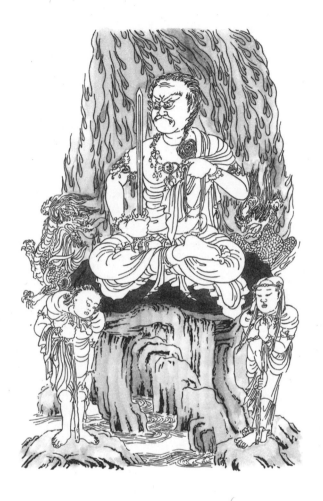

Figure 19: Fudō Myōō and His Attendants

Fudō Myōō is usually depicted sitting on a rocky precipice *(shitsushitsuza)*, in this case over water. In his right hand, Fudō holds a sword *(goma no riken)* to cut away evil and in his left hand a snare rope *(kensaku)* with which to bind it. Standing before Fudō are the Two Attendants *(Nidōji)*, and flanking him are the dragon-like Kurikara Ryūō and bird-like *garuda*. A glory of fire rises behind him, a symbol of his power to purge evil from the world. *(Gazō Fudō Myōō*, Kyōto: Kyōto National Museum)

purging evil from the world and from the souls of men. During intense prayer to the deity the practitioner is said to enter a state of concentration called *sanmai*, during which flames blaze from his or her body, erasing evil. There is, however, in esoteric Buddhism a form of ritual prayer that is performed standing under a waterfall in which water takes the place of fire as a purifying element.[20] Cold water falling hard on a practitioner's shoulders and neck from high above increases the power of the meditative moment. Prayers performed while making ablutions in waterfalls are usually directed to Fudō. In this case, water is also believed to have the same power of spiritual cleansing that fire does, and while most paintings of Fudō depict the deity's seat, *iwa za*, or more properly, *shitsushitsu za,* as a stone pedestal or as a barren, rocky outcropping, others include waterfalls as part of the scenery.

There are many legends that link Fudō with waterfalls, tales in which visions of Fudō appear from within waterfalls to priests or apprentices undergoing ritual training. *A Collection of Uji Tales,* an anthology from the early thirteenth century, contains one story about the priest Sōō (831-918) that begins with the passage: "Sōō of Mudōji on Mount Hiei used to practice regularly at a triple waterfall just north of the mountain, invoking the fiery Fudō."[21] That waterfall was most likely the Katsuragawa waterfall where, in 858, Sōō made a retreat and was inspired through his meditations to carve a sculpture of Fudō.[22] Sōō, who must have been a dynamic and charismatic character, was reputedly in good standing among the nobles in Heian. It is more than likely that the general understanding of Fudō in Heian society, and specifically of the deity's relationship to waterfalls, was fostered by Sōō and other religious men like him.

There are, as well, many temples then and now that have statues of Fudō placed by waterfalls within their precincts. Shimyōin, a temple from the Heian period which lies at the source of the Kamo

20. Interestingly enough, water and fire are complementary *Yin* and *Yang* elements.

21. *A Collection of Uji Tales, Uji Shūi Monogatari* 宇治拾遺物語; Mudōji 無動寺; Sōō 相応 See Royall Tyler, *Japanese Tales* (New York: Pantheon Books, 1987), 97.

22. Matsunaga, *Foundation of Japanese Buddhism* (1), 247-8.

River in Kyōto, has as its central figure of worship a sculpture of
Fudō that was carved by Kūkai, the founder of the temple. In front
of a high waterfall behind the main hall where the Fudō figure
is enshrined is a bronze sculpture of Kurikara Ryūō, the Dragon
King."[23] The sculpture is recent but the connection between the
Dragon King, Fudō, and waterfalls is not. The Shimyōin sculpture
depicts a dragon twisting around a sword, its mouth open in prepa-
ration to swallow the sword. The sword represents evil, *ja*, and the
Dragon King twisted about it is none other than an incarnation of
Fudō, poised to destroy that evil. Dragons are traditionally linked
with waterfalls and even the word *waterfall* is written with the Chi-
nese characters for *dragon* and *water* combined into one character.
The Universal Buddha manifested as Fudō, Fudō incarnated as the
Dragon King, and the Dragon King linked to waterfalls.

> According to the *Rituals of Fudō:* "Those who see my form, aspire
> to enlightenment. Those who hear my name, reject evil and master
> virtue ..."
>
> VII. Waterfalls (p. 172)

The *Rituals of Fudō* mentioned above refers to a text called *Fudō
giki*. In Esoteric Buddhism, *giki* refers to the rules that govern ritu-
als, offerings, hand gestures *(mudrā)*, sacred words *(mantra)*, and so
on. *Giki* also refers to the sutras within which those rules are dis-
closed. In esoteric Buddhism, teachings are usually received directly
from a master and, as a result, many *giki* are secret. The particular
Fudō giki referred to in this passage is the *Secret Rituals for the Re-
alization of Victorious Fudō Myōō's Forty-eight Messengers*, a single-
scroll text that explains the most fundamental of Fudō's rituals. This
teaching was allegedly translated into Chinese sometime in the late
eighth century by the priest Bukong, who is known in Japan as
Fukū, the sixth patriarch of the Shingon sect, a lineage purported
to begin with Dainichi Nyorai and continue to the Japanese priest
Kūkai. Bukong's disciple, Huiguo, became the seventh patriarch
and in turn passed the teachings on to Kūkai, who introduced them

23. The Dragon King, Skr. Krkāla, Jp. Kurikara Ryūō, 俱利迦羅竜王.

to Japan in AD 806.[24] The earliest record of the *Fudō giki* in Japan is from 988 and states that the priest Chōnen of Tōdaiji brought back a copy produced in Szechwan, China.[25] Certainly by the mid-eleventh century, when the Sakuteiki was written, the *Fudō giki* would have been circulated and available within the Heian capital. Within the *Fudō giki* is a passage that introduces the Four Great Vows, the first two of which appear in the Sakuteiki:

> Those who see my form, aspire to enlightenment.
> Those who hear my name, reject evil and master virtue.
> Those who listen to my teachings, gain vast knowledge.
> Those who come to know my true spirit, will experience sudden enlightenment as Buddhas.[26]

Buddhist Trinity Stones

> All waterfalls are surely expressions of a Buddhist Trinity: the two flanking stones, to the right and left of the dominant stone, probably represent the Buddha's attendants...In order to behold my form it is not necessary to know the form of Shōkoku Dōji.
>
> VII. Waterfalls (p. 172-173)

Buddhism has an affection for numerology: forty-eight vows of Amida *(Amida no shijūhachigan)*, ten realms of being *(Jikkai)*, six basic elements *(rokudai)*, and so on. Among these, references to threes are very common: three treasures *(sanbō)*, three types of Buddha nature *(sanbusshō)*, and three types of wisdom *(sanchi)*, to name just a few.[27] One manifestation of threes is the Buddhist Trinity,

24. Ch. Bukong, Jp. Fukū 不空; Skr. Amoghavajra (705-774); Ch. Huiguo, Jp. Keika 惠果 (746-805); Kūkai 空海 (774-835).

25. The author of the entry in the *Bussho Kaisetsu Daijiten*, vol. 5, p. 355b, does not specify when the text was included in the Buddhist Canon. He also suggests that it may be an apocryphal text.

26. The Four Great Vows, *shikōgan* 四弘頭, are found in the sutra called *Secret Rituals for the Realization of Victorious Fudō Myōō's Forty-eight Messengers* (Ch. *Shengjun Budong mingwang sishiba shizhe mimi chengjiu yigui*, Jp. *Shōgun Fudō myōō shijūhachi shisha himitsu jōju giki* 勝軍不動明王四十八使者祕密成就儀軌) which was referred to as the *Fudō giki* 不動儀軌 in the Sakuteiki. The Four Vows are: 見我身者 發菩提心　聞我名者 斷惡修善　聞我說者 得大智慧　知我心者 即身成佛. *Taishō Shinshū Daizōkyō* 大正新脩大藏経; Vol. 21, No. 1205, p. 33c4-6.

sanzon bosatsu, which refers to a trinity of deities usually containing a central Buddha figure attended by two *bodhisattva,* or *bosatsu* in Japanese. The Amida Trinity, for instance, depicts Amida Nyorai in the center, with Kannon Bosatsu and Seishi Bosatsu to the right and left. In addition to Amida Nyorai, there are as well a Shaka Nyorai trinity and a Yakushi Nyorai trinity. The trinity that the Sakuteiki is referring to is most likely the Fudō trinity, a lesser trinity that centers on Fudō Myōō flanked by two attendants, Seitakya Dōji and Konkyara Dōji (simply termed Nidōji or Two Attendants).[28] Dōji literally means "child or youth," especially one that is apprenticing to become a priest, but the term has also become an appellation for *bosatsu* because *bosatsu* are, metaphorically, children of *nyorai.* Acalanātha, the Indian progenitor of Fudō, was usually represented with his Śākti, a female counterpart, seated on his lap, representing a fusion of the elements of Spirit and Matter. This particular vision was not followed in Chinese or Japanese Buddhism; instead we find Fudō attended by two youths, Seitakya and Konkyara.

The Shōkoku Dōji, Blue/Black Dōji, mentioned in the above passage, most likely does not refer to Seitakya and Konkyara, who are usually associated with the colors red and white. Instead, Shōkoku Dōji probably refers to Fudō himself, who is often depicted in a specific color: red, yellow, blue, etcetera. There is a well-known painting on silk called the *Ao Fudō* [Blue Fudō], at Shōrenin in Kyōto that was completed at the end of the eleventh century, just around the time of the writing of the Sakuteiki. In that painting Fudō was depicted in a deep indigo, a color that was called *kon* in Heian Japan and *gunjō* in later eras, and is referred to as being blue/black. The implication of the passage, therefore, is that in order to come in touch with the powers of Fudō, it is not necessary for a devotee to understand Fudō's standard painted or sculpted form, replete with sword and rope and fierce visage, because waterfalls capture the true image of the deity.

27. Buddhism is not the only religion with an affection for triads; The Father, Son, and Holy Ghost of Christianity is another, and it may be possible that conceptualizing phenomena in threes is panhuman, perhaps related to the very basic triad we all share: father, mother, and child.

28. Jp. Seitakya (Seitaka), Skr. Ce aka 制多迦; Jp. Konkyara (Kongara), Skr. Kimkara 金伽羅; Jp. *dōji,* Skr. *kumāra* 童子.

FIGURE 20: Buddhist Trinity Stones

Stones set in triads to represent Buddhist Trinities are called *sanzon seki gumi*. The classic arrangement has one taller stone in back, flanked by two "Attendant" stones placed slightly forward to the right and left. In front of this is a Fore Stone *(mae ishi)* set as a place from which to offer prayers and respect.

Religious practice such as fervently praying to Fudō while standing under a streaming waterfall was almost certainly not performed in Heian gardens. This is due in part to the fact that the land levels and slopes within the city would have made it difficult to create in the garden a waterfall tall enough to stand under. (The Sakuteiki mentions 1.2 meters to 1.5 meters as being the reasonable height limit for waterfalls.) Another reason this religious practice did not take place in the gardens was that it was the vocation of impassioned priests to perform that sort of rigor. The aristocracy strove for less strenuous enlightenment. Still, even though waterfalls in the garden would not have been used for Fudō rituals, they were clearly seen as allegorical symbols that evoked the presence of that deity.

> It is considered common sense that Buddhist Trinity arrangements shall be made with standing stones while arrangements in the "shape of piled boxes" shall use horizontal ones.
>
> IX. Setting Stones (p. 182)

Not all groups of three stones in the garden were Buddhist Trinities as the passage above suggests. The "piled-box" type, which is modeled after the *kanji shina*, 品, meaning "goods," was done for aesthetic reasons. The classic Buddhist Trinity stone arrangement includes a central, upright stone with two stones of lesser height placed slightly forward to the left and right, forming an overall triangular shape. In the Sakuteiki, the triad exists both as a freestanding set of stones, as well as in the form of a waterfall. According to the Sakuteiki, waterfalls should be built with a central stone, over which the running water actually flows, supported by two flanking stones that lean in and support it from the right and left. This arrangement is suggested for reasons of engineering strength as well as aesthetic beauty, and now, with the addition of the Buddhist Trinity interpretation, we see that there is an added layer of allegorical significance. The freestanding Buddhist Trinity Stone arrangements, called *sanzon butsu no ishi* in the Sakuteiki, are still common in gardens today, and there are many extant examples beginning from the medieval period.[29] Buddhist Trinity Stones are also mentioned several times

29. Buddhist Trinity Stones are called *sanzon sekig umi* these days.

in the section on Taboos, and those will be discussed in the following chapter. Suffice it to say now that Buddhist Trinity Stones were thought to be capable of causing imbalances in the garden as well as correcting them. Compare the following passages, the first of which depicts Buddhist Trinities as potentially disruptive while the second shows them to be a curative measure.

> Do not arrange a Buddhist Trinity so that it faces directly toward the main residence. Have it face slightly to the side. Violating this taboo is terribly unlucky. (p. 186)

> However, if a Buddhist Trinity is placed in the southwest, there will be no curse, neither will devils be able to enter. (p. 186)

The Sakuteiki was not intended by the author to be an encyclopedic text. He wrote about those aspects of gardening in which he was interested and with which he happened to have experience. We realize that there was much more to the relationship between Buddhism and Heian-period gardens than the author chose to include. Still, thinking back over the things the author did present, we can clearly see three aspects of Buddhism reflected in the garden.

First, Buddhism was a constant presence in the daily lives of the aristocrats and because of that familiarity, aristocrats were able to couch their phrases in Buddhist terms to express certain ideas, assured that those listening (or in the case of the Sakuteiki, those reading) would understand the reference. This ability even extended to the point where they could use Buddhist imagery to make comments on garden design. The references in the Sakuteiki to making the garden look as it does in the story of Gion Shōja, or to the Eastern Flow of Buddhism, are examples of the way Buddhist imagery could be casually referred to in relation to gardens.

The second relationship between Buddhism and gardens that we find in the Sakuteiki relates not to design but rather to a fundamental reason for building gardens. Even as the elaborate rituals associated with Heian-period esoteric Buddhism were performed to delight the aristocrat's aesthetic sensibilities, so too the development of the garden with grand trees and mountains fashioned after images appearing in Buddhist texts was done to lend an air of

nobility to a residence. Not unlike the rich clothes worn by priests or the gilded utensils they used in their practices, the garden was a means to evoke the kind of august and stately atmosphere associated with the Buddhist religion at that time.

The third relationship relates to the aspect of Buddhism by which the religion (or at least some of the deities within the pantheon) is seen as a protector of the individual. This was especially true of Fudō Myōō. We saw how waterfalls were thought to evoke the image of that deity, and we can imagine that residents who built those waterfalls were comforted by the knowledge that Fudō was close at hand, standing ready to chase evil from the premises. Inserting Buddhist elements in the garden, therefore, was done for reasons similar to those for introducing elements that had geomantic influence. Both the Buddhist elements, Fudō Myōō in the waterfall being the prime example, and the geomantic elements, for instance the flow of water or placement of certain stones or trees, were perceived as protecting the household.

禁忌

Kinki

Taboos

TABOOS

Regarding the placement of stones there are many taboos.
If so much as one of these taboos is violated,
the master of the household will fall ill and eventually die,
and his land will fall into desolation and become the abode of devils.
X. Taboos (p. 183)

With these harsh words the author of the Sakuteiki begins his instructions on taboos, which are referred to as *kinki* in the text.[1] Taboos played a large part in the lives of Heian-period aristocrats, who commonly referred to them as *imi* or *mono imi*.[2] They determined much of the aristocrats' daily life—their schedule, when and where they would travel, even minutia such as when to take a bath—according to an aggregation of superstitious beliefs that were related to a variety of things, among them Buddhism, geomancy, Shinto religion, and other local beliefs. By the time of the writing of the Sakuteiki, the original sources for these beliefs were not always clearly defined, and we find that taboos were often based on a mixture of some or all of the aforementioned influences.[3]

One of the main sources of taboo was defilement, a concept that has its roots in the native Shinto religion. Defilement could be the result of numerous events as varied as a death in the household, sickness, menstruation, or recent sexual intercourse. During a period of taboo, people in general remained cloistered and avoided meeting

1. Along with *kinki,* we also find the expression *tatari,* "a curse."

2. For more information on taboos see Morris, *World of the Shining Prince,* 136-52, and for directional taboos, Bernard Frank, *Etude sur les interdicts de direction a l'époque Heian* (Tōkyō: Maison Franco-Japonaise, 1958) or the translation of Frank's work by Hironobu Saito, *Kataimi to Katatagae* (Tōkyō: Iwanami Shoten, 1989).

3. Morris, *World of the Shining Prince,* 325.

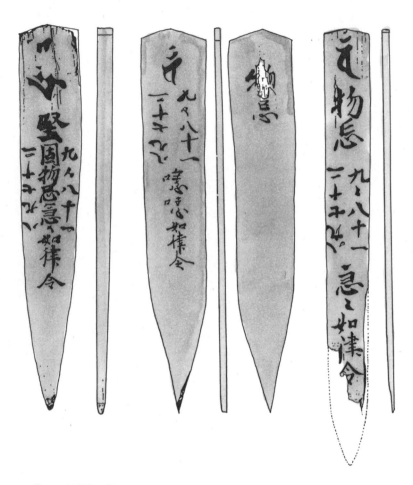

FIGURE 21: Taboo Plaques

Taboo plaques *(mono imi fuda)* were made in many sizes and for different purposes by practitioners of Yin Yang *(onyō ji)*. Some were small enough to be worn, while those shown here were about forty to fifty centimeters long. These were placed outside, in the ground or in piles of sand, and were used to warn passersby that the household in question was in a period of taboo. (Redrawn from *Nihon Bukkyō Kiso Shiryō Shōsei*, p. 145)

strangers, to spare them from being affected by the taboo. Tags made of willow wood, called *mono imi no fuda*, would be inscribed with the characters for *taboo (mono imi)* and then hooked onto the hanging screens that separate the rooms of a *shinden* palace from the garden, alerting anyone approaching not to enter because the person inside was afflicted by a taboo. If a trip was unavoidable, the tags could be hung from one's headdress instead. We also know that larger *mono imi no fuda* were designed as stakes about forty to fifty centimeters long, and we can surmise that they were placed in front of the gates of the residence to warn visitors away, as well as in the garden at different points around the residence. These stakes would have been stuck into the ground or perhaps into a pile of sand on the ground.

Stakes like these were painted with magic incantations by *onmyō ji*, masters of geomancy. These stakes have been found during archeological digs in various parts of the garden area, suggesting that perhaps they may have been set not only in front of the main gate but in the garden as well, perhaps depending on the direction that was "closed" that day or in response to an "earth-violating" taboo, terms that will be explained below. As an example of what is written on the plaques, the one on the extreme right of figure 21 reads as follows:[4]

The first character is a Sanskrit character, *vam* (Jp. *ban*), that represents the deity Dainichi Nyorai. It is placed at the top of the stake to improve the effectiveness of the charm. The next two characters read *mono imi*, "taboo," and are standard on all such plaques. The next set of characters are numbers; on the right hand side is written "nine, nine, eight, ten, one" in which "eight, ten, one" means "eighty-one." This is written from top to bottom while on the left, written upside-down from bottom to top is "eight, nine, seven, ten, two" in which "seven, ten, two" means "seventy-two." In geomantic texts, there are expressions such as "nine palaces, eighty-one gods" and "eight trigrams, seventy-two gods."[5] Nine (the highest of odd

4. These examples of taboo plaques, *mono imi fuda*, are as shown in Tsujimura Taien, *Nihon Bukkyō Minzoku Kiso Shiryō Shōsei: Gankōji Gokurakubō*, Vol 4. Tokyo: Chūōronsha, 1977, 145. The translation is as informed by Yamashita Shin'ichirō of the Mokkan Gakkai.

5. "Nine palaces, eighty-one gods" 九宮八十一神 and "eight trigrams, seventy-two gods" 八卦七十一神.

numbers) multiplied by nine yields eighty-one, and eight (the highest of even numbers) multiplied by nine yields seventy-two. Eight plus one, and seven plus two, both yield nine, forming cyclical expressions. The use of odd and even, up and down, and the cyclical ending, are all numerical expressions of the balance of *Yin* and *Yang*, and the whole arrangement is meant as a geomantic, numerical incantation. The set of characters at the bottom of the plaque read *kyukyu nyo ritsuryo*. In Han-dynasty China, this expression meant something like, "Adhere to the Law Immediately." In Heian-period Japan, however, the meaning had no relation to the *ritsuryō* government but rather was a simple appeal for an immediate response to the request of the *onmyō ji*. More than anything, the contents of the *mono imi* plaque reveal the mixture of practices—geomancy, numerology, and Buddhism—that was prevalent in Heian-period aristocratic society.

Another type of taboo, called *kata imi*, in which *kata* means "direction," was related to magnetic directions, a concept that is geomantic in origin. There were three forms. First, there were directions that were considered to be taboo for *all people* at *all times*, for instance the northeast, which in China and Japan has traditionally been the direction of evil. In Japan, the northeastern direction is known as *kimon*, the devil's gate. We have already seen in the chapter on geomancy how the northeast is noted in the Sakuteiki as a direction to be avoided for setting stones, especially tall ones. A second form of directional taboo relates to directions that are taboo at *all times* but *not for all people*, in other words a direction that is permanently taboo but affects different people at different times in their lives (and may be related to the effects of other directions at other times). The third directional taboo relates to directions that are taboo for *all people* but only at *certain times*, temporarily or cyclically.

The taboo days of the third type, *mono imi no hi*, were decided by the position of the Circuit Gods, *yūgyōjin*, which were believed to make cyclical travels through the magnetic directions. The five Circuit Gods that governed the directional taboos were Ten'ichijin (also called Nakagami), Taihakujin, Daishōgun, Konjin, and Ōsōjin, each of which moved through the magnetic directions at different cadences. Taihakujin moved one day at a time, Ōsōjin once a month,

while Daishōgun spent three years in one spot. The most complex was Ten'ichijin, who descended from heaven in the northeast, spent six days there before continuing through east (five days), southeast (six days), south (five days), southwest (six days), west (five days), northwest (six days), and north (five days) for a total of forty-four days. Having returned to true north, Ten'ichijin would reascend to heaven, spend sixteen days there and then begin the process all over again.

When a god was resident in a certain direction, that direction was described as being blocked, *kata fusagari*, making it a taboo direction. According to the principles of the system, it was inadvisable to travel in a taboo direction and absolutely forbidden to stay overnight in that direction. Constantly troubled by these limiting directional taboos, Heian-period aristocrats developed an ingenious, if ludicrous, system for avoiding them. The process was simple: if a particular direction was blocked, and therefore taboo, one would simply move first in a nontaboo direction and stay a while somewhere along that unimpeded route before heading to one's actual destination, a technique called *kata tagae*, or literally "direction-switch." For instance if one wished to visit an acquaintance whose residence lay south from where one was, but south was a taboo direction at that time, then one might first visit someone at a place that lay to the west and then proceed from there southeast to his final destination so that neither leg of the trip actually moved in a true southerly direction.[6]

The technique of direction-switching, and the degree to which taboos affected the lives of the aristocrats in general, are revealed in other literature from the Heian period. In *The Tale of Genji*, for instance, in the chapter called "The Broom Tree (Hahakigi)," we find that Prince Genji has traveled from the imperial palace, where he resides as a captain of the guards, to visit his wife, Aoi, at her father's mansion on Sanjō street.[7] As evening draws near, he is reminded by the women of Aoi's house that the direction he traveled in from the

6. The place of origin was called the *honzo*, while the midway place one stopped to avoid the taboo was called *tabi dokoro* or *katatagae dokoro*.

7. At this point in the story, Genji is still only seventeen years old. It was typical for a wife to live with her parents and be visited by her husband until he was able (socially and financially) to build a residence for his family. In Genji's case, it was not a financial restriction but a personal choice that kept them living apart.

imperial palace to get to the Sanjō mansion was blocked on that day by Nakagami, making it a taboo direction for him, and they urge him to not consider staying overnight. He agrees but realizes that since his own residence on Nijō street lies in the same direction from the imperial palace as Aoi's Sanjō palace, continuing on there would not alleviate the taboo.[8] It is then suggested that since the residence of one of his retinue, the governor of Kii, lies in a direction that is nontaboo, they could seek shelter there, a classic example of direction-switch. There are many directional taboos related to geomancy in the Sakuteiki as mentioned in the preceding chapter on that subject. At the end of chapter twelve, however, we find the following passage relating to taboos, directions, and plants.

> Planting a *sakaki* in the direction one usually faces should be avoided.
>
> XII. Trees (p. 197)

The *sakaki, Cleyera japonica,* is a small, broadleaf evergreen plant that has been used since ancient times in Shinto rituals. The shrine priest, *kannushi,* or any other person leading a ritual, will usually wave a *sakaki* branch through the air in quick strokes, making a sharp rustling sound before beginning a ceremony. The purpose of this act is to purify the prayer site, be it a shrine or a building construction site. *Sakaki* may have been originally planted as borders delineating a shrine precinct, thus the name, which derives from *saka,* meaning "border" or "boundary," and *ki,* which means "tree." The plant is apparently taboo because it is an obvious symbol of spiritual matters and thus not to be used lightly in a secular place like a garden. Also of interest is the sensitivity to directions revealed here, especially directions as they relate to an individual—such as where one usually faces.

Directional taboos affected a broad range of things. In particular, when Daishōgun or Ōsōjin were occupying a particular direction, acts called "earth-violating acts," *hando zōsaku,* were considered taboo. Earth-violating acts included earth work and soil-related work, but they also included seemingly unrelated things as well.

8. The "same direction" is expressed as *onaji suji,* meaning "along the same line."

The list of *hando zōsaku* includes house building, house moving, marriages, births, Buddhist ceremonies, grave work, building foundations, setting up posts and ridgebeams, repairs, traveling, oven plastering, well digging, fence building, and even sending out the army. Since these acts were forbidden by directional taboos, they were also made available by using direction-switch rituals, and so there are instances where aristocrats leave their residence for a short stay in a non-taboo direction, after which they return home, all done simply to exempt themselves from a *hando* taboo. The effect of direction-switch rituals lasted for a certain period of time, but not indefinitely, requiring a succession of periodic direction-switch rituals to be performed throughout the year.

Taboos in the Sakuteiki

Although *hando* taboos are not directly mentioned in the Sakuteiki, since so many of them were related to construction, maintenance, and soil work, their combined effect on garden work must have been tremendous. It was more than likely that on any given day, at least part of the garden was unavailable for work, be it construction of a new section or maintenance of an existing portion. While the words "violation" *(okasu)* and "taboo" *(imi* or *kinki)* are used only a little over ten times, taboos are implied in the Sakuteiki much more frequently. In fact, chapter ten is devoted entirely to enumerating taboos, and the quotations related to taboos that follow are all taken from that chapter unless otherwise noted. The importance of taboos to the author of the Sakuteiki is succinctly expressed in the following remark found in chapter eleven, "Miscellany":

> To make a garden by studying nature exclusively, without any knowledge of various taboos, is reckless. (p. 192)

Most of the taboos mentioned in the Sakuteiki relate to the choice or placement of stones. The source of these taboos, however, is varied and at times mixed, revealing the influence of Buddhism, geomancy, Shinto religion, and other local beliefs. Two taboos that relate to geomancy are as follows, and the explanation for these can be found in the chapter on geomancy:

Do not build a hill in the southwest quadrant of the garden. However, if a path is constructed over the hill, then it will prove no hindrance. The problem with a hill is that it will become an obstacle to the Great Path of the White Tiger, so building a hill that closes off paths to that direction is an offense. (p. 187)

Do not set a white stone that is bigger than those around it in the easterly direction or harm will come to the master of the house. Likewise, in all other directions, be careful not to set stones that are of "controlling" colors nor ones that are larger than the other stones there. Doing so is considered unlucky. (p. 187-188)

Certain taboos are related to Buddhism, although Buddhist teachings are not the source of the taboo. In the following passage, for instance, we find that Buddhist Trinity Stones are said to be unlucky if set in a frontal position. The Trinity Stones are Buddhist in origin, but the source of the taboo regarding a frontal position is unclear and may stem simply from respect and caution when using religious icons in a secular setting, as with the use of *sakaki* in the garden.

Do not arrange a Buddhist Trinity so that it faces directly toward the main residence. Have it face slightly to the side. Violating this taboo is terribly unlucky. (p. 186)

Some of the passages are not strictly taboos because they use neither the expression "violate" nor "taboo." They do, however, have the same intent of acting as a warning against danger.

When building hills, the valleys between them should not face directly toward the house for it is said that it is unlucky for women of the house to be faced with a valley. Also, do not face a valley toward the front façade of a house; rather, turn it slightly to the side. (p. 187)

Do not set stones where rainwater will drip off a roof onto them. Anyone hit by rainwater splashed off such a stone will develop terrible sores. This is because rainwater that runs off cypress bark contains poison. It has been said that men lumbering in cypress forests have many sores on their feet. (p. 187)

Other taboos seem to be revealing nothing more than a sensitivity to the natural order of things. For instance, the first two passages below, which emphasize the importance of using stones in the gar-

den in the same position that they are found in nature, are simply saying that there is an innate correctness to the way things are found in nature and if that is disturbed, it will have a halo effect, disturbing the harmony of things around it wherever it is placed. The same thing can be said for the third passage, relating to copying deserted places, which implies that if such places are abandoned or in ruins, there must have been a reason, and evoking the image of a ruined place in the garden runs the risk of initiating the same trouble within one's household.

> Using a stone that once stood upright in a reclining manner or using a reclining stone as a standing stone. If this is done, that stone will definitely become a Phantom Stone and be cursed. (p. 183)

> Taking a flat stone that once was reclining and standing it upright to face toward the residence. Whether it is set in a high or low place, far or near, it will make no difference. This will result in a curse. (p. 186)

> Regarding the use of famous landscapes as models for gardening, if a landscape is in ruins, then it should not be used. Reproducing such a desolate place in front of a home would lead to all sorts of troubles. (p. 188)

The following taboo relates to Buddhism, geomancy, and local superstition, all at once. The avoidance of the northeast is a basic geomantic postulation while the Phantom Stone *(reiseki)* is a superstitious idea of unknown origin. Alleviating the problem by balancing the offending stone with a Trinity grouping in the southwest is geomantic in method while the Trinity Stones themselves have their origin in Buddhism.

> A stone that is 1.2 to 1.5 meters tall should not be placed in the northeasterly direction. This will become a Phantom Stone, and, since it would become a landmark to aid the entry of evil spirits, people will not be able to live there for long. However, if a Buddhist Trinity is placed in the southwest, there will be no curse, neither will devils be able to enter. (p. 186)

There are also many warnings against the misuse of stones that are not specifically related to their geomantic nature or to Buddhism, all of which are accompanied by admonitions such as "Violate this

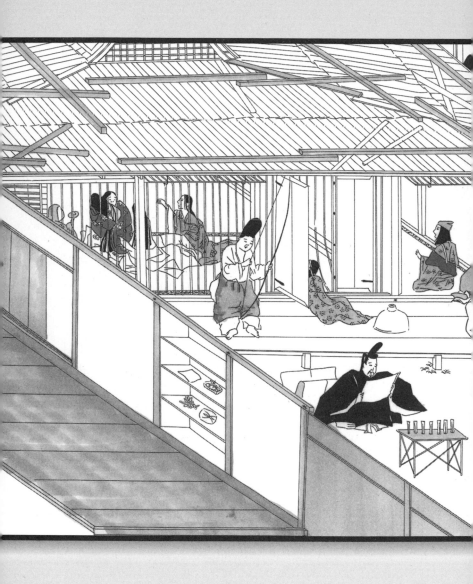

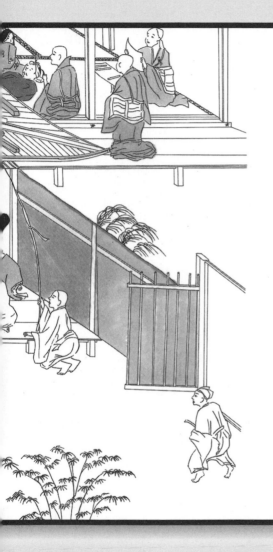

FIGURE 22: Aristocratic Life

This one scene tells volumes about the nature of aristocratic life in Heian-period Japan, especially the mixing of cultures. In the right rear, a group of Buddhist priests, undoubtedly of an esoteric sect, are reciting prayers to help a sick man; at left center, a man twanging the string of a bow, and the mountain-shaped object on the veranda, are intended to ward off evil spirits that may cause trouble for the woman giving birth inside the curtains; and sitting in the garden we find a *Yin Yang* practitioner *(onyō ji)* performing a divination. (Redrawn from *Kitano Tenjin Engi Emaki*, p. 41)

taboo and even one's descendants will suffer, evil happenings will abound, and all one's wealth and possessions will be lost."

> Do not set a stone that is higher than the veranda in the immediate vicinity of the house. (p. 186)

> Do not set a stone so that it falls direcdy in line with the columns of the buildings. (p. 186)

> Do not set a stone by the southwest column of the house. (p. 187)

> When a stone from the mountains or riverbeds is set in the manner of deities, it will become a Demon Stone. There are many cases throughout the country of trouble stemming from doing this. (p. 188)

Numerous references to taboos in the Sakuteiki reveal the degree to which a "taboo mentality" pervaded the lives of the Heian-period aristocrats. Every move was tempered by consultations of astrological charts to determine whether a day or direction was taboo, the knowledge of which may have influenced a decision to do anything from getting married to taking a trip across town. Naturally, we would expect that the design of the aristocrats gardens, which were so central to their social and aesthetic lives, would also be influenced by these taboos, and so it was. The references to taboos in the Sakuteiki also reveal the degree to which the various philosophies that were favored at the time intermingled, including Buddhism and geomancy. Taboos could be the result of a number of causes without regard to the purity of dogma.

Having looked at how nature, geomancy, Buddhism, and taboos formed a framework for garden design, we develop a mental picture of the way the Heian-period aristocrats perceived their gardens. First, to some degree they noticed in the garden aspects of the natural world they had experienced themselves, heard about from travelers, or read about in poetry. A meadow scene in the garden might have reminded them of a trip taken recently, perhaps to a temple in the outskirts of Kyōto. They would be reminded of how their elegant procession had wound a slow, graceful trail through fields of golden grass. A pine-covered island in the garden, encrusted with rugged boulders along the shore, may have struck a chord for

someone whose loved one had been posted to a province across the Inland Sea, someone who recognized in the garden image a lonely windswept shore that their lover wrote about in poems sent home.

They may have also noticed something about the geomantic qualities of the garden. Crossing the slightly bowed bridge in the Breezeway that led from the *shinden* to the eastern Annex Hall, they would have heard the burbling sound of water come rising up to them. Pausing, they may have stopped to watch the winding stream that flowed beneath the bridge, tracing its path from its source behind some outbuildings to the north, to the point where it flowed under the Breezeway and then arched gently across the garden to the pond, its final outflow to the southwest hidden from view by plantings at the rear of the garden. Something in the way the garden stream was made to run seemed to fit perfectly the nature of the site, and that would have instilled in them a sense of comfort; conversely, while spying out the source of the stream in the northern reaches of the property, they may have noticed a certain stone of a distinctive color, perhaps a large white boulder quite near the veranda of the second wife's quarters, that had been set there against tradition. It would have made them wonder whether that ill placement was not the cause of some trouble that had befallen the poor lady of late.

The trees in the garden may have seemed particularly beautiful that day, and one of the retinue among a few aristocrats gathered on the veranda might have commented on them in Buddhist terms, flattering his host by saying that even the august trees of Jetavana were no match for the likes of these. Or perhaps there was a priest among them, a man with religious zeal burning in his eyes, and on that day he may have been thrilling the gathered aristocrats, so pale and wan, with tales of his mountain retreat and the arduous travails he and his disciples endured in pursuit of enlightenment. He may have turned to the garden and, pointing a muscular finger to the waterfall splashing out from the darkness of the trees, made allusions to it as a way of supplementing his story, titillating his listeners by asking, "Can't you see the Holy Lord Fudō there even now, standing amid the spray?"

Or perhaps one of those gathered, the kind of busybody who likes to critique other people's work, would have snickered at a per-

ceived mistake, as the author of the Sakuteiki did upon finding that the maker of a garden (a well-known garden-making priest whose word on garden design was considered final) had mistakenly set one or two stones in a manner that was taboo. Or perhaps the meddler would turn to another of their group and warn them against visiting the western part of the garden on that day, whispering that the master of the house had started rebuilding the rockwork, the ground had been dug into and laid bare, and surely, considering their birth date, they should avoid that earth-violating taboo for the next two weeks.

Undoubtedly, all of these appraisals were possible, which leads us to see that the gardens of the Heian period were complex constructions. They were not simply aesthetic playthings—neatly designed pretty pictures or sculptural objects—although they contained those aspects too, and it is in this depth of meaning that the gardens of the Sakuteiki offer us, nearly one thousand years later, inspiration for our own designs and for our appreciation of gardens in general.

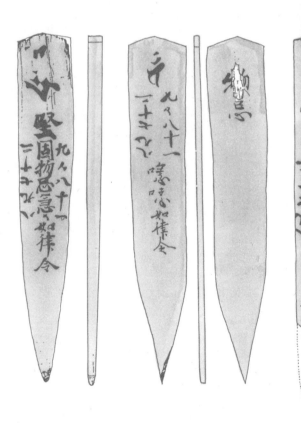

Sakuteiki

COLOR PLATES

FIGURE 23:

When creating a garden, first be aware of the basic concepts.

Select several places within the property according to the shape of the land and the ponds, and create a subtle atmosphere, reflecting again and again on one's memories of wild nature.

The opening lines of the Sakuteiki contain several of the key words of the text: *ishi wo taten koto* 石をたてん事, which means garden building; *fuzei* 風情, which means atmosphere or taste; and *shotoku no senzui* 生得の山水 which means nature. The image on the right is from a photographic reproduction of the Tanimura scroll which was hand-written with brush and ink and made into a scroll. The image on the left is from an actual copy of the Edo-period *Gunsho Ruijū,* which was produced in book form using wood-block prints. Both texts are held by Kyōto University.

石をたてん事まづ大旨をこゝろうべき也

地形により池のすがたにしたがいてよりくる所々
に風情をめぐらして生得の山水をおもはへて
その所々はさこそありしかとおもひよせ
たつべき也

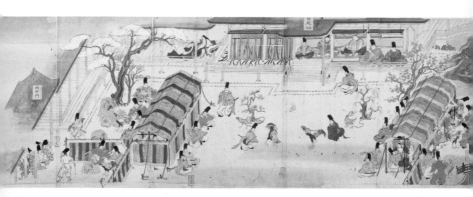

FIGURE 24: Festivities in the Southern Court

This scene is from *Nenjū Gyōji Emaki* (Scroll of Annual Festivities), which depicts various events—mostly cultural gatherings and religious festivals—that played an important part in the lives of the imperial household, aristocratic class, as well as plebeian society of the Heian capital. The events range from horse races and cockfights to formal, ceremonial dance performances. The original volume was reputedly composed of sixty scrolls, but the extant edition is an Edo-period copy that contains only a third of those.

The original was created around 1156, the very end of the Heian period and about one hundred years after the Sakuteiki was written. It was painted at the request of Emperor Goshirakawa (1127-1192; r. 1155-1158) who, though reigning for only four years, was

intent on reviving traditional court ways. He had the imperial palace rebuilt in a matter of just eight months and revived a number of court festivals that had not been practiced for some time, including the display of sumo wrestling, *sumai no sechi,* at court. The painting is traditionally ascribed to Tokiwa Mitsunaga 常磐光長 a court painter of the late Heian period. This copy is known as the Sumiyoshi family copy, having been reproduced by Sumiyoshi Jokei (1599-1670) and his son, Gukei (1631-1705).

The scene depicted above is a section from scroll number three, which contains images of cockfighting, *tori awase,* and court kickball, *kemari.* Cockfighting took place in palace events from spring through early summer but was customary at the festival of the third

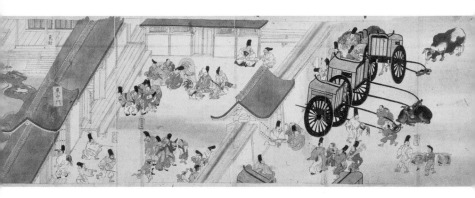

day of the month. The festival also included music and dance, with the winners of the cockfight receiving the right to perform. The participants to the east (right side of the courtyard) would perform Chinese music, *tōgaku*, while those in the west would perform Korean music, *komagaku*. In the eastern tent, preparations are being made for a performance of a children's dance, called *warawamai*.

There are many festival venues included in the *Nenjū Gyōji Emaki*, with the most common among them being street scenes of the Heian capital and the Southern Courts of aristocratic residences. The details of the layout of these courts as presented in the scroll, including the design of the architecture, the location and direction of flow of the Garden Stream, as well as many other details of the gardens,

matches the descriptions within the Sakuteiki to an extraordinary degree. To see the entire scroll, please refer to *Nenjū Gyōji Emaki, Nihon no Emaki* Vol. 8, Chūōronsha.

Tanaka Family Collection

Note: The viewer is facing north; the left side of the scroll is west and the right side is east. Ordinarily a scroll would be viewed from right to left.

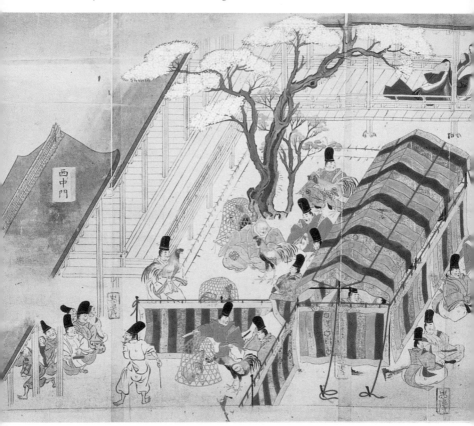

The roofed structure that borders the west of the Southern Court, within which several retainers sit, is the Western Middle Gate, *nishi chūmon;* extending north from it is the Western Corridor, *nishi chūmonrō,* which abuts the Breezeway, *surwatadono,* within which sit two princesses in elaborate, layered robes; a large cherry is planted at the corner, and the West Annex Hall is not shown.

The brightly colored tents, *akunoya* or *gakuya,* were used as staging grounds for cockfights, *tori awase,* as well as places for musicians and dancers to prepare themselves.

In the center of the Southern Court, two cocks face off backed by their attendants. Two more wait nearby, tied to trees: willow in the east and pine in the west. Kickball, *kemari,* had specific trees associated with it (NE cherry, SE willow, SW maple, and NW pine), together called *shihongakari.*

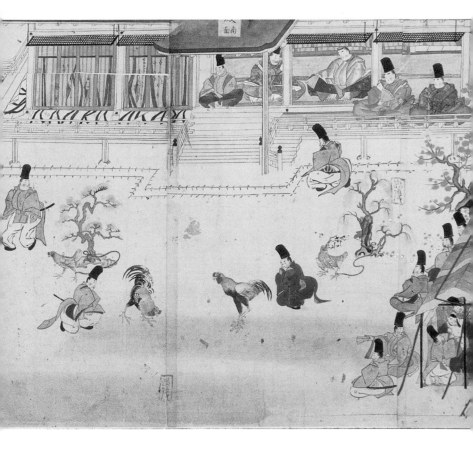

In the left side of the Main Hall, *shinden*, green, semi-transparent curtains, *misu*, have been hung for privacy, with movable fabric screens, *kichō*, set behind them. The ends of the screens can be seen flowing out from under the curtains and above them, the faces of curious princesses.

In the center of the Main Hall is a set of stairs, *hashi*, covered by a flared roof, *hashi kakushi*. The Sakuteiki suggests using the posts that hold up the roof as benchmarks when measuring the depth of the garden.

Inside the Main Hall (to the right) the master of the residence sits framed by attendants, two of whom sit inside on the *tatami* and two on thin mats placed on the veranda, *sunoko*. Above them, the upper half of the black grillwork doors, *shitomi*, have been raised (the lower half are removed). The parallel dotted lines on the ground following the veranda represent a stone-lined gutter, *mikawamizu*, which caught rain falling from the roof.

133

FIGURE 25 (CONTINUED)

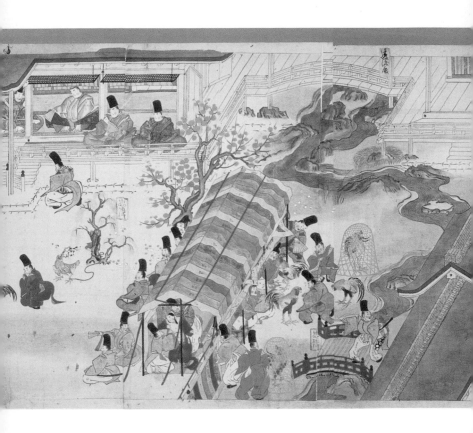

At the northern end of the eastern tent is a large plum tree, and inside, at the southern end, a young boy is being prepared for the children's dance, *warawamai*.

The "large, rugged mountain stones" mentioned in the Sakuteiki as desirable for veranda post pedestal stones for can be seen clearly beneath the Breezeway. The single stone in the middle of the stream perfectly fits the description of the Turning Stone, *meguri ishi*, which is intended to be set after a bend in a stream where the water will flow most strongly.

The Garden Stream, *yarimizu*, follows the classic route set out by the Sakuteiki, flowing from the northern end of the property, under the Breezeway, *suiwatadono*, that connects the Main Hall with the Eastern Annex Hall, *higashi no tai*, under a curved bridge, *sori hashi*, that is placed in front of the Eastern Middle Gate, *higashi chūmon*, and on south into the garden.

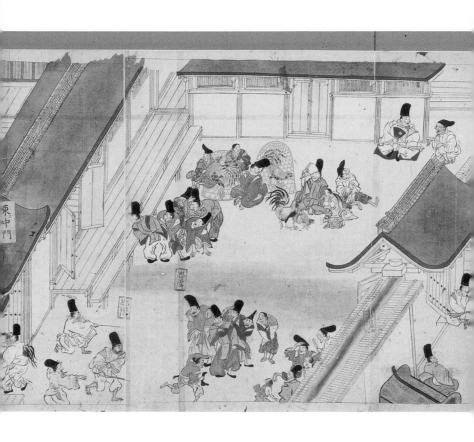

The eastern side of the Southern Court is bordered by the Eastern Corridor, *higashi chūmonrō*, which clearly shows the shutters that could be used to close it as needed, for privacy or protection.

The outer court that lies between the Eastern Corridor and the Eastern Gate (not shown, see page 131) was used as a multipurpose service court. In this scroll we see men waiting with then-roosters for their turn in the festivities or peeking in on what is taking place. Who was allowed to enter the Eastern Gate, and in turn, the Eastern Middle Gate, was dependent on their rank and purpose for visiting, and so we see a man who should not be in the entry court being chased out by stick-wielding household staff.

<small><small>Figure 26:</small></small> An Aristocrat's Garden

Kasuga Gongen Kenki Emaki depicts the foundation of the Kasuga shrine, located in present-day Nara city, as well as tales of the spiritual powers related to the shrine. Kasuga shrine was founded just after the construction of the Heijō capital (Nara capital) by the Fujiwara clan and continued through the centuries as the clan-shrine of that family. In 1309, Saionji Yasuko, daughter to Saionji Kinhira, entered the service of retired emperor Gofushimi. Yasuko was awarded the third rank and conferred as *nyōgo*, a high position in personal service to the emperor. It was common for daughters of regents to be awarded the role of *nyōgo* and, from the mid-Heian period, common practice for *nyōgo* to ascend to the formal position of emperor's wife. Later, Kinhira was conferred as Minister of the Left, perhaps

the most important position in aristocratic society after emperor and regent. In order to show their thanks for the blessings bestowed upon them, and since the Saionji family is in fact a branch of the larger Fujiwara clan, they commissioned the *Kasuga Gongen Kenki Emaki* and presented it to Kasuga shrine. The work was undertaken by Takashina Takakane 高階隆兼 who was the administrator of the division of the government in charge of court paintings, *edokoro* 絵所, and who in turn employed the artists of his office to complete the work. The original was painted on silk and comprised twenty scrolls. It is known for its rich use of color and extremely fine detail. The only remaining copy is held by the Imperial Household Agency but was so badly damaged as to be unusable in reproduction. From 1926 to 1935, at the request of the

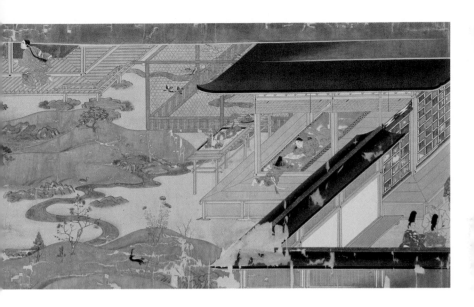

Imperial Museum (now the Tokyo National Museum), artists Maeda Ujizane and Nagai Ikuma painted a reproduction that depicts the original as is (with all existing damage) but that is strong enough to be handled. The scene shown above is taken from that reproduction.

Among the many tales of Kasuga Shrine included in *Kasuga Gongen Kenki Emaki,* the scene shown here comes from a short sequence in scroll number five that relates the tale of how Fujiwara Toshimori benefited from his devotion to Kusaga shrine. The story is related in only three scenes: one which shows Toshimori down on his luck in a dilapidated house being visited by a shrine priest who implores him to visit Kusaga to better his luck (the disheveled wall by the willow, figure 37, pp. 194-95, is from that

scene); a scene of Toshimori and his retinue riding into Kasuga shrine; and a final, long section that depicts Toshimori's now thriving household, with servants and guests bustling about in the courtyards and a resplendent garden (of which the scene above is only a detail). The ample wildlife in the garden symbolizes a natural balance that has been regained in Toshimori's household through his devotion to Kasuga shrine.

Tokyo National Museum

137

FIGURE 27: An Aristocrat's Garden
Note: In this scroll, it is unclear which direction the viewer is facing. The bright green areas in the
scroll are most likely grass, *shiba*, the brown is sand-covered, and the pale green perhaps moss.

At the left end of the pond is grillwork built into the stream where it leaves the pond. This was most likely a device that allowed water to flow out without allowing fish to enter or leave.

The pond is shown as being full of waterfowl. The Sakuteiki states that this symbolizes the good fortune of the household: "If the pond is continually inhabited by waterfowl then the master of the house will know peace and happiness."

The shoreline above is punctuated by large stones, and the hills behind are planted with pine trees. This corresponds exactly with the Rocky Shore style as described in the Sakuteiki: "Set stones as if they are heading out from the point of a wave-washed shore. Add many prominent stones with sharp edges at the shoreline, and a few Solitary Stones jutting out here and there ... and plantings of trees, especially pines."

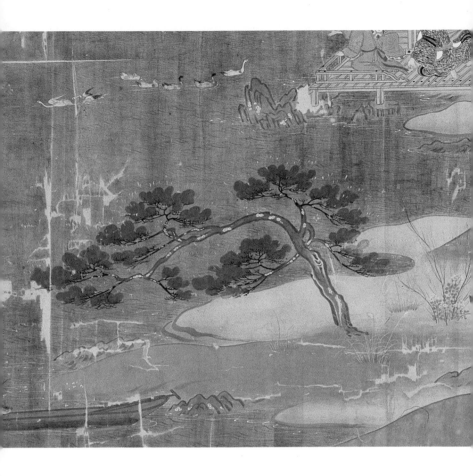

The boat at the bottom of the painting is not the elaborate, dragon-headed kind used by musicians nor the roofed type used by aristocrat themselves, but a simple rowboat of the kind that would have been kept for maintenance of the garden.

The undulating shoreline near the boat is reminiscent of the Cove Beach, *suhama,* which the Sakuteiki describes as having "elongated types, bent types, and even back-to-back types To complete the scene, spread sand and plant a few pine trees."

The Sakuteiki states, "The posts of the Fishing Pavilion should also be set upon large stones," but whether the pavilion pictured is the Well-spring Pavilion, *izumidono,* or the Fishing Pavilion, *tsuridono,* is unclear. In any case, just below where the children sit playing, are rocks that fit that description.

Figure 27 (continued)

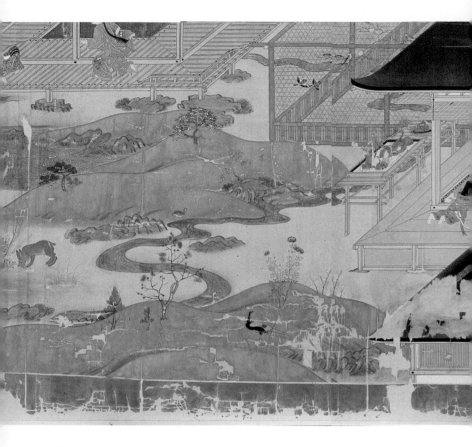

The garden pavilion seen at the top of the page sits on top of where a garden stream meets a pond. The central section of the pavilion floor is open, allowing a view down to the water. This design would also make the pavilion cool in summer.

Just in front of the garden pavilion is a series of small mounds bordered by a stream, about which the Sakuteiki states: "The creation of mountain forms or Meadows *(no suji)* should follow the lay of the land and the shape of the pond" and "The Meadow scenes in the vicinity of a Garden Stream should not be planted with plants that will grow thick and full."

Exactly what style of stream is being depicted is not clear, but regarding Garden Streams, *yarimizu,* the Sakuteiki states, "stones should not all be set in a similar manner and crammed together. The same can be said for stones placed in a stream where it... turns about the bluff of a hill, enters the pond, or flows back upon itself sharply."

In the middle ground can be seen a rabbit, nibbling on some flowers, and a pheasant, strolling along the hillocks. It is unclear whether these are representing pets or were painted to emphasize the degree to which the garden was naturalized.

140

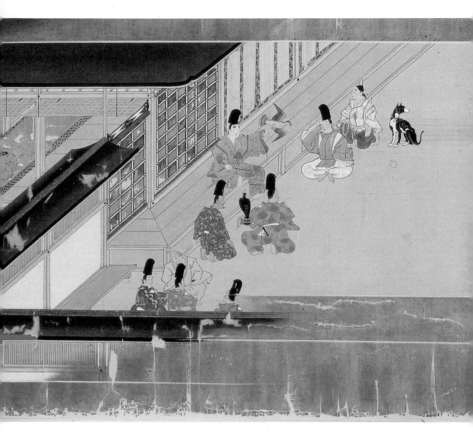

Half-hidden behind the roof of the hall is a bird cage made of bamboo slats, and just next to that a miniature landscape arrangement, *bonkei,* has been placed on a stand in the *senzai,* that part of the garden near the pavilion veranda.

The two children reading in the hall are lying on straw mats, *tatami.* Movable *tatami* existed in the Heian period, but the system of entirely covering a floor with fixed *tatami* mats would not develop until the middle ages.

Just outside the garden, in one of the interior courts, some men have gathered to talk about hunting. One among them (of higher rank as can be understood by his position above, on the veranda) is displaying his hunting hawk, *taka,* and dog, *kari inu.* There was a department in the *ritsuryō* bureaucratic system *(shuyōshi)* responsible for falconry and hunting dogs, and one of the attendant men might be from that department.

Figure 28: Heiankyō Overview (looking north)

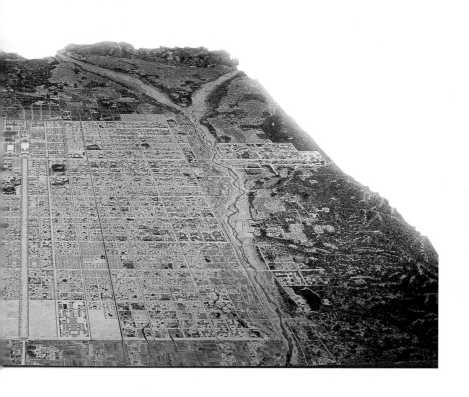

This 1:1000 scale model was built for an exhibition held in 1994 on the occasion of the 1200th anniversary of the founding of the capital. The urban plan of Heiankyō was a rational grid imposed on the natural plain of the valley, spanning approximately 4.5 kilometers east to west and 5.3 north to south. As we can see from the model, however, the imperial bureaucracy was only partially successful in its development of the city, especially in the southwest (lower left) which was boggy and difficult to work. A broad willow tree-lined avenue, Suzaku-ōji, ran up the center of the city from the main southern gate, Rajōmon (Rashōmon), to the imperial administration compound, *daidairi,* in the north. East and west of Rajōmon were two temples, the eastern of which, Tōji, still exists. The residences of the aristocrats, and thus the gardens referred to in the Sakuteiki, were primarily concentrated in the northeast of the city. Bordering the city to the east is the Kamo river, and off to the west of the city (running at an angle) the Katsura river.

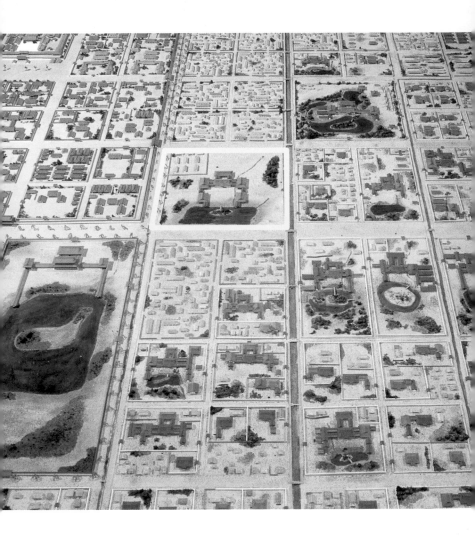

This photo makes evident the great variety of property sizes and building shapes that were extant in Heiankyō as well as the way the gardens (organic, natural environments) fit within the honeycomb grid of the urban plan (rationally structured environment). Shown here is the section of Heiankyō that lay near the southeast corner of the Imperial palace grounds, *daidairi* (upper left corner of photo). Each compound in the *daidairi* had a separate function, for instance the square enclosure in the extreme southeast corner was the Gagakuryō, which administered court music and dance. To the south of the *daidairi,* (lower left corner of photo), is the imperial garden, Shinsenen. The broad east-west avenue dividing Shinsenen from the daidairi is Nijō ōji. The north-south street that borders the east side of the *daidairi* and Shinsenen is Ōmiya ōji. The compound of small buildings southeast of Ōmiya-Nijō is the carpenters' village, *mokuchō,* and the property to the south

of that, the Mikohidari residence, is typical of *one-chō* lots awarded to aristocrats of the third rank or higher. One *chō* was approximately 120 meters by 120 meters in size. At the northeast corner of Ōmiya-Nijō is a *four-chō* property, Reizeiin, which was built by emperor Saga (786-842) as an annex imperial palace, *satodairi.* Bordering the east side of Reizeiin is a wide, canal-lined street, Horikawa kōji, and to the northeast of Reizeiin is another *four-chō* property, Kayanoin, which was the residence of Fujiwara no Yorimichi (992-1074), imperial regent and father of Tachibana no Toshitsuna, purported author of the Sakuteiki. The street bordering the east side of Kayanoin, with a smaller canal running along it, is Nishinotōin ōji. On the south side of Nijō ōji there are three two-*chō* estates side by side. The easternmost is Higashi Sanjōdono, from which, the Hōgen Monogatari records, it was possible to spy on Takamatsudono, the one-*chō* estate directly to its south.

Sakuteiki

Translation and Annotation

Translators' Notes

The following translation of the Sakuteiki is based on several texts but primarily on *Sakuteiki: Gendaigo Taiyaku to Kaisetsu* written by Takei Jirō, which contains three versions of the Sakuteiki: the text as it appears in the Edo-period *Gunsho Ruijū* edition; an amended text by Tamura Tsuyoshi that replaces some of the *kana* script in the *Gunsho Ruijū* edition with *kanji;* and a modern Japanese-language version that was translated by Professor Takei. After an intial translation using these sources, cross-references were made to three other versions of the Sakuteiki: an edition with original text and parallel modern Japanese by Mori Osamu; an edition with original text, parallel modern Japanese, and interpretations by Tamura Tsuyoshi; and an English-language edition by Shimoyama Shigemaru.

We have tried to be as faithful to the original language as possible, and yet, because of the great difference in the two languages and the even greater cultural gap between the eleventh and twentieth centuries, the translation has required some degree of interpretation. One result was that we decided to add chapter headings to the text, which are not in the original. The original text was subdivided only by use of the *kanji* representing the number one, pronounced *ichi,* which can be translated as "item." These divisions have been recorded in our English translation in the form of a ∽ which has been used to replace the original character. In order that the reader not be confused, however, the chapter headings that we have introduced have been marked in bold capital letters. The order of the text has not been changed at all. Although the author did not introduce chapter headings, there are groups of similar ideas placed together in the text. References to building waterfalls or islands, for instance, are grouped in the same place. Despite this conscientious grouping, from time to time a thought appears in the text completely unconnected to what comes before or after it. If these seem to be odd at times—such as a comment on riverbanks in with garden styles or a

note on *kanji* in with those about trees—that is simply the nature of the original Sakuteiki. The capitalization of certain nouns expresses that those terms are not generic but are translations of specific terms in the Sakuteiki such as Southern Court *(nantei)*, Breezeway *(suiwatadono)*, and Fishing Pavilion *(tsuridono)*.

SAKUTEIKI

~ *marks a point where the text of the original Sakuteiki was prefaced by the character* ichi, *meaning "item."*

I. Basics

When creating a garden,[1] first be aware of the basic concepts.

~ Select several places within the property according to the shape of the land and the ponds, and create a subtle atmosphere,[2] reflecting again and again on one's memories of wild nature.[3]

~ When creating a garden, let the exceptional work of past master gardeners be your guide. Heed the desires of the master of the house, yet heed as well one's own taste.[4]

1. "Creating a garden" is expressed as "setting stones," *ishi wo taten koto;* literally, the "act of setting stones upright." At the time the Sakuteiki was written, the placement of stones was perceived as the primary act of gardening. Similar expressions are also used in the text, however, to mean literally "setting garden stones" rather than "creating gardens," as in chapter four: "It is unusual to set large stones ..."
". .. *takaki ishi wo tatsuru koto mare naru beshi*" 高き石をたつることまれなるべし
2. "Create a subtle atmosphere" is *fuzei wo megurashite. Fuzei*, written with the characters for *wind* and *emotion*, is a term that appears often in the text, with various meanings such as "atmosphere" and "taste."
3. While in modern Japanese the word for "nature" is *shizen*, in the Sakuteiki the expression used is *senzui*, "mountain-water," or more accurately *shōtoku no senzui*, in which *shōtoku* means "natural constitution" or "innate disposition." *Senzui* is also used in the Sakuteiki to mean "garden," a usage that becomes more prevalent in Japan by the middle ages. It is interesting to note that during the mid-Heian period, *senzui* maintained the older, perhaps original, meaning of "nature."
4. Here again the word *fuzei* appears, in this case meaning "taste."

~ Visualize the famous landscapes[5] of our country and come to understand their most interesting points. Re-create the essence of those scenes in the garden, but do so interpretatively, not strictly.

In order to create the appropriate solemnity in a noble's residence, build mountains in the garden such as those seen in the *Gion Illustrated Text.*[6] At the place where the garden will be built, first study the land and devise a general plan. Based on that, dig out the shape of the pond, make some islands, and determine from what direction the water will enter the pond as well as from where it will exit.

II. Southern Courts

When designing the Southern Courts[7] of aristocratic residences,[8] the distance from the outer post of the central stair roof[9] to the edge of the pond should be eighteen to twenty-one meters. On the other hand, if there are to be imperial processions in the court, this distance should be increased to twenty-four or even twenty-seven meters. However, consider this: If the property is 120 meters square,[10] and the Southern Court is made to be twenty four or twenty-seven

5. Famous landscapes, *meisho,* were often used as models for garden design. For instance the maple-covered hills that line the Oi river in Arashiyama are mentioned as a model for gardening in *The Tale of Genji* ("Otome" "The Maiden"). The pine islands of Ōshū Shiogama 奥州塩竈, part of Matsushima Bay, Miyagi Prefecture, were used by the Minister of the Left, Minimoto no Tōru, as a model for his garden at the Rokujō Kawaranoin palace. Amasaki and Takei, *Teienshi wo Aruku,* 61.

6. The *Gion Illustrated Text, Qiyuan tujing* (Jp. *Gion Zukyō* 祇園図経) is a Buddhist text describing Jetavana, an ancient Indian monastery, written by the Tang-dynasty priest, Daoxuan (Jp. Dōsen 596-667). See Gion Shōja, p. 92.

7. The Southern Court, *nantei,* was a broad flat space created to the south of the Main Hall, the functions of which included entry court, playing field, and gathering place for formal ceremonies.

8. Aristocratic residences are known collectively as *shinden* residences. The *shinden* (literally "Sleeping Hall" but here translated as Main Hall) was the central building of the complex, and acted both as residence for the master of the household and hall for public functions. The entire architectural style called *shinden zukuri* derives its name from this one hall.

9. The Main Hall had at the center of its southern side a set of stairs called *hashi* that was used as a formal entry. Above the *hashi* was a small, curved roof known as a *hashi kakushi.* See figure 30, p. 154.

meters deep, what should the size and shape of the pond be? This must be carefully thought out. For shrines or temples, a depth of only twelve to fifteen meters should be sufficient.

∼ Regarding the placement of islands in the pond, first determine the overall size of the pond according to the conditions of the site. As a rule, if conditions will allow it, the side of the central island should be on axis with the center of the main residence."[11] On the back side of this island, a place for musicians[12] should be prepared, as large as twenty-one to twenty-four meters across.[13] The front of the island should remain plainly visible in front of the musicians' area and so, if there is not enough room on the central island, another island may be constructed behind it, and a plank deck constructed to connect the two. I have heard that because it is important to allow the island to show fully before the musicians' area, these temporary decks may be built when the central island is too small.

It is commonly considered to be improper if the underside of the curved bridge[14] can be seen from the seat of honor.[15] To amend this, many large or tall stones should be placed beneath the bridge.[16]

10. The size of a property that was awarded to a noble of the third rank or higher was one *chō* in size, or approximately 120 meters square. See footnote 16, p. 10, and the measurement chart on p. 227.

11. It is typical of Japanese gardens not to stress symmetry, as here where the islands are placed off-center. There is no mention, however, of whether to place the island to the east or west of center.

12. The musicians' area is called a *gaku ya*.

13. This wooden deck was known as a *kari ita jiki*, with *kari* meaning "temporary."

14. The arch shape of the curved bridge, *sori hashi*, served the purpose of allowing pleasure boats to pass under it and move freely about the pond. If the other bridges over the pond were flat, however, boaters would have a severely limited choice of direction. It appears the point of boating was not to circumnavigate the pond, but rather simply to be out on the water, floating, enjoying the garden from a new vantage point or providing a glorious vista for those of higher rank seated on the verandas of the buildings looking out into the garden.

15. The seat of honor is expressed as the *"hare* direction." *Hare* is written with the character for *clear weather* and refers to something that is formal, pure, or extraordinary. The opposite of *hare* is *ke*, which refers to something that is everyday or commonplace at best, and unclean or impure at worst.

16. It is common in Japanese gardens from the Muromachi period (1333-1568)

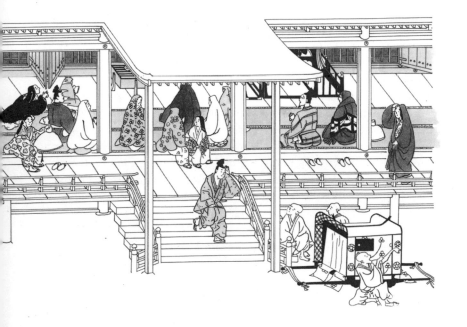

FIGURE 30: Central Stairs, *Hashi*

This scene is of Seiryōji temple in Saga (west of Kyoto); the robed women gathered in the hall are noblewomen who have become nuns *(nikō)* visiting from Kyoto. The architecture is similar to the *shinden* places of Heian-period aristocrats, including the set of stairs *(hashi)* in the center of the southern side of the Main Hall, which was used as a formal point of entry from the sand-covered court. According to the Sakuteiki, the two posts that held up the flared roof *(hashi kakushi)* over the stairs were to be used as reference points when positioning elements in the garden such as the curved bridge and islands in the pond. (Redrawn from *Kasuga Gongen Kenki Emaki*, Vol. 1 pp. 50-51)

The bridge should not align with the center of the central stair roof but rather should be placed off-center in the garden[17] so that the eastern post of the bridge aligns with the western post of the central stair roof.

The creation of mountain forms or Meadows[18] should follow the lay of the land and the shape of the pond. Breezeway posts should not be buried in the ground but rather should be cut short and set on large, rugged mountain stones.[19] The posts of the Fishing Pavilion should also be set upon large stones.[20]

III. Ponds and Islands

Since it is not possible to fill ponds with water before they are built, prior to the construction of a pond and its islands, a Water Level[21]

on to place stones at the four corners of a bridge in order to strengthen and stabilize it, both physically and aesthetically. The placement of stones to hide the underside of the *sort hashi* may reveal an early precedent.

17. As with the placement of islands, the instructions for placing bridges reveal a predilection toward asymmetry. By placing the bridge at an angle to the main residence, the curved line of the bridge surface would be shown to its best advantage.

18. Meadow scenes, called *no suji,* were created by building low earth berms in the garden and planting them with pampas grass, bushclover, and other low plants to evoke the image of a meadow. These meadow scenes were not broad and open, as the name implies; rather they were simply symbolic fragments that contained certain essential qualities found in meadows, for instance an undulating groundplane and grass cover.

19. Separate halls on an aristocrat's property were connected to one another by means of roofed, open corridors called *suiwatadono,* literally "transparent crossing hall," thus the translation "Breezeway." For an example of posts on rugged pedestal stones, see figure 10, pp. 54-55.

20. In its classic form, the layout of an aristocrat's residence included roofed pavilions that were built in the garden, sometimes overhanging the pond, and linked to the Main Hall by hallways called *chūmonrō,* so called because they contained *chūmon,* or middle gates. There are two names commonly associated with these buildings: the Fishing Pavilion *(tsuridono)* and the Wellspring Pavilion *(izumidono).* Although the *kanji* for *fishing* was used in the *Gunsho Ruijū* text, it is doubtful that the pavilion was actually used for that sport. Instead, the pavilions were most likely used for viewing the garden or the moon, for poetry writing, and for the launching of boats. Another explanation is that *tsuri,* also meaning "to hang or suspend," refers to the lightness of the pavilion.

21. The Water Level referred to here was called a *mizu bakari.* If it was like the one depicted in the fourteenth century scroll *Kasuga Gongen Kenki Emaki,* it comprised

must be set up. The surface of a pond should be twelve to fifteen centimeters beneath the bottom edge of the veranda of the Fishing Pavilion.[22] Stakes should be placed where a pond will be built and marked with this height. In this way one can determine exactly how much a given stone will be covered with water and how much will be exposed. The soil base underneath stones set in a pond must be reinforced with Foundation Stones. If this is done, even though many years might pass, the stones will not collapse and, moreover, even if the pond is drained of water, the stones will look as if they are well set.[23]

If an island in the pond is constructed to the exact shape that it is planned to be and then lined with stones along its edges, the stones will not hold when the pond is filled with water. It is better to dig out the shape of the pond in a more general way and then after setting stones on the island edge, gradually determine the shape of the islands.

The waters of the pond and Garden Streams should flow out of the garden to the southwest,[24] because the waters of the Blue Dragon should be made to flow in the direction of the White Tiger.[25] A horizontal stone should be set at the outflow of the pond, its top set twelve to fifteen centimeters below the bottom side of the Fishing Pavilion's veranda. When the pond is completely filled with water, the excess will flow out over this stone, thereby establishing the water level in the pond.

a low, flat table with sides a few centimeters high that could hold a shallow pool of water. The table would be set beneath a string that was drawn taut between two posts and then the string could be compared with the level surface of the water and adjusted until it too was level. See figure 31, p. 157.

22. Heian-period verandas, called *sunoko*, were narrow decks that wrapped around the outer edge of a building under the eaves. See figure 3, p. 16.

23. The stones in the pond at Tenryūji are a good example of such well-set stones. See figure 32, p. 158.

24. At times the Sakuteiki refers to directions by name—east, west, and so on—and at other times by the name of the associated animal or Guardian God. In this case, southwest is expressed as the Sheep/Monkey direction. See figure 12, p. 73.

25. The Blue Dragon is the eastern Guardian God while the White Tiger is that of the west. See Four Guardian Gods in Geomancy, p. 81.

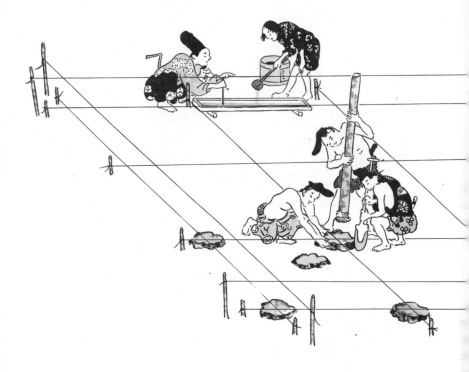

FIGURE 31: Garden Building Techniques

This scene depicts the construction of a palace called Chikurinden 竹林殿 but the materials, tools, and techniques used by the craftsmen are similar to those applied to garden contsruction as mentioned in the Sakuteiki. For instance, the trough being used to level the lines in the rear is a water level *(mizu bakari)*; the flat-topped angular stones are like those suggested as foundation stones for the veranda posts; the post being used to ram in the pedestal stone would have been used to firmly set the Foundation Stones of garden stones as well; and the shovel-like tool *(suki)* has an attenuated shape, which was suggested in the Sakuteiki as a model for pond edges and riverbanks. (Redrawn from *Kasuga Gongen Kenki Emaki,* Vol. 1 pp. 4-5)

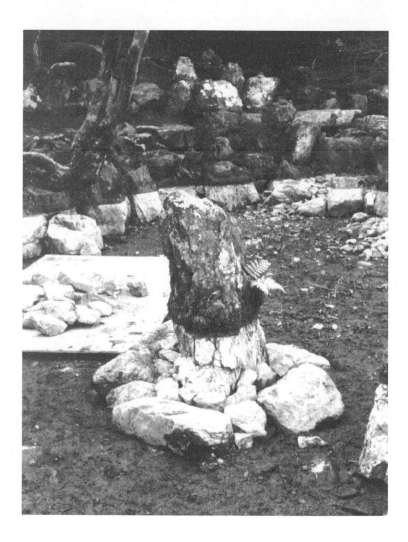

FIGURE 32: Foundation Stones

The Sakuteiki suggests that foundation stones for boulders in ponds should be placed so firmly that ". . . even if the pond is drained of water, (they) look as if they are well set." When the pond at Tenryūji (Kamakura period) was drained for repairs, the Foundation Stones *(tsume ishi)* seen here revealed just that construction technique.

IV. Stones

It is unusual to set large stones in places other than beside a water-fall, on the tip of an island, or in the vicinity of a hill. In particular, stones taller than ninety centimeters should not be set near any buildings. He who ignores this rule will not be able to hold onto his household; it will fall into disorder. Solitary Stones[26] are best set on a rocky shore, at the foot of a hill, or at the tip of an island. To form a foundation for a Solitary Stone set in water,[27] several large stones should be set deeply in a triangular pattern so that they are not visible above the water. After the Solitary Stone is set in the center of this triangle, other Foundation Stones should be firmly packed in around it.

～ There is also a way to create gardens without ponds or streams. This is called the Dry Garden Style[28] and should be created by setting stones along the base of a hill or with Meadows in the garden.

To create a garden scene that evokes the feeling of a mountain village, first build a high hill by the building, and then set stones from the top to bottom[29] in such a way as they appear as bedrock breaking the surface of the ground. The posts[30] of the building should be set directly on top of these stones.

26. Solitary Stones are referred to as *hanare ishi,* literally "separate stones."

27. This triangular form is termed *mitsu kanae,* a three-legged iron pot that was so well known it was used as an appellation for tripartite or triangular things. See figure 33, p. 161.

28. The Dry Garden Style was called *kara senzui* (literally, "dry mountain water"). At the time the Sakuteiki was written, the use of water was so prevalent that *kara senzui* simply referred to an area within the larger garden where water was not used. Although the word is written with the same characters, this is somewhat different from the *kare sansui* of the middle ages, which are sand and stone courtyard gardens built in Zen temples and residences of the warrior class. In these later gardens, designers re-created images of wild nature as depicted in ink landscape paintings.

29. In actuality this kind of stone-work should be built in reverse, bottom to top.

30. The posts referred to here are the short posts, *tsuka* or *tsuka bashira,* which support the veranda of a building.

Stones can also be set at the foot of small hills, by the base of a tree, or near the posts of a veranda, depending on one's own intuition. Care should be taken, however, when setting stones or planting plants in the court[31] since space must be left directly in front of the Main Hall stairs for people attending formal ceremonies.[32]

It is rare that all stones within a garden will be set upright; most will be set horizontally. Even so, one says *standing* stones, not *laying* stones."[33]

V. Gardening Styles

There are many styles of gardening: the Ocean Style, the Broad River Style, the Mountain Torrent Style, the Wetland Style, and the Reed Style among others.[34]

~ In order to make the Ocean Style, one must first re-create the image of a Rocky Shore. To do so, set stones as if they are heading out from the point of a wave-washed shore. Add many prominent stones with sharp edges at the shoreline, and a few Solitary Stones jutting out here and there. All these stones should appear dug out and exposed, as if they had been lashed by violent waves. To complete the scene, there should also be promontories of white sand[35] and plantings of trees, especially pines.

31. "Plants" are referred to as *senzai*. "Court" is *niwa*, which means "garden" nowadays but in the Sakuteiki referred exclusively to the flat, sand-covered area rather than to the planted pond-garden that lay adjacent. These courts were called *ting* (same written character) in the Chinese residences that were models for those in Japan.

32. During formal ceremonies, one was seated either within the *shinden*, on the *sunoko*, or on reed mats laid out on the ground in front of the stairs leading up to the Main Hall. The mats on the ground were called *kai ge no za*, "seats beneath (in front of) the stairs."

33. "Standing" is *tateru* and "laying" is *fuseru*.

34. "Style," *yō* 様, refers to a stylized design form that expresses some essential character of a natural scene without actually copying it. The various garden styles are: Ocean Style, *taikai no yō;* Broad River Style, *taiga no yō;* Mountain Torrent Style, *yama kawa no yō;* Wetland Style, *numa ike no yō;* Reed Style, *ashide no yō*.

35. The promontories of white sand are termed *sūsaki shirahama*.

FIGURE 33: *Mitsukanae*

Three-legged pots, called *mitsukanae*, were so well known during the Heian period that the name became a euphemism for anything in threes or set in triangles, such as the foundation stones for larger garden stones. The elaborate Chinese-style pot served as a model for the simpler clay pot, which was excavated on an archeological dig of a Heian-period residence. (Chinese-style redrawn from Kōjien; Japanese-style redrawn from Kyōtoshi Maizō Bunkazai Kenkyūsho pamphlet)

~ The Broad River Style of garden should be made like a path left in grass by a snake or dragon slithering through. The first thing to do when making this Style of garden is to set a Main Stone—an august stone with clean edges—where the headwater of the river will be. The other river stones should be set in relation to the request of this one stone.[36] There are Secret Teachings regarding this.[37]

Regarding the placement of the subordinate river stones, remember that flowing water will erode whatever is in its path, and neither the mountainside nor the riverbank can endure its effects. As water flows and strikes against these stones, the stream will be forced to twist, bend, and flow with greater strength. One should try to grasp the spirit of what is to follow downstream and design various scenes so that the atmosphere of the stream gradually changes along the way. The number of stones set in the river, as well as the distance between them,[38] will depend on the nature of the environment and one's own artistic feelings.

Water flows more rapidly through narrow channels; where the river broadens it will relent. At this point a sandbar[39] should be created. A Middle Stone[40] should be set at the head of such a sandbar, and if such a stone is set, there is all the more reason to create a sandbar downstream from it.

~ The Mountain Torrent Style requires the use of many stones,

36. The expression "request of the stone," *ishi no kowan*, implies that the stone itself has a will and desire. See explanation, p. 4.

37. Gardening knowledge was primarily passed on from person to person orally—a tradition that continues to this day. The Secret Teachings, *kuden*, mentioned time and again in the text, refer to a deeper knowledge that an "apprentice" received directly from his "master" in order to fully understand any topic.

38. "The number of stones set in the river, as well as the distance between them" is described with the elegantly succinct expression *en kin ta shō*, or "far near, many few."

39. Sandbar, *shirasu*, is written with characters that mean "white sandbar," implying that these sandbars were made of white sand rather than ordinary brown sand.

40. The Middle Stone, *naka ishi*, is set in the stream forcing the water to flow around it on both sides. This would naturally cause sand to accumulate on the downstream side of the stone, a hint that the author of the Sakuteiki was well studied in the nature of flowing water.

scattered randomly.[41] Stones may be set in the flowing water, caus-
ing the stream to divide around them, and more on the banks near-
by, dug in and sunken. These methods of creating Broad Rivers and
Mountain Torrents can also be used to make Garden Streams,[42] yet
for Garden Streams, it is best to use stones so big that even just one
is difficult to carry in one or even two carts.

Stones are rarely used in designing the Wetland Style; rather, in a
little inlet, one should plant some water plants such as reeds and
irises.[43] There is no need for an island, and only a glimpse of water
should appear between the plants. In the Wetland Style, water from
a small channel should gather in one place, and the point where
water runs in and out of the Wetland should not be clearly revealed.
Water should simply appear from some hidden, unseen origin, and
the surface of the water should appear high and full.

～ In the Reed Style,[44] hill-forms should not be too high. A few
stones should be set along the edge of Meadows or on the water's
edge; next to those, some grass-like plants such as grass bamboo or
tall field grasses[45] should be planted. Plums, willows, or other such
trees with soft and gentle forms can also be planted according to
one's taste. Among these plantings, some flat-shaped stones should
be set in the shape of piled boxes;[46] those stones in turn should be
accented with low plantings.

41. Today, this kind of garden river design is referred to as *sawa tobi*.

42. Garden Stream, with capital letters, is used to refer to a *yarimizu* specifically
rather than generically any garden stream. *Yarimizu* were meandering streams, more
like those found in meadows than in steep mountains.

43. Reeds are *ashi* and *katsumi*. Irises are *ayame* and *kakitsubata*.

44. The Reed Style, *ashide no yō*, is literally "Reed-hand Style," although "hand"
could also be translated as "technique." *Ashide* was the name given to a type of paint-
ing/poem that was prevalent in the Heian period. See figure 7 and text, pp. 28-29.

45. Grass bamboo is *kozasa*. Field grasses are *yamasuge*, which could be one of three
plants: a wild variety of *suge*, a kind of light reed harvested to make raincoats and umbrel-
las; *masuge*, a finer variety of the same plant; or a kind of orchid now called *yaburan*.

46. Setting stones in the shape of piled boxes is described in the text as making the
stones look like the character *shina* 品, which means "articles" or "goods." Of course
this character itself looks like boxes piled on top of one another, but the stones were
not actually set this way. Instead, the technique required that three stones be set in

There are many styles of gardening, but that does not mean that only one should be used to the exclusion of other styles. In fact, within any one garden—in accordance with the shape of the pond and the general conditions of the site—it would be best to use a combination of styles. For instance, where the pond is broad, or along the edges of an island, the Ocean Style should be considered, while Meadows should be treated with the Reed Style. One should follow one's intuition on these matters. It is amusing to see ignorant people attempt to critique a garden according to a certain style.

The forms of pond edges and riverbanks should recall the attenuated shapes of spades, halberds, and helmet crests.[47] A sandbar along the banks of a pond or riverbank should be made pointed like the tip of a spade, or indented like the elongated crest of a warrior's helmet. To create this kind of scene, stones should be set slightly away from the water's edge. The inspiration for how stones are to be set around a pond should come from the ocean, and so the beach must contain deeply set stones that are made to look like exposed outcroppings of a ledge repelling the ocean waves.

VI. Islands

Styles of Islands

The styles are Mountain Isle, Meadow Isle, Forest Isle, Rocky Shore Isle, Cloud Type, Mist Type, Cove Beach Type, Slender Stream, Tide Land, Pine Bark, and so on.[48]

To create a Mountain Isle, one should build hills in the middle of the

a simple triangle, one taller stone in the center with two other, lower stones set to its right and left.

47. Several terms are used to evoke the image of elongated shapes: Spades/plows *(suki)*, dagger tip or halberd tip *(hokosaki)*, halberds *(hoko)*, mattocks/hoes *(kuwa)*, and helmet crests *(kuwa gata)*.

48. Mountain Isle *(yama jima)*, Meadow Isle *(no jima)*, Forest Isle *(mori jima)*, Rocky Shore Isle *(iso jima)*, Cloud Type *(kumo gata)*, Mist Type *(kasumi gata)*, Cove Beach Type *(suhama gata)*, Slender Stream *(kata nagare)*, Tide Land *(hi gata)*, Pine Bark *(matsu kawa)*.

pond, alternating high peaks with low, and then plant them all heavily with evergreen trees. On the front part of the island build a white sand beach, and set stones at the foot of the hills and by the water's edge.

～ To make a Meadow Isle, build several low earth-berms traversing back and forth, and set some stones here and there so that just their tops are visible above the ground. Plant autumnal grasses and, in the remaining open areas, plant moss and such. In this style too, there should be a white beach in the foreground.

～ The Forest Isle is simply flat land with trees planted here and there. The lower branches should be thinned out if it all seems too dense. Some stones should be set around the base of the trees. Some grass should be planted and then spread with sand.[49]

～ The Rocky Shore Isle is made by setting tall stones here and there. Following the request of the stones, set them out on the shoreline roughly, boldly, and plant pine trees in between them. The trees need not be too tall, but they should be old, splendid in form, and laden with deep green needles.

～ The Cloud island should appear as a trailing wisp of cloud blown by the wind. No stones, no plants—just a white sandy beach is all that is needed.

～ The Mist island, when seen from across the pond, should appear as trailing mist in a light green sky, in two and three layers, fine, indefinite, here and there disconnected. Again, no stones, no trees. Only a white sandy beach.

～ The Cove Beach[50] island is a standard form. However, the design

49. It is still customary in Japan to plant grass as small patches of sod with wide joints between the patches and then spread fine sand over the whole. The general warmth and wetness of the country, especially in the region around Kyōto where the Sakuteiki was written, make sand a better planting medium than loam soil.

50. Cove Beach, *suhama*, refers to a shoreline that contains a series of deeply indented coves. This classic undulating pattern is also the basis for many designs other

should not be overly rigid like a formal indigo pattern.[51] Within the Pebble Beach Style there are elongated types, bent types, and even back-to-back types. These should be made to look somewhat like a Pebble Beach and yet must also be somehow unique. To complete the scene, spread sand and plant a few pine trees.

~ The Slender Stream Style island should not be overly designed but rather should appear as a slim islet left remaining within the flow of the stream.

~ The Tide Land Style should appear like a beach at ebb tide, half exposed above water and half below, so that the beach stones are partly visible above the water. No plants are needed.

~ The Pine Bark Style, just like a pine-bark print, should be grooved, appearing fragmented—and yet not be so.[52] Whether stones or plants should be placed is up to the individual designer.

VII. Waterfalls

~ Ways to Make Waterfalls

First, one must choose the Waterfall Stone.[53] A smooth stone that appears to have been cut is uninteresting. If the waterfall is 90 to 120 centimeters tall, then it should be made of mountain stones with rough surfaces. Even though it is said that the surface of the Waterfall Stone should be rough, more importantly, it must fit well with the Bracketing Stones.[54] So, first set a Waterfall Stone with a good surface, one that seems as if it will harmonize with the Bracketing

than gardens including fabric design, the shape of trays, wedding ornaments, and so on. See figure 34, pp. 170-171.

51. Exactly what this formal indigo pattern, *kon no mon*, may have been is unclear.

52. The Pine Bark Style does not refer to actual pine bark but rather to a woodblock print pattern called "pine-bark print," *matsu kawa zuri*. The bark of old pine trees is rough and gnarled, producing a pattern like that on the shell of a tortoise, broken into small, repeating sections, yet continuing endlessly.

53. The Waterfall Stone, *mizu ochi no ishi*, is the upright stone in the central portion of the waterfall over which, and in front of which, water was caused to fall.

Stones. Then pack soil in and around the base of the stone so that it will not budge so much as a speck, and finally reinforce it with well-fitted Bracketing Stones. After all this, pack all the gaps between the stones with clay and then again with a mixture of soil and gravel.[55] One should strictly adhere to these steps when making a waterfall.

Next, if the main point of view is from the right side, set a good-looking stone of reasonable height above the left Bracketing Stone; above the right-hand Bracketing Stone, set a shorter stone that will show the stone on the left side to its best advantage. If the main viewpoint is from the left side, then the opposite holds true.

In the area above the waterfall set some flat stones. One should not set these stones as if they were just riprap on a stream bank. Yet do not determine their placement too formally; just make certain that the water does not escape sideways. There should be only a few stones in the middle of the stream that show slightly above the water surface.

Finally, in front of both Bracketing Stones, set complementary stones of about half the height of the Bracketing Stones, and then, further downstream, place some more stones in accordance with the request of the stones already set. In front of the waterfall, the stream should widen and be scattered with stones that split the running water right and left. Beyond this point the water should be made to flow like a Garden Stream.

Since there are many different ways in which water can be made to fall, this is best left to the tastes of the individual. If it is preferred that the water fall freely away from the surface of the Waterfall Stone, then a stone with a clean, sharp corner should be chosen and

54. Bracketing Stones, *waki ishi*, are set on both sides of a Waterfall Stone to lend it physical as well as visual support.

55. If the original is read *ishi maze ni tada no tsuchi wo mo irete*, the meaning can be construed as "mixing *(maze)* gravel with ordinary soil," referred to these days as *kirikomi jari*. If, instead, it is read *ishi mase ni tada no tsuchi wo mo irete*, as some scholars claim, the translation would be "put ordinary soil between the cracks *(mase)* of the stones."

set leaning slightly forward.[56] On the other hand, if a waterfall with water running down the surface of a stone[57] is preferred, then a stone with a rounded corner should be selected and set with a slight backward lean. At times this type of waterfall can look like fine threads spilling over into the air. In addition, if one sets two or three stones in front of the main Waterfall Stone, gradually stepping down and away from it, then the water will splash left and right as it falls.

It may be impossible to build a tall waterfall within the precincts of the capital except in the case of the Imperial palace grounds.[58] It has been said that Ichijō street and the rings at the top of the pagoda at Tōji temple are the same height.[59] If so, then if one draws water from a wellspring and carefully brings it through the garden in a trench with a shallow pitch, it should be possible to make a waterfall 1.2 or even 1.5 meters in height.

The width of a waterfall and its height are not necessarily related. If one looks at waterfalls as they appear in nature, tall waterfalls are not always wide and low ones are not necessarily narrow. The width of the waterfall is dependent only on the width of the Waterfall Stone; however, waterfalls that are 0.9 to 1.2 meters in height should not exceed 60 centimeters in width. Waterfalls that are both low and broad have a number of problems. One is that the waterfall tends to look overly low. Another is that the waterfall can be mistaken for a

56. Water falling away from the surface of the Waterfall Stone is known as *hanare-ochi*, or "separated" fall.

57. Water running down the surface of the Waterfall Stone is called *tsutai ochi*, "guided" fall.

58. The palace grounds were particularly large. This would allow for a greater difference between the ground level at the water source and at the place where the waterfall was to be built.

59. In the valley within which the Heian capital was built, the land falls gently from north to south. According to Kyoto City's planning maps, Ichijō street (at Kawabata St.), which was the very northern edge of Heian capital, is 50.6 meters above sea level while the ground at the base of the pagoda at Tōji, which was at the very southern edge of Heiankyō, is at 22.6 meters above sea level; a difference of 28 meters. The pagoda itself is actually 57 meters in height, so the author of the Sakuteiki was off by half. The distance from Ichijō street to Tōji's pagoda is about 5200 meters, so the average slope across the Heian capital was approximately two percent.

dam. Lastly, low waterfalls reveal the source of the water flow[60] behind them and consequently lack depth and appear insignificant.

On the other hand, waterfalls appear graceful when they flow out unexpectedly from narrow crevices between stones half-hidden in shadows. At the source of the waterfall, just above the Waterfall Stone, some well-chosen stones should be placed so that, when seen from afar, the water will appear to be flowing out from the crevices of those boulders, creating a splendid effect.

~ Regarding the Types of Waterfalls

The types of waterfalls are: Twin Fall, Off-Sided Fall, Sliding Fall, Leaping Fall, Side-Facing Fall, Cloth Fall, Thread Fall, Stepped Fall, Right and Left Fall, Sideways Fall.[61]

~ The Twin Fall has double streams that match each other beautifully.

The Off-Sided Fall has water flowing over it somewhat to the right. In front and slightly to the left of the Waterfall Stone, set a stone with a well-shaped top that is about half the height and width of the Waterfall Stone. Water falling over the Waterfall Stone will hit this stone and splash off to the right in a white spray.

The Sliding Fall has water slipping right down the surface of the Waterfall Stone.

The Leaping Fall is made with a sharp-cornered Waterfall Stone. Water running to it from above is not allowed to slow down before falling, forcing it to leap away from the surface of the Waterfall Stone.

60. The "source of the water flow"—the stream that feeds the waterfall from above—is referred to as the "throat" of the waterfall, *taki no nodo.*

61. Twin Fall, *mukai ochi;* Off-Sided Fall, *kata ochi;* Sliding Fall, *tsutai ochi;* Leaping Fall, *hanare ochi;* Side-Facing Fall, *soba ochi;* Cloth Fall, *nuno ochi;* Thread Fall, *ito ochi;* Stepped Fall, *kasane ochi;* Right and Left Fall, *sa yū ochi;* Sideways Fall, *yoko ochi.*

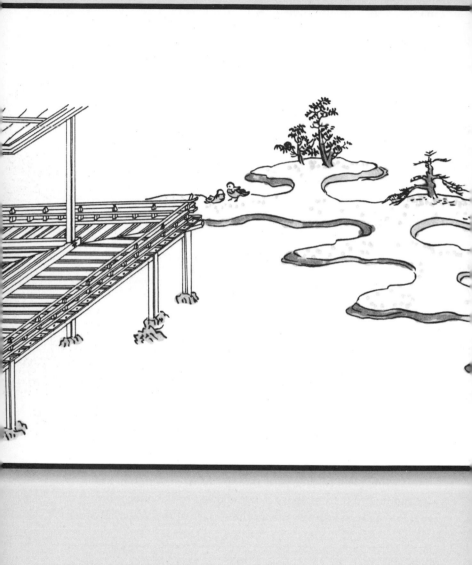

FIGURE 34: Cove Beach, *Suhama*

In this scene from the *Sumiyoshi Monogatari*, the hero has come to the ocean shore at Sumiyoshi (near present-day Osaka) to seek his lover who has run away. The pines *(matsu)* in the background create a pun on his "waiting" (also *matsu);* the ducks, which mate for life, are an image of fidelity. The convoluted, sandy shoreline, formed by constant battering by wind and waves, and the tortured pines that grew along such shores, were the images used to create *suhama* in Heian-period gardens.

The Side-Facing Fall has a Waterfall Stone the front of which is set facing slightly off to one side, allowing the side of the fall to be seen from the front.[62]

The Cloth Fall employs a Waterfall Stone that has a smooth surface. If the water running to the waterfall is allowed to pool before it cascades, it will flow slowly down the face of the Waterfall Stone and appear as a cloth hung out to dry in the sun.

The Thread Fall is made with a Waterfall Stone that has a saw-toothed corner at the top. This will cause the flowing water to split into many fine lines, appearing like a cascade of threads hanging off a spool.

The Stepped Fall is made with two sets of waterfall stones, one above the other, allowing the water to fall naturally in two or three steps.

It has been said there are many ways to make a waterfall, but no matter what, they should always face the moon, so that the falling water will reflect the moonlight. There are Secret Teachings about building waterfalls and many things written in Chinese texts.

Fudō Myōō has vowed that "all waterfalls over 90 centimeters in height are expressions of my self."[63] Needless to say, those of 1.2 meters, 1.5 meters, 3.0 meters or even 6.0 meters are also symbolic of Fudō. All waterfalls are surely expressions of a Buddhist Trinity: the two flanking stones, to the right and left of the dominant stone, probably represent the Buddha's attendants.[64]

According to the *Rituals of Fudō:* "Those who see my form, aspire to enlightenment. Those who hear my name, reject evil and master vir-

62. Here again, the "front" or main viewing angle is referred to as the *hare* direction. See footnote 15, p. 153.

63. Fudō Myōō is a Buddhist deity who, as an incarnation of Dainichi Nyorai, works to purge the world of evil. See Fudō Myōō, p. 99.

64. The Buddhist Trinity is *sanzon bosatsu* and Buddha's attendants are called Nidōji, Two Attendants. See explanation, p. 104.

tue," and so forth. Thus the name Fudō, The Unmovable. In order to behold my form it is not necessary to know the form of Shōkoku Dōji.[65] Always be aware of waterfalls, for although Fudō Myōō takes many forms, the most fundamental of all these are waterfalls.

VIII. Garden Streams

Regarding Garden Streams

∼ First the direction of the stream source must be determined. According to the scriptures[66] the proper route for water to flow is from east to south and then toward the west. Flowing from west to east is considered a reverse flow, thus a flow from east to west is standard practice. In addition, bringing water out from the east, causing it to flow under one of the residence halls, and then sending it off to the southwest is considered the most felicitous. This is because the waters from the Blue Dragon will wash all manner of evil off to the Great Path of the White Tiger. The master of a household who does this will avoid sickness and tumors, be of sound health, and lead a long and happy life.

When one is trying to select a site with correct geomantic conditions,[67] remember that the place on the left side where water runs

65. Unlike the Nidōji mentioned in the previous footnote, Shōkoku Dōji [Blue/Black Dōji], probably refers to Fudō himself. See explanation, p. 105.

66. The word "scriptures" in this section refers to the *Sishu wujing, Four Books/Five Classics* (Jp. *Shisho Gokyō*; 四書五経). The Four Books are *Lunyu* (Jp. *Rongo* 論語) *Analects; Zhongyong* (Jp. *Chūyō* 中庸) *Doctrine of the Mean; Mengzi* (Jp. *Mōshi* 孟子) *Mencius;* and *Daxue* (Jp. *Daigaku* 大学) *Great Learning.* The Five Classics are *Yijing* (Jp. *Ekikyō* 易経), commonly known by the old Wade-Giles rendering, *I Ching) Book of Changes; Shijing* (Jp. *Shikyō* 詩経) *Book of Odes; Shujing* (Jp. *Shokyō* 書経) *Book of History; Chunqiu* (Jp. *Shunjū* 春秋) *Spring and Autumn Annals;* and *Liji* (Jp. *Raiki* 礼記) *Book of Rites.* Many of these have been translated by James Legge in his series *The Chinese Classics.*

67. "Geomantic conditions" is expressed as the proper arrangement of the four guardian gods *(shijin sōō).* In the year AD 793, Emperor Kammu sent an expedition to survey the area now known as Kyoto, then called *yama shiro no kuni,* in hopes of finding a felicitous location for a new capital. The report of the survey team included the phrase *shijin sōō,* or the "four guardian gods are in balance."

from[68] is called the Land of the Blue Dragon. Similarly, water should run from the east of the Main Hall or outer buildings, then turn south and finally flow out to the west. In the case of water that flows from the north, the stream should first be brought around to the east and then caused to flow to the southwest.

According to the scriptures, the inner curve of the Garden Stream is considered to be the belly of the dragon, and it is considered felicitous to build one's home there. Conversely, the outside of the curve—the dragon's back—is considered to be unlucky. There is also a theory of sending water from north to south because north is the Water direction while south is that of Fire.[69] In other words one should send *Yin* in the direction of *Yang,* and thus by facing the two forces against each other, create a state of harmony. Considered in this way, the notion of sending water directly from north to south is not without merit indeed.

The idea of water running to the east comes from the Well of the Turtle, Kame-i, at Tennōji temple. According to the records of the Great Master,[70] the Spirit Waters guarded by the Blue Dragon run to the east. If this is true, then the eastward direction of a reverse flow would also be felicitous. When the Master of Buddhist Law was searching for a felicitous place on Mount Kōya, an old man appeared to him.[71] The Master asked the old man if he knew of a place in the area that would be good for building a temple. The old man answered, "Right in the middle of my lands there is a special place, shrouded in purple mist by day. In the evening there is a Goyō

68. "Left side" in this case means "east," revealing the fact that the Sakuteiki was written (and Heian-period gardens were designed) with a south-facing frame of reference.

69. Fire in the north and Water in the south is a relationship defined under the Later Heaven Circle. See geomantic chart, figure 11, p. 68.

70. The Great Master, *Taishi,* refers to Shōtoku Taishi (574—622) who, as regent for Empress Suiko (r. 593-628), was responsible for initiating formal relations with the Sui Dynasty of China and introducing to Japan many political reforms based on Chinese models.

71. The master of Buddhist Law, Buppō Taishi, refers to Kūkai (774—835), the founder of the Shingon sect, also known as Kōbō Daishi. The old man who appeared to him was in fact Nifu Daimyōjin, the resident god of the mountain.

pine[72] that emits a mysterious light, and all the water there runs to the east. A place fit for a castle if there ever was."

In fact, the idea that all water should run to the east stems from the concept of the Eastern Flow of Buddhism.[73] If this is true, it follows that such noble places are not appropriate for mere residences.

It has been said that when making a garden, deep spiritual concentration is required. Earth is lord, water servant.[74] If earth permits it, water will flow, but if earth prevents it, it will not. Seen another way, mountain is lord and water the servant, while stones are the lord's counsellors. Water thus flows in accordance with the nature of the mountain. However, if the mountain is weak, it will be destroyed by water without fail, like a servant opposing a lord. The mountain is weak where there are no stones to lend it support, just as the lord is weak when he lacks supporters. Therefore, the mountain is complete when it contains stones, even as the lord rules by the support of his servants. This is why stones are imperative when making a garden.

〜 With regard to the slope of a waterway and the manner in which water will be made to flow, a fall of nine millimeters over thirty centimeters, nine centimeters over three meters, or ninety centimeters over thirty meters will make for a murmuring stream that flows without stopping.[75] At the end of such a stream, where the land turns flat, the water will be pushed by the force of the incoming stream above it and continue to flow forward. Since the slope of the stream is difficult to perceive while it is under construction, place a length of bamboo that has been split in half lengthways on the ground and fill it with water in order to determine the slope of the ground. Building a home without having performed these studies

72. The Goyō pine is called a Japanese white pine.

73. Buddhism, beginning in the Indus Valley, spread increasingly to the East; first to China, then the Korean peninsula, and finally Japan. The concept of the Eastern Flow of Buddhism, *buppō tōzen*, professes this easterly flow to be holy.

74. According to the Five Phase Control Theory, "Earth conquers Water." See Theory of Five Phases, p. 76.

75. All of these proportions define a 3 percent pitch.

is the act of an unrefined man. In the case of property that has a natural water source in a high place there is little need to consider such matters, making such places ideal for garden building.

No matter which direction the source of the water is in, a stream should not be made to appear contrived, but rather it should flow this way and that, from the edge of one hill to the edge of another. Dig the water channel in such a way as to create a stream that flows in a captivating manner.

Garden Streams that enter Southern Courts flow most commonly out from under the Breezeway then turn to the west. Similarly, streams are often constructed in order to flow from beneath the Northern Annex Hall, between the Twin Halls,[76] then under the Breezeway before passing in front of the Middle Gate and entering the pond.

Regarding stones in the Garden Stream, stones should not all be set in a similar manner and crammed together. The same can be said for stones placed in a stream where it flows out from under the Breezeway, turns about the bluff of a hill, enters the pond, or flows back upon itself sharply. In any of these places, first set one stone. Any other stones set there, without regard to their number, should be set according to the request of this first stone.

The first place to set a stone in the Garden Stream is where the flow bends sharply. In nature, water bends because there is a stone in the way that the stream cannot destroy. Where the water flows out of a bend, it flows with great force. As it runs diagonally, consider where the water would strike an obstacle most powerfully, and at that point set a Turning Stone.[77] The same should follow for stones set downstream as well. Other stones should be set without affectation or pretense in the places that require them. In most cases, if too

76. Twin Halls, *nitōya* (two-ridge hall), probably refers to two halls set together, such as those that linked the Main Hall with the Northern Annex Hall.

77. The Turning Stone, *meguri ishi,* owing to its shape and placement, causes the stream to bend around it and change direction.

many stones are set at the point where a stream curves, although it may appear acceptable when seen up close, from a distance it simply appears as if there are too many stones. It is uncommon to see these stones up close, so preference should be given to how they are seen from a distance.

The types of stones to set in a Garden Stream are Bottom Stones, Water-Splitting Stones, Foundation Stones, Crosswise Stones, and Spillway Stones.[78] All of these must be set deeply into the riverbed.

Crosswise Stones are those that are set diagonally in the water. They should be long, and somewhat rounded. It is most attractive when water flows around both ends of the stone and more so if the water is caused to fall evenly over the whole surface of the stone.

The style of Garden Stream called Valley Stream is one where the water runs full force from between the narrow confines of two hills. Where water flows over stones in the stream, if it falls off to the left side of stone, then next it should be made to fall to the right. The flow of water should alternate this way and that, left and right, splashing white froth as it goes. Where the stream widens, there should be a Middle Stone that is somewhat tall, and, on both sides of that, Crosswise Stones should be placed, forcing the stream to flow quickly about the upright Middle Stone. If another stone is placed in the midst of this accelerated stream, then the water will foam white as it passes over it, making for a most pleasing sight.

~ According to one explanation, it does not matter whether the source of a Garden Stream is from the east, north, or west; if there is an Annex Hall,[79] then the stream should flow beneath it before

78. All of these stones were set in streams so that they were completely or partially submerged, the purpose being to affect the flow of the water, to create effects as found in a natural stream (except for the Foundation Stones, which were used to support larger stones). Bottom Stones, *soko ishi;* Water-Splitting Stones, *mizukiri ishi;* Foundation Stones, *tsume ishi;* Crosswise Stones, *yoko ishi;* Spillway Stones, *mizukoshi no ishi.*

79. For an explanation of Annex Halls, *tai no ya,* see Structure of Shinden Residences, p. 10.

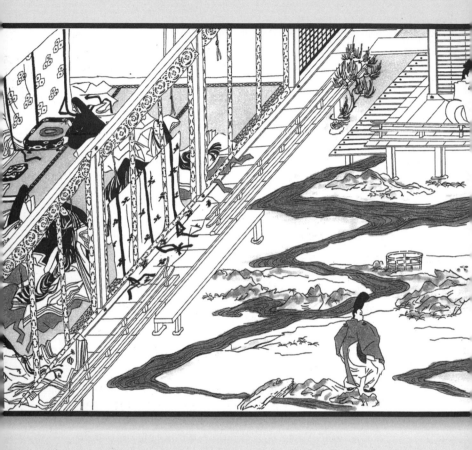

FIGURE 35: Life at Red Plum Villa

The scene is at the Red Plum Villa (Kōbaidono 紅梅殿), residence of
Sugawara no Michizane (845-903). Michizane was a leading political
and cultural figure of his time but fell prey to the machinations of the
powerful Fujiwara family and was exiled to Kyushu where he died. We
find him here (inside the room, upper right) bemoaning his sad fate
while courtiers sympathize: men in the garden, women behind curtains
in the Northern Annex. A red plum tree litters the ground and veranda

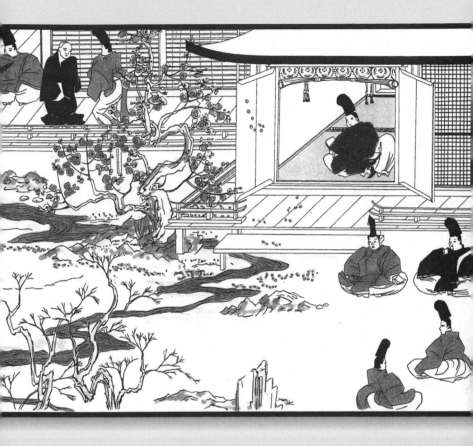

with its blossoms, the evanescence of which reflects Michizane's life, and the Garden Stream *(yarimizu)* splits in two, as if at a crossroads. The hummocked treatment of the ground plane reflects what the Sakuteiki refers to as a Meadow *(no suji)*. (Redrawn from *Kitano Tenjin Engi Emaki*, pp. 16-17)

continuing out to the Southern Court. Similarly, water that runs out from below the Twin Halls, under the Breezeway, and then into the garden pond is typically made to flow in front of the Middle Gate. In the case where there is no garden pond, but only a Garden Stream, Meadow scenes should be built in the Southern Court and used as the theme for the design of the garden.

Even in a flat garden, with neither hills nor Meadows, it is appropriate to set stones. However, a stream in a garden with no pond should be made considerably wide and the ground plane kept quite flat, allowing the gently burbling water to be easily seen from the halls nearby.

The Meadow scenes in the vicinity of a Garden Stream should not be planted with plants that will grow thick and full. Rather, plants like Chinese bellflower, patrinia, burnet, and plantain lily should be planted.

In the areas where the Garden Stream runs shallow, if a stone with a sharply toothed surface and wide bottom is placed crosswise in the flow, and another stone set facing this is placed just downstream, then water that flows over the top of the second stone should turn white with foam.

The width of the Garden Stream should be determined by considering the overall size of the garden and the volume of water expected to flow through the stream. Sixty centimeters, ninety centimeters, 1.2 meters, and 1.5 meters are all possible widths. If the garden is particularly broad, and water runs plentifully, then a width of 1.8 meters or 2.1 meters should be considered.

IX. Setting Stones

Secret Teachings on Setting Stones

~ When setting stones, first bring a number of different stones, both large and small, to the garden site and temporarily set them out on the ground. Set those that will be standing stones with their

"heads" upright, and those that will be reclining stones with their best side facing out.[80] Compare the various qualities of the stones and, keeping the overall garden plan in mind, pull the stones into place one by one.

Choose a particularly splendid stone and set it as the Main Stone.[81] Then, following the request of the first stone, set others accordingly.

Choose one with a well-balanced head[82] and then set other stones in front of this in succession, culminating in the Fore Stone.[83] If a stone that does not have a well-balanced head is chosen, set it so that it shows its best side. Do not be concerned if it leans a little.

For a stone that will descend from the shoreline to the depths of the pond, or ascend from the depths out to meet the shore, a majestic stone of grand proportions is best. If this is to be constructed, then gather stones of the same color, the shapes of which seem like they will fit each other well, and set them to together so that they make one huge, composite form.

Set a splendid stone that will balance well with the Bracketing Stones and Fore Stone when they are set, and then set the Rear Stone following the request of the first stone set.[84]

80. Standing stones, *tatsu beki ishi,* are those that will be set upright; reclining stones, *fusu beki ishi,* are those that will be placed horizontally. The upper portion of the stone is referred to as the head, *kashira;* the best side of the stone, set facing forward, is called *omote.*

81. The splendid nature of the Main Stone, *onto ishi,* is expressed as "having corners," *kado aru.* Stones with clean angular lines or crenulated surfaces with many "corners" were considered desirable.

82. Nowadays, in order to create visual stability when setting a Main Stone, gardeners in Kyoto often level the top of the stone, *tenba wo dasu.* Perhaps the "balanced head" here is referring to the same technique.

83. The Fore Stone, *mae ishi,* is a low stone placed directly in front of an arrangement of stones.

84. The Bracketing Stones, *waki ishi,* frame the Main Stone slightly forward to the right and left, adding visual (and at times physical) stability to the whole arrangement, while the Rear Stone, *oku ishi,* is set behind and slightly higher than the Main Stone to lend depth.

Anonymous Secret Teachings

The stones of steep mountain cliffs rise in the angular manner of folding screens, open shutters, or staircases.[85]

The stones at the base of a mountain or those of a rolling meadow are like a pack of dogs at rest, wild pigs running chaotically, or calves frolicking with their mothers. As a rule of thumb, when setting stones, if one pair "flees" from the group, then seven or eight should "chase" after them, like children playing tag.[86]

It is considered common sense that Buddhist Trinity arrangements shall be made with standing stones while arrangements in the "shape of piled boxes" shall use horizontal stones.[87]

Retaining stones should be amply set in places where hillsides have been deeply cut away. In areas that will abut an expanse of lawn, such as the boundary where a hillside meets the flat courtyard, or the edges of the lawn itself, set some low stones, scattered this way and that, some upright and some laid flat.

There are many names of stone groupings, including Multilayered shape, Crown Shape, Writing Desk shape, Bucket Type, and so on.[88]

85. The shutters, *to*, of Heian buildings were wooden panels, solid or lattice-work. While the lower portion was completely removable, the upper half could be swung open on hinges at the top and held out from the building at an angle. The screens, shutters, and stairs are all images of staggered, angular progression.

86. In gardening terminology today there is an expression "tossed stones," *sute ishi,* referring to random stones that are set here and there near a formal arrangement of stones or next to a stepping stone path. The *sute ishi* diffuse the overall design of a cluster of stones allowing them to meld with their surroundings. The "fleeing" stones, and those "chasing" them, are of the same nature. In the Heian-period game of tag *tochō tochō hihikume,* one child tries to catch the others who are protected by another child who is the leader of their group.

87. Today, Buddhist Trinity stone arrangements are termed either horizontal *(yoko san-zon)* or vertical *(tate sanzon)* depending on whether they employ tall, upright stones or lower, horizontally broad stones. For an explanation of "piled boxes" see footnote 46, p. 163.

88. Multilayered shape, *kiri kasane;* Crown Shape, *kaburi gata;* Writing Desk Shape, *tsukue gata;* Bucket Type (fitted together like the boards of a bucket), *oke sue.*

If there are stones that "flee," then there should be stones that "chase" after; if there are stones that lean, then there should be those that lend support; if some proceed then others should acquiesce; if some face up, then others should face down; and to balance with stones that stand upright there should also be those that recline.[89]

Stones must be set powerfully, which means that the "roots" of the stone must be set deeply.[90] However, even if a stone is deeply set, if it is not balanced with the Fore Stone, then it will appear weak. Even a stone set too shallowly will appear strong if it is well balanced with a Fore Stone. There is a Secret Teaching about this.

When setting a stone, soil must be packed in all around the bottom of the stone so that there is not room for so much as a speck of dust left. If the soil is compacted only around the perimeter of the stone then the soil will run away when it rains, leaving empty pockets beneath the stone. Use a slim pole and ram the soil bit by bit from the bottom up.

X. Taboos

Regarding the placement of stones there are many taboos. If so much as one of these taboos is violated,[91] the master of the household will fall ill and eventually die, and his land will fall into desolation and become the abode of devils.

The taboos are as follows:

∼ Using a stone that once stood upright in a reclining manner or using a reclining stone as a standing stone. If this is done, that stone will definitely become a Phantom Stone[92] and be cursed.

89. This balance of mutual opposites is reminiscent of (and most likely inspired by) *Yin Yang* theory.

90. The "root" of the stone is that portion which is buried beneath the soil. Gardeners these days refer to burying a stone deeply as "killing" the stone, *ishi wo korosu.*

91. "To violate a taboo" in the Sakuteiki is expressed as *kinki wo okasu.*

92. A Phantom Stone, *reiseki* (literally, "spirit stone"), implies that the stone becomes inhabited by an evil spirit.

Figure 36: Construction Methods

These men are excavating a well, but the work could as easily be garden construction: carrying in stones by hand; digging with shovels *(suki)* and hoes *(kuwa);* hauling soil in a straw-mat container; and leveling the ground with a scraping tool. This scroll was painted in the mid-thirteenth century, but the construction techniques do not differ greatly from those that would have been used at the time of the Sakuteiki. (Redrawn from *Taima Mandala Engi*, pp. 12-13)

～ Taking a flat stone that once was reclining and standing it upright to face toward the residence. Whether it is set in a high or low place, far or near, it will make no difference. This will result in a curse.

～ A stone that is 1.2 to 1.5 meters tall should not be placed in the northeasterly direction. This will become a Phantom Stone, and, since it would become a landmark to aid the entry of evil spirits, people will not be able to live there for long. However, if a Buddhist Trinity is placed in the southwest, there will be no curse, neither will devils be able to enter.[93]

～ Do not set a stone that is higher than the veranda in the immediate vicinity of the house. If this rule is not obeyed, troubles will follow one after the other, and the master of the household will not live for long. However, temples and shrines are exempt from this rule.

～ Do not arrange a Buddhist Trinity so that it faces directly toward the main residence. Have it face slightly to the side. Violating this taboo is terribly unlucky.

～ Do not set a stone so that it falls directly in line with the columns of the buildings. Violate this taboo and even one's descendants will suffer, evil occurrences will abound, and all one's wealth and possessions will be lost.

～ If a large stone is set in a reclining position so that it faces to the west or north near the veranda of a house, the master of the household will surely die within a season. In general, one should be extremely careful about setting large stones horizontally in the vicinity of the house or the master will not be able to live there for long.

93. Directions are perceived radially from the center of a building, in this case most likely the main hall, *shinden*. The northeast direction is known as the Front Devil's Gate, *omote kimon*, while the southwest is the Rear Devil's Gate, *ura kimon*. Both of these are associated with the flow of evil spirits. See explanation, p. 114. This passage reveals the admixture of geomancy and Buddhism that was prevalent at the time; the sensitivity toward magnetic directions is derived from the former and the Buddhist Trinity Stone arrangement from the latter.

~ Do not set a stone by the southwest column of the house. If this taboo is violated, the household will be unceasingly plagued by disease.

~ Do not build a hill in the southwest quadrant of the garden. However, if a path is constructed over the hill, then it will prove no hindrance. The problem with a hill is that it will become an obstacle to the Great Path of the White Tiger, so building a hill that closes off paths to that direction is an offense.

~ When building hills, the valleys between them should not face directly toward the house for it is said that it is unlucky for women of the house to be faced with a valley.[94] Also, do not face a valley toward the front façade of a house; rather, turn it slightly to the side.

~ Do not face reclining stones to the northwest. Those who violate this taboo will not be able to hold on to their wealth, servants, or livestock. Also, do not build a water channel out toward the northwest. Since it is said that fortune lies within the home,[95] do not let it flow out with the water.

~ Do not set stones where rainwater will drip off a roof onto them. Anyone hit by rainwater splashed off such a stone will develop terrible sores. This is because rainwater that runs off cypress bark contains poison.[96] It has been said that men lumbering in cypress forests have many sores on their feet.

~ Do not set a white stone that is bigger than those around it in

94. The valley was undoubtedly perceived to be evocative of a vulva and thus somehow disruptive to women.

95. Although the expression *fukutoku konai naru* translates literally as "fortune lies within the home," it may be that the intended meaning is "fortune lies within that direction." In *The Tale of Genji* ("Otome"), we find a passage mentioning the northwest as the storehouse area, *mikura machi*, where all the wealth of the household was held in safekeeping. Abe et al., *Nihon Koten Bungaku Zenshū* (14), 73.

96. The bark of the cypress tree *(hinoki)*, like most conifers, will leech an acidic effluent when wet. The dripline under roofs covered with cypress bark *(biwada buki)* may turn red from this effluent, but a few drops would hardly cause sores.

the easterly direction or harm will come to the master of the house. Likewise, in all other directions, be careful not to set stones that are of "controlling" colors nor ones that are larger than the other stones there.[97] Doing so is considered unlucky.

~ Regarding the use of famous landscapes as models for gardening, if a landscape is in ruins, then it should not be used. Reproducing such a desolate place in front of a home would lead to all sorts of troubles.

Hirotaka[98] has said the setting of stones should not be done thoughtlessly.[99] There are many taboos with regard to setting stones. Violate just one of them, it is said, and something terrible will befall the master of the house, and his household, too, will not continue for long.

When a stone from the mountains or riverbeds is set in the manner of deities, it will become a Demon Stone.[100] There are many cases throughout the country of trouble stemming from doing this. Surely people will not be able to live for long in such a place. However, if a stone has been carried over many mountains and rivers, there will be no curse.

~ If a Phantom Stone tumbles down from its perch high on a cliff, it will invariably settle in the most natural manner. This kind of stone, however, should not be set in a garden, but rather it should be discarded. Also, do not set a stone that is more than 1.5 meters tall in the northeast, as this will allow devils to enter from the devil's gate.

97. The expression "controlling colors," *kokusuru iro*, literally "victorious" or "triumphant color," derives from the Five Phase Control Theory which associates colors, directions, and Phases. See Theory of Five Phases, p. 76.

98. Kose no Hirotaka, artist and garden designer, who lived during the late tenth and early eleventh centuries, was a descendant of Kose no Kanaoka, founder of the Kose school of painting. Kanaoka is also reputed to have been involved with the design of the imperial garden, Shinsen'en.

99. ". . . should not be done thoughtlessly . . ." (*kōryō* 荒涼) can also be translated as "set in a way that evokes a desolation or dreariness."

100. Demon Stone is *ishi garni*, which literally means "stone god" but implies an evil or disruptive god.

XI. Miscellany

∼ Rocky shores are interesting to look at, but, since they eventually fall into desolation, they should not be used as models for gardening.[101]

∼ Regarding the placement of islands, if an island is built as a hill, it will break up the view of the horizon line of the water. In fact, the horizon is best glimpsed just slightly through the gaps between the hills.[102]

∼ Do not build one hill directly on top of another because two overlapping hills evoke the image of the written character for "curse."[103]

Water will take the shape of any vessel that it is put into and, according to that shape, become good or bad. For that reason, the shape of the pond must be given proper consideration.

∼ It has been said that waterfalls should not be built in the shade of trees in the mountains, but this is not true. A waterfall that is seen splashing out from the darkness of the trees is truly fascinating, as is often seen in old gardens. Man cannot live in the depths of the mountains; however, a little waterfall could be built near a mountain hut with some trees planted around it and present no problems. The opinion that trees should not be planted near waterfalls is entirely without merit.

∼ According to a man of the Sung Dynasty,[104] stones taken from mountains or riverbanks have in fact tumbled down to the base of a

101. In the beginning of the Sakuteiki, Rocky Shores, *ara iso,* are suggested as a model for garden design; now we find a passage suggesting *not* to use them as a gardening motif. This is seen as possible evidence that there was more than one author to the text.

102. This technique of "dividing the view" is a way to make a pond in a small garden look as large as possible.

103. The word for "mountain," *yama,* is written 山 and the word for "curse," *tatari,* is written 祟. Note that, *tatari* contains at the top two radicals of the character for "mountain," one piled on top of the other.

104. The Sung dynasty (AD 960-1279) of China overlaps the Heian period (AD 794-1185) of Japan. Official relations between Japan and China ended in 894, and it

mountain or valley floor from above, and in doing so the head and base of the stone have become reversed. Some are upright while others lie flat. Still, over time they will change color and become overgrown with moss. This weathering is not the work of man. Because the stones have weathered naturally, they can be set or laid in the garden as they are found in nature without impediment.

~ Ponds should be constructed in the shape of a tortoise or a crane[105] since water will take on the shape of the vessel it enters. Ponds may also be made in the shape of felicitous words written in *kana* script.[106]

~ The best ponds are shallow. When a pond is deep, fish become too big and big fish cause problems for people.

~ If the pond is continually inhabited by waterfowl, then the master of the house will know peace and happiness.[107]

~ The place where water flows out of a pond should be in the southwest so that the waters of the Blue Dragon will head off to the Great Path of the White Tiger and carry away with them all manner of evil spirits. The pond must be kept clean by regular dredging.

~ Water must not be allowed to flow in or out of the property in the northwest direction. This is in order to preserve the good fortune that is within the property.[108]

is unclear whether this "man of Sung" is a literary reference, a visitor from China, or member of a Chinese family resident within the Heian capital.

105. The tortoise and crane are associated with longevity, a tradition that stems from the Chinese legend of the mystical mountain/isle, Hōrai, an archipelago populated by immortal beings. The immortals flew from isle to isle on the backs of cranes which were reputed to live for one thousand years; the isles themselves were borne on the backs of immense tortoises which had lifespans of ten thousand years; therefore, the images of tortoises and cranes became linked with those of long life.

106. Since water is life, if water takes on the shape of a felicitous character, life itself will become felicitous.

107. That a pond would be continually inhabited by waterfowl reveals that it has an inherent natural balance which, it was believed, would reflect well on the people who lived in that environment.

108. See footnote 95, p. 187.

~ The flow of water should come from the east, pass beneath the buildings, turn to the southwest, and thus wash away all manner of evil. In other words, this is using the waters of the Blue Dragon to wash out all evil to the Great Path of the White Tiger. It is said that no one living in such a place will be afflicted by malediction or tumors.

~ It is not unusual to set a reclining stone without a companion standing stone. A standing stone, however, should have Attendant Stones on either side and a reclining stone as a Fore Stone. Incidentally, setting stones scattered one by one, like stars on a helmet, is terribly strange.[109]

~ It is said that in old gardens, when there was a stone that caused evil of its own accord, if stones of a controlling color were intermingled nearby, the evil would stop. Likewise, it is suggested to set a Buddhist Trinity, set somewhat apart and facing the offending stone.

~ In particular, one should refrain from setting stones over the height of ninety centimeters near the eaves of a building or else within three years something bad will happen to the master of the house. In addition, one must certainly refrain from setting stones upside-down.

Even at the Tōhokuin Palace, among the garden stones set by the priest Renchū, has not a taboo been violated?[110]

A certain person once said that man-made gardens can never exceed the beauty of nature. Travel throughout the country and one is certain to find a place of special beauty. However, there will surely also be several places nearby that hold no interest whatsoever. When people make gardens they should study only the best scenes

109. Warriors' helmets, *kabuto*, developed during the mid-Heian period along with body armor in general. The classic form of helmet was studded with protruding rivets known as "stars," *hoshi*.

110. Renchū was a garden-building priest, *ishitatesō*, although not much else is clear about him. Tōhokuin was a building in the northeast corner of Kyōgokudono. Kinsaku Nakane, *Niwa: Meitei no Kansho to Sakutei* (Ōsaka: Hoikisha, 1984), 221.

as models. There is no need to include extraneous things.

What is recorded in this text regarding gardens is what I have heard over the years, recorded without my own opinion of what is good or bad. The priest En'en Ajari received the knowledge of garden making through direct teachings."[111] I, in turn, am able to pass on what was written. Even after studying all these matters related to gardens, I have found that the spirit of the garden is inexhaustible. I feel my quest incomplete in many ways. In fact, there is no one these days who understands these things.[112]

To make a garden by studying nature exclusively, without any knowledge of various taboos, is reckless. With the building of the palace, Kayanoin, there was no one proficient in gardening, just people who thought they might be of some help. In the end, displeased with the results, Lord Uji took the task of designing the garden upon himself.[113] I often visited the site at that time and was able to observe and study. It was said at that time that a man who finds, and makes a gift of, good garden stones is a loyal man, so we found many people, from the nobles of the day on down, going to nearby mountains in search of stones.

XII. Trees

～ Regarding Trees

One should plant trees in the four cardinal directions from the residence and thereby evoke the presence of the Four Guardian Gods—

111. Direct teachings, *sōden*, means passing on knowledge orally directly from master to apprentice, a common practice in esoteric religions.

112. The section from "What is written here regarding gardens . . ." until ". . . no one these days who understands these things," reads like a concluding statement. Combined with some contradictions in material presented before and after this point, this suggests that what is written hereafter may be the work of a second author.

113. Lord Uji is another name for Fujiwara no Yorimichi, imperial regent and father to Tachibana no Toshitsuna. Yorimichi owned a splendid country house in Uji, south of Kyoto, thus his nickname.

so it is written. The flow of water to the east of the house is the Blue Dragon. If there is no water there, then plant nine willow trees instead.[114] The Great Path to the West is the White Tiger. If there is no Great Path, then plant seven catalpas in its place. The pond to the south is the Scarlet Bird. If there is no pond, then plant nine katsura trees there. The hill to the north is the Black Tortoise. If there is no hill there, then plant three cypress trees.[115] Those who follow these rules will create places encompassed by the Four Guardian Gods and be blessed by ascending careers, personal wealth, good health, and long lives.

Trees express the solemnity of man and Buddha. For this reason, when Kodoku Chōja, the wealthy merchant, decided to build the splendid monastery Gion Shōja with the intent of giving it to Śākyamuni as a gift, he was troubled when placing a value on the trees. At the suggestion of Gida Taishi, Kodoku Chōja gathered up his gold and spread it evenly across the entire garden and, having bought the garden for the price of that gold, he presented it to Śākyamuni. Gida said, "It is not right for me to accept money for these trees" [and so he donated all the gold toward the building of the monastery]. For this reason that place is called Giju-gikkodoku-on, "Kodoku's garden made with Gida's trees."[116]

At the time when the first emperor of the Qin dynasty was burning books and persecuting Confucianists, he chose to spare only those books regarding seeds and plants.[117] When the Buddha preached

114. The Chinese-derived pronunciation of the word *willow, ryūi,* is the same as the pronunciation of the word *dragon,* the god that guards the Eastern quadrant. None of the other three plant names, however, is a homonym with the direction it is related to.

115. Some texts interpret this tree not as cypress *(hinoki)* but rather as sandalwood *(byakushin)* which, like cypress, is a conifer.

116. For a full explanation of the story of the Gion Shōja monastery see p. 92.

117. Around 212 BC, in response to Confucianists who criticized his policies, Qin Shi Huandi (Jp. Jinshi Kōtei 秦始皇帝), the first emperor of the Qin dynasty, ordered the burning of all books in the land with the exception of those having to do with functional topics like agriculture and divination. In addition, those found hiding books were buried alive as punishment. This persecution is known in Japanese as *funsho kōju* 焚書坑儒; literally "Burn Books, Bury Confucianists."

Figure 37: Willow Gate

The Sakuteiki mentions that willows should only be planted at the gates of people who are high-ranking in society. This house belongs to Fujiwara no Toshimori who we partially see within the house. An aristocrat in charge of the residence of the retired empress, Toshimori's own residence would suitably have had a willow-gate. It would seem, however, by the condition of the wall and roof, that a willow by the gate was not assurance of continued success. In following scenes of

the same scroll, Toshimori makes pilgrimages to Kasuga shrine, and his fortunes rebound as was presaged by the willow and cherry in this scene, brimming with new life. Two scenes later we see this same courtyard fully rebuilt and bustling with visitors but oddly, no cherry or willow. (Redrawn from *Kasuga Gongen Kenki Emaki*, Vol. 1 pp. 29-30)

his faith, and when the gods of Japan descend from heaven, they both choose places with trees. Likewise, the houses of men should be the same.[118]

Regarding trees, other than the directions of the Four Guardian Gods—the Blue Dragon, White Tiger, Scarlet Bird, and the Black Tortoise—there are no restrictions on placement of plantings. However, according to Men of Old, it is best to plant trees that flower in the east and those that produce pleasing fall colors in the west.[119] If there is a pond, then plant pines and willows on the island, and by the Fishing Pavilion, plant trees such as mountain maples that will offer pleasant, cool shade in summer. Pagoda trees should be planted in the vicinity of the gate. The custom of planting pagoda trees by the gates of the Ministers of State, and calling them Pagoda-tree Gates, is to illustrate the closeness of the Ministers to the people of the land and thus encourage the people to support the Emperor.[120] I wonder if there is a special reason why some people plant willows before their gates. It must be done only for those who are the leaders of their time. Although this need not be maintained as a strict rule, surely planting a willow by the gate of one who is unworthy would be shameful.[121]

118. Shakamuni, the historical Buddha, is said to have reached his enlightenment while sitting under a bo tree *(Ficus religiosa)* and, afterward, to have preached his philosophies while sitting in the shade of trees. In the case of Japan, of the myriad gods, many are said to inhabit the heavens or mountaintops. When they descend to earth they are believed to choose particular spots within nature collectively called *yorishiro.* Included among these are sacred boulders *(iwakura),* sacred ponds *(kami ike),* and sacred trees *(shinboku).*

119. Since the characters for *fall color* and *maple* are one and the same, this passage may refer to either. An Edo-period gardening text, *Tsukiyama teizō den,* advises readers to plant ornamental trees *(keiyō boku)* such as cherries in the east, and trees such as maples that will offer shade against strong afternoon light, as well as look good in the reddish evening glow *(sekiyō boku),* in the west. This is an example of a gardening tradition being passed down from the Heian period (if not before) to the modern age.

120. The custom of lords planting pagoda trees by their gates is most likely derived from a wordplay that links the Chinese pronunciation of the tree name, *kai,* with the verb for "being close to" or "take to one's bosom" *(kai* or *natsukashimu* 懐*),* the feeling that the lord was expected to have for his people.

121. As mentioned in footnote 114, the words *willow* and *dragon* can be homonyms. As such, *willow gate* and *dragon gate* are also homonyms. In ancient China,

Planting a *sakaki* in the direction one usually faces should be avoided.[122]

Planting a tree so that it lies directly on axis with the center of a gate should be avoided as this will form the character for *idle* or *neglectful*.[123] Likewise, if a tree is planted in the immediate center of a square-shaped property, the master of the house will be eternally troubled, as that will form the character for *trouble*.[124] Likewise, if one builds a residence in the center of a square-shaped property, the master of the house will surely be incarcerated, as that will form the character for *imprison*.[125] Even matters such as these should be given proper consideration.

XIII. Wellsprings

Regarding Wellsprings

A wellspring is always desirable in a residence, as it offers best relief in hot weather. For this reason, the Chinese of the Tang dynasty always built wellsprings at their homes, at times evoking the form of the mystic mountain, Hōrai, or causing water to flow from the mouths of sculpted animals. Likewise, in India when Sudatta Chōja built the garden Gion Shōja,[126] Kenrō Jishin[127] was called upon to construct a wellspring. This is what is known as the Sweet Spring.

Dragon Gate was a term that referred to the strict tests required to become a government official. Passing the test was tantamount to becoming socially elite. It may be for this reason that planting a willow by one's gate, and thereby evoking the sound-image of Dragon Gate, was unacceptable for those below a certain status.

122. For an explanation of *sakaki* and directions see p. 116.

123. The character for *gate* is 門, while that for *tree* is 木. The character for *idle*, 閑 *kan*, depicts a tree inside, or directly in line with, a gate.

124. The character for *trouble*, 困 *komaru*, depicts a tree 木 in the center of a square.

125. The character for *person*, in this case the master of the house, is 人. The character for *imprison* or *capture*, 囚 *toraeru*, depicts a person in the center of a square.

126. Sudatta Chōja, also known as Gikkodoku, was a wealthly merchant in ancient India. Gion Shōja was the monastery he built for Śākyamuni. See Gion Shōja in Buddhism, p. 92.

127. Kenrō Jishin (Skr. Prthivī), the Earth Goddess, is also known as Kenrō Jiten or simply Jiten; one of the twelve *devas, ten,* tutelary gods of Esoteric Buddhism.

In our own country, when Emperor Shōmu built the great temple Tōdai-ji, Komibu Myōjin dug a wellspring there, known as the Akai wellspring of the temple Kensaku-in.[128] Examples beyond these are too plentiful to mention.

If there is a wellspring that gives forth cool water on the site, it is common to build a roof over it, set a large pipe into it to encourage the flow of water, and to also build a small, slatted deck in front of it where the water will spill.[129] If the place where the water bubbles forth is inappropriate, then amend this by digging a trench to bring the water to where the wellspring is needed. If it is unsuitable to have the water run in an exposed trench, then insert a box-shaped culvert in the trench. Have a small pipe come out of this box at the point where the water will flow forth. If the source of the water is higher than the place where the wellspring will be, set the beginning of the water pipe as high as possible and let the water flow down gradually, connecting a mid-sized pipe to the top of that arrangement. The height of the outflow pipe need be only three centimeters lower than the source to create a flow. If one wishes to make a water channel last a long time, then it should be covered with a stone lid. Well-fired ceramic tiles will serve just as well.

If a man-made wellspring is to be used to feed a well, then construct a large water tank on a high pedestal next to the well. Beneath this build a box pipe, as mentioned before, and connect the bottom of the tank to the top of the box-pipe with a bamboo pipe, thereby feeding water from the tank into the pipe. Water will be caused to gush out from the well; a vision of coolness.

128. Kensakuin (built 753), which lies northeast of the Main hall of Tōdaiji in Nara, is also known as Nigatsudo, Second Month Hall, because of an important esoteric Buddhist ritual held there annually in the second month (now March). Part of that ritual is the well-known Omizutori, during which ritually blessed water *(kozui* 香水*)* is used to purify practitioners. Of the Akai wellspring, *Aka* (Skr. *argha; arghya)* means an offering made to an honored guests or to a Buddhist deity and *i* means 'wellspring.'

129. The "open deck" mentioned here (like the outer veranda of a *shinden* building, also called a *sunoko)* was a slatted, wooden deck that would let water run through.

The technique for keeping water from leaking from the sides and bottom of a wellspring is as follows. First, the wooden well-box should be built so that there are no gaps at the joints, and then it should be buried about thirty centimeters deep in the ground.[130] As for the part that is buried, there will be no problems if the joints are well constructed. Dig out the base and line the hole twelve to fourteen centimeters thick with high-quality clay that has been mixed with water and well kneaded. On top of that, take flat stones and push them into the clay, leaving no joints between them. Dry until hard, then layer more flat stones the size of small plates on top, finishing with a top-dress of small black and white pebbles.

According to another explanation, a wellspring should not be dug out at all, but rather a pipe should be set on top of the ground to drain off every drop of water.

Water will turn foul, start to smell, and breed insects within one or two days of being drawn. It is common practice to regularly change the water as well as to thoroughly clean the stones and pipe at the bottom of the wellspring and, if necessary, add new water. Even if the wellspring pipe is made to rise above the ground, wooden boards should be set down to its base and clay should be applied here, as mentioned before. Dig out the soil from around the wellspring pipe as well as from the outside of the boards that form the well itself and firmly tamp clay in around them.

One explanation suggests that a slatted deck should be placed so that it protrudes slightly over the wooden box that forms the well. Another explanation holds that the well should be made wide enough so that the deck can extend sixty to ninety centimeters out over it, somewhat like the veranda of the Fishing Pavilion. If this is done, the darkness below the deck will create a feeling of mystery as one descends to the wellspring. Above all, heed the conditions of the site and the taste of the owner. If the wellspring is on higher

130. See figure 5, p. 22.

ground than the residence, simply dig down to the source of the water, connect a water pipe to the water source below, and the water will never cease to flow.

XIV. More Miscellany

~ Miscellaneous Items

The residences of the Chinese always include splendid buildings called *rōkaku*. Of course multistory pavilions, *kōrō*, are included in this group. In general, buildings with short eaves are called *rō* while those with deep eaves are known as *kaku*. *Rō* are used for moon viewing while *kaku* are enjoyed for their coolness. Buildings with deep eaves are cool in summer and warm in winter.

FINAL SIGNATURES
(At the end of the *Gunsho Ruijū* text)

Reproduced from a scroll.

The preceding volume is the personal work of Gokyōgokudono, and has been reproduced without so much as a single mistake.

The preceding work, Sakuteiki, was reproduced from a book held by Hyaka Ansōgo, and although there were many questions regarding grammar and letters, it has been copied without mistake.

(At the end of the Tanimura scroll)

On the 27th day of the 6th month, in 1289, bored with the world, I read through this.

An Old Fool

This volume is the property of Gokyogokudono. Precious—it must be secret, it must be secret.[131]

131. We do not know who the person is who calls himself An Old Fool, *Gu Rō*. Since the second signatory, Gokyogokudono, is referred to by the honorific appellation *dono* we can surmise that he did not sign the volume himself, but rather that it was signed by a scribe at his request.

Sakuteiki
APPENDICES

GLOSSARY

Regarding the Japanese characters, if there are two entries, the first is the word as found in the *Gunsho Ruijū* text (or other historical texts) and the second, in brackets [], is the modern Japanese equivalent. If there is only one entry, the word is the same in both cases or has no modern equivalent. (Jp.), (Ch.), and (Skr.) refer to Japanese, Chinese, and Sanskrit words, respectively. Alternative pronunciations are marked with "alt."

A

akunoya	performance tent: 幄屋
Annex Hall	see *tai no ya*
ara iso	a gardening style evoking the image of rough, wind-swept ocean beaches, lined with rough boulders: 荒磯
ara iso no oki	synonymous with *ara iso:* 荒磯の沖
ashide no yō	a garden style with undulating shorelines planted with soft grasses; based on the painting style of the same name: 蘆手のやう [葦手の様]
Attendant Stones	see *waki ishi*

B

Black Tortoise	see *genbu*
Blue Dragon	see *seiryū*
bodhisattva (Skr)	a deity destined to become a Buddha, who seeks enlightenment for others as well: Jp. *bosatsu* 菩薩
bonkei	a miniature landscape arrangement created on a tray: 盆景
bosatsu	see *bodhisattva*
Bottom Stones	see *soko ishi*
Bracketing Stones	see *waki ishi*
Breezeway	see *suiwatadono*

Broad River Style	see *taiga no yō*
Bucket Type	see *oke sue*
Buddhist Trinity	see *sanzon butsu*
Buddhist Trinity Stones	see *sanzon butsu no ishi*
buppō tōzen	a theory that ascribes a sacredness to the general eastward spread of Buddhism from the Indus Valley through Asia to Japan: 佛法東漸
byakko	White Tiger; westerly of the Four Guardian Gods: 白虎

C

central stair roof	see *hashi kakushi*
central stairs	see *hashi*
Changan	Capital city of the Tang dynasty: Jp. Chōan 長安
Chinese music	see *tōgaku*
Chinese pavilion	see *rōkaku*
chō	Measurement of land approximately 120 meters square; the typical size of a high-ranking aristocrat's property: 町
chūmon	Middle Gate; a gateway in the *chūmonrō* dividing the entry court from the southern court: 中門
chūmonro	Middle Gate Corridor; an open corridor that led southward into the garden connecting Annex Halls with garden arbors such as the Wellspring Pavilion or Fishing Pavilion: 中門廊
Circuit Gods	see *yūgyōjin*
Cloth Fall	see *nuno ochi*
Cloud Type (isle)	see *kumo gata*
cockfight	see *tori awase*
court kickball	see *kemari*

Cove Beach	see *suhama*
Cove Beach Type (isle)	see *suhama gata*
Crosswise Stones	see *yoko ishi*
curved bridge	see *sort hashi*

D

dagger/halberd tip	see *hokosaki*
Deep-eaved pavilion	see *kaku*
Demon Stone	see *ishi garni*
direction switch	see *kata tagae*
direct teaching	see *sōden*
domin	serfs; landless workers on aristocratic estates: 土民
doyō	four subseasons described as existing between the four standard seasons: 土用
Dry Garden Style	see *kara senzui*

E

Eastern Flow of Buddhism	see *buppō tōzen*
eto	a shortened pronunciation of *jikkan jūnishi,* see those entries separately: 干支

F

famous landscapes	see *meisho*
Fishing Pavilion	see *tsuridono*
Five Phase Control Theory	see *gogyō sōkoku setsu*
Five Phase Creation Theory	see *gogyō sōshō setsu*
Five Phases	see *gogyō*
Fore Stone	see *mae ishi*
Forest Isle	see *mori jima*
Foundation Stones	see *tsume ishi*
Four Guardian Gods	see *shijin*
Fudō Giki	*Rituals of Fudō:* a Buddhist text describing

	religious rituals related to the deity Fudō Myōō: 不動儀軌
Fudō Myōō	a Buddhist deity corresponding to the Indian deity Acalanātha; in Japan, Fudō is believed to be a manifestation of Dainichi Nyorai; associated with waterfalls in the Sakuteiki: 不動明王
fuseru	to recline; to set (stones) horizontally: 臥
Fushimi Shuri no Daibu	Chief of Maintenance and Construction for Imperial Properties in Fushimi; a position awarded Tachibana no Toshitsuna: 伏見修理大夫
fuzei	atmosphere or taste: 風情

G

gaku ya	musicians' area; a leveled area or stage built on a pond island to accommodate musical performances: 楽屋
Garden Stream	see *yarimizu*
gekisu bune	a boat used to carry musicians with a prow carved as a mythical bird's head: 鷁首船
genbu	Black Tortoise; northerly of the Four Guardian Gods: 玄武
Geomancy	an ancient means of divination; see *Yin Yang, Yi, Gogyō*
Giju-gikkodoku-on	the garden Kodoku made with Gida's trees; Skr. Jetavana: 祇樹給孤獨薗 [祇樹給孤独]
Gion Illustrated Text	see *Qiyuan tijing*
Gion Shōja	a monastery built at the garden of Prince Gida: Skr. Jetavana-vihāra: 祇園精舎
gogyō	Five Phases; a geomantic theory based on five basic elements or phases: wood, fire, earth, metal, and water: 五行
gogyō sōkoku setsu	Five Phase Control Theory; the phases in the order of control; i.e., wood, earth, water, fire, metal, wood: 五行相克説

gogyō sōshō setsu	Five Phase Creation Theory; the phases in order of creation; i.e., wood, fire, earth, metal, water, wood: 五行相生説

H

halberd	see *hoko*
hanare ishi	Solitary Stones; stones set apart from others; literally, "separate stones": はなれ石 [離れ石]
hanare ochi	Leaping Fall; a type of waterfall where the stream falls away freely from the face of the Waterfall Stone: 離落 [離れ落]
hando zōsaku	a taboo against earthwork; literally, "earth-violating works": 犯土造作. *Hando* can also be pronounced *tsuchi*
hare	forward facing, formal, or place of honor: 晴 [晴れ]
hashi	the central, formal stairway leading up from the Southern Court to the Main Hall: 階
hashi kakushi	a light roof that covered the central, formal stairway *(hashi):* 階隠
He Tu (Ch)	River Diagram; an ancient diagram of Chinese divination icons: Jp. *kato,* 河図
helmet crest	see *kuwa gata*
hexagram	see *taiseike*
hi gata	Tide Land (isle): 干潟
hisashi	the sections of the *shinden* hall that surround the central core rooms *(moya):* 廂、庇
hoko	halberd; attenuated shape used as a model for pond edges and riverbanks: 鉾
hokosaki	a dagger/halberd tip; attenuated shape used as a model for pond edges and riverbanks: 鋒
honzo	the place of origin during a direction switch *(kata tagae);* usually one's main residence: 本所 alt. *honjo*

I

ike	pond; often the central feature of a garden, punctuated by islands; built partly for displaying festive boats: 池
imi	see *mono imi*
ishi garni	Demon Stone; literally "Stone God"; a garden stone that causes evil: 石神
ishi no kowan	"request" of the stone; a term revealing the animistic mentality of Heian-period gardeners who believed garden stones had "desires" regarding the way they should be used: 石のこはん [石の乞わん]
ishitatesō	Buddhist priests who also designed and/or built gardens; literally, "stone standing priests": 石立僧
ishi wo taten koto	gardening; the act of making a garden is described in the Sakuteiki as "setting stones," showing the central importance of stone work to gardening: 石をたてん事
island	see *shima*
iso jima	Rocky Shore Isle: 磯嶋 [磯島]
ito ochi	Thread Fall; a waterfall in which water falls in narrow, thread-like rivulets: 絲落 [糸落]
iwakura	a sacred boulder used as a place at which to make prayers to the gods: 磐座
izumidono	Wellspring Pavilion; one of the typical names for a garden arbor, used for moon watching and poetry reading, and as a launching point for pleasure boats: 泉殿

J

jikkan	Ten Stems; a divination system based on the Five Phases combined with *Yin* and *Yang:* 干支
Jōdo	Pure Land; a paradisiacal land, situated in the west, presided over by Amida Buddha: 浄土 formally Amida Buddha's Western

	Paradise Pure Land (Amida Nyorai no Saihō Gokuraku Jōdo) 阿弥陀仏西方極楽浄土
Jōdo teien	Pure Land garden; a gardening style that seeks to re-create through symbolization the Pure Land of Amida Buddha: 浄土庭園
jūnishi	Twelve Branches; a divination system that applies animal names to twelve magnetic directions: 十二支

K

kaburi gata	Crown Shape; a type of stone grouping: かぶりがた [かぶり形]
kabuto	a warrior's helmet; used as a motif for garden design: かぶと [兜、冑]
kai ge no za	the area of the Southern Court directly in front of the Central Stairs where retainers of lower rank would wait in attendance; literally, "seats before the stairs": 階下の座
kaku	a deep-eaved Chinese garden pavilion enjoyed for its coolness in summer and warmth in winter: 閣
kami ike	a sacred pond used as a place at which to make prayers to the gods: 神池
kana	a phonetic script used in the Japanese language: かな [仮名]
kanji	literally, Chinese script; a calligraphic script that was imported to Japan from Korea and China in the mid-sixth century: 漢字
kara senzui	the Dry Garden Style; literally, "dry mountain water"; a gardening style employing no water; in later years, pronounced *kare sansui*: 枯山水
kare sansui	see *kara senzui*
kari ita jiki	a plank deck; a temporary, wooden platform constructed toward the rear of the main island; used by musicians as a performance platform during festivities: かりいたじき [借板敷]

kasane ochi	Stepped Fall; a waterfall with multiple, stepped cascades: 重落
kashira	head; the top of a stone; the modern term is *ten* (天) or *tenba* (天場): 頭
kasumi gata	Mist Type (isle): 霞形
kata fusagari	literally, a "blocked" direction, implying a direction that was taboo: 方塞がり, alt. *kata futagari*
kata imi	a directional taboo: 方忌 alt. *bō imi*
kata nagare	Slender Stream (isle): 片流
kata ochi	Off-sided Fall; a waterfall in which water splashes off to one side: 片落
kata tagae	direction switch; a method of alleviating the ill effects of taboos: 方違え
ke	not formal, everyday, lowly, unclean: 褻
ke	see *shōseike* and *taiseike:* 卦
keiyō boku	an ornamental tree: 景養木
kemari	court kickball: 蹴鞠
Kenrin-kaku	a pavilion in Shinsen-en, the Imperial garden: 乾臨閣
Kenrō Jishin	one of the twelve devas, tutelary gods of Esoteric Buddhism, Skr. Pṛthivī: 堅牢地神, alt. Kenrō Jiten 堅牢地天
kimon	the devil's gate; the northeast direction, from which evil was thought to enter: 鬼門 *Ura* (rear) *kimon*, 裏鬼門 is the southwest
kinki	a taboo: 禁忌
kinki wo okasu	to violate a taboo: 禁忌を犯す
kiri kasane	Multilayered shape; a type of stone grouping: きりかさね
kō	the basic building block of geomantic iconography; a single line, either broken or unbroken: 爻
kokusuru iro	according to the Five Phase Control theory,

	a color that has a dominant effect over another color: 尅する色, also *kokuseramu iro* 尅せらむ色
komagaku	Korean music: 高麗楽
komori	gardener; a term for a member of an estate staff who cared for the gardens: 木守
kon no mon	an indigo pattern that was an appellation for something overly formal: 紺の文、紺の紋
kōran	the railings along the *sunoko* or *sort hashi:* 高欄
Korean music	see *komagaku* 高麗楽
kōrō	a multistory pavilion; tall, Chinese-style garden architecture: 高楼
kuden	Secret Teaching; information passed on from master to student orally that would be necessary in order to fully understand written texts: 口伝
kumo gata	Cloud Type (isle): 雲形
Kurikara Ryūō	a manifestation of the Buddhist deity Fudō Myōō: 倶利迦羅竜王
kuwa	a mattock/hoe; attenuated shape used as a model for pond edges and riverbanks: 鍬
kuwa gata	a helmet crest; an attenuated, undulating shape used as a model for pond edges and riverbanks: くわがた [鍬形]
kyokō	an appellation for residents of the Heian capital: 京戸

L

Leaping Fall	see *hanare ochi*

M

mae ishi	Fore Stone; a stone, usually of low height, placed in the forward portion of a stone arrangement: 前石
Main Hall	see *shinden*

Main Stone	see *omo ishi*
mappō	Latter Days of Buddhist Law or End of Law; a degenerate age: Skr. saddharma-vipralopa 末法
matsu kawa	Pine Bark (isle): 松皮
matsu kawa zuri	a pine-bark print; made from rough pine bark, the resulting pattern of which was used as an image for garden making: 松皮刷り
mattock/hoe	see *kuwa*
Meadow	see *no sup*
Meadow Isle	see *no jima*
meguri ishi	Turning Stone; a stone placed in a garden stream that, owing to its shape and placement, causes the stream to bend around it and change direction: 廻石
meisho	a famous landscape; sites throughout Japan of majestic beauty or historical significance that were commonly referred to in poetry and later re-created in gardens: 名所
Middle Gate	see *chūmon*
Middle Stone	see *naka ishi*
mikawamizu	stone-lined gutter that caught rain falling from roofs: 御溝水
Mist Type (isle)	see *kasumi gata*
misu	a hanging screen made of very finely split bamboo used to separate one room from another or from the outside: 御簾
mitsu kanae	a three-legged pot used in China that served as a model for the triangular form of stone groupings: みつかなえ [三つ鼎]
mizu bakari	Water Level; a level-measuring device comprising a low wooden box filled with water: 水ばかり [水準], alt. *mizu hakari*
mizukiri ishi	Water-Splitting Stones; those set along the bed of a stream to divide the flow of the water: 水切の石

mizukoshi no ishi	Spillway Stones; those set along the bed of a stream to modulate the flow of the water by slightly damming it: 水ごしの石 [水越しの石]
mizu ochi no ishi	Waterfall Stone; the upright stone in the center of a waterfall over which the stream falls: 水落の石
mono imi	a taboo: 物忌, alt. *imi*, 忌; the Sakuteiki uses the expression *kinki*
mori jima	Forest Isle; a style of island: 杜嶋 [森島]
Mountain Isle	see *yama jima*
Mountain Torrent Style	see *yama kawa no yō*
mountain water	see *senzui*
moya	the central area of a *shinden:* 母屋、身屋、身舎
mujō	impermanence; Skr. *anitya,* 無常
mukai ochi	Twin Fall; a double-stream waterfall: 向落
mukashi no jōzu	masters of old; those of past eras who held superior skills: むかしの上手 [昔の上手]
Multilayered shape	see *kiri kasane*
multistory pavilions	see *kōrō*
musicians' area	see *gaku ya*

N

naka ishi	Middle Stone; a stone placed in the middle of a flow of water to divide the waters as well as to allow a spit of sand to build up downstream from it: 中石
nantei	Southern Court; a broad open area to the south of the *shinden* that was spread with sand and used for events as wide-ranging as poetry readings to archery: 南庭, alt. *dantei*
nature	see *shotoku no senzui*
ni tō no oku	Twin Halls: two closely spaced halls or a single building with a double ridge: 二棟の屋
niwa	a flat, sand-covered area directly adjacent to the Main Hall: Ch. *ting* 庭

nodo	see *taki no nodo*
no jima	Meadow Isle: 野嶋
no suji	Meadow; low earth-berms planted with grasses were built in the garden to evoke the image of a meadow: 野筋
numa ike no yō	Wetland Style; a garden style evoking the image of marshland: 沼地のやう [沼地の様]
nuno ochi	Cloth Fall; a waterfall in which water falls smoothly like a sheet of cloth. 布落

O

Ocean Style	see *taikai no yō*
Off-sided Fall	see *kata ochi*
oke sue	Bucket Type; a type of stone grouping fitted together like the boards of a bucket: 桶すへ [桶据え]
oku ishi	Rear Stone; a stone placed in the hindmost section of a stone arrangement to lend depth to the whole: 奥石
omo ishi	Main Stone; the central stone in an arrangement of stones, usually taller than the others, placed in rear center: 主石
omote	face; the front surface of a stone; modern term is *kao* 顔 : 面, alt. *omo*
onyō	see *Yin Yang*
onyō hakase	a professor of *Yin Yang* theory: 陰陽博士, alt. *onmyō hakase*
onyō ji	a practitioner of *Yin Yang* theory: 陰陽師, alt. *onmyō ji*

P

Phantom Stone	see *reiseki*
pine-bark print	see *matsu kawa zuri*
Pine Bark (isle)	see *matsu kawa*
plank deck	see *kari itajiki*

planting	see *senzai*
pond	see *ike*
post	see *tsuka*
Pure Land	see Jōdo
Pure Land garden	see *Jōdo teien*

Q

| *Qiyuan tijing* (Ch) | a text describing the Gion Shōja monastery written by the Chinese priest Daoxuan, Jp. Dōsen in the seventh century: Jp. *Gion Zukyō,* 祇園図経 |

R

Rear Stone	see *oku ishi*
Reed Style	see *ashide no yō*
reiseki	Phantom Stone; a stone believed to possess a spirit, often one with a malicious disposition: 霊石
"request" of the stone	see *ishi no kowan*
Right and Left Fall	*see sa yū ochi*
ritsuryō sei	a Chinese-style system of government used in Japan since pre-Heian times: 律令制
Rituals of Fudō	see *Fudō Giki*
rō	a short-eaved pavilion; a Chinese garden pavilion with short eaves; used for moon viewing: 楼
Rocky Shore	see *ara iso*
Rocky Shore Isle	see *iso jima*
rōkaku	a general term for splendid Chinese-style garden architecture: 樓閣 [楼閣]
rokujūyonshi	sixty-four combinations of geomantic hexagrams: 六十四支
ryūtō bune	a boat used to carry musicians with a prow carved as a dragon's head: 竜頭船

S

sakon no sakura | literally "left-hand cherry"; a cherry tree planted for ceremonial reasons to the left (east) side of the central stairs leading up to the Main Hall of the imperial residence (originally a plum); deciduous, brief flowering period, representative of the *Yin* element: 左近の桜

sandbar | see *shirasu*

sanmai | concentration of the mind on a single object; state of enlightened awareness; also Sk. *samādhi* 三昧, alt-*sammai*

sanzon butsu | depiction of three Buddhist deities in painting, sculpture, or otherwise, placing a Buddha in the center and Bodhisattva in attendance on either side: 三尊佛

sanzon butsu no ishi | an arrangement of stones that evokes the image of a trinity of Buddhist deities: 三尊佛の石 [*sanzon sekigumi* 三尊石組]; also, reclining (horizontal) Buddhist Trinity, *yoko sanzon,* 横三尊; standing (vertical) Buddhist Trinity, *tate sanzon,* 縦三尊

sa yū ochi | Right and Left Fall; a type of waterfall: 左右落

Scarlet Bird | see *suzaku*

Secret Teaching | see *kuden*

seiryū | Blue Dragon; easterly of the Four Guardian Gods: 青龍, alt. *seiryō*

sekiyō boku | trees that look best in the reddish glow of dusk: 夕陽木

senzai | planting; any of the plants used in the garden (usually refers to grasses or shrubs); also, a small part of a larger garden given over to favored plants, especially that part close to the residence: 前栽

senzui | literally "mountain-water, "meaning either "nature" or "garden." The word used to mean

	"nature" in modern Japanese is *shizen,* while the Sakuteiki uses the older expression *senzui* (modern pronunciation is *sansui),* 山水, or *shotoku no senzui:* 生得の山水
shijin	Four Guardian Gods; geomantic entities perceived to modulate the cardinal directions: 四神 (Blue Dragon *seiryū,* Scarlet Bird *suzaku,* White Tiger *byakko,* Black Tortoise *genbu)*
shijin sōō	the Four Guardian Gods in balance, a term applied to places that had harmonic geomantic qualities: 四神相応
shima	an island; an often-used element of Heian-period garden design; traditionally ponds were punctuated by islands, constructed for a variety of reasons, including scenic beauty, as stages for musicians, and as earthly representations of Amida's Pure Land; in pre-Heian times, *shima* was one word used to mean "garden": 嶋 [島]
shinden	Main Hall; the central hall of an aristocratic residence: 寝殿
Shinden-style architecture	see *shinden zukuri*
shinden zukuri	*shinden* architecture; a general term for the architecture of Heian-period aristocratic residences; named after the Main Hall, *shinden,* of the residence: 寝殿造り
shirasu	a sandbar; a spit of land built of white sand in a garden stream: 白洲
shitsushitsu za	Fudō Myōō's seat; usually depicted as a stone pedestal or rocky precipice; sometimes includes a waterfall: 瑟瑟座
shōen	an agricultural manor owned by an aristocrat: 荘園
short-eaved pavilion	see *rō*
shōseike	a trigram; a geomantic icon consisting of three lines: 小成卦, also simply Jp. *ke,* Ch. *gua* 卦

shotoku no senzui	see *senzui*
Shumisen	Mount Sumeru; the central mountain of Buddhist and Hindu cosmology: Skr. Sumeru 須弥山
shuyōshi	department of the *ritsuryō* bureaucracy responsible for falconry and hunting dogs: 主鷹司
Side-Facing Fall	see *soba ochi*
Sideways Fall	see *yoko ochi*
Slender Stream (isle)	see *kata nagare*
Sliding Fall	see *tsutai ochi*
soba ochi	Side-facing Fall; a waterfall in which the stones are set so as to look best from one side or the other: 稜落
sōden	the direct transmission of a teaching from master to apprentice: 相伝
soko ishi	Bottom Stones; those set along the bed of a stream to modulate the flow of the water and perhaps to prevent erosion: 底石
Solitary Stones	see *hanare ishi*
sori hashi	a curved wooden bridge, often with railings finished with vermilion lacquer, that connected the Southern Court to the central island: そりはし [反橋]
source of the waterfall	see *taki no nodo*
Southern Court	see *nantei*
spade/plow	see *suki*
Spillway Stones	see *mizukoshi no ishi*
Stepped Fall	see *kasane ochi*
suhama	Cove Beach; a shoreline built along garden ponds that contains a series of deeply indented coves: 洲浜
suhama gata	Cove Beach Type (isle): 洲浜形
suiwatadono	literally "transparent crossing hall"; an

	open-sided, roofed corridor used to connect the various buildings of a *shinden* residence: 透渡殿
suki	spade/plow; an attenuated shape used as a model for pond edges and riverbanks: 鋤
sunoko	a narrow veranda that circled a building beneath its eaves; also a slatted wooden deck for use near water: すのこ [簀子]
sute ishi	tossed stones; a modern term literally meaning "thrown-away stones"; these ancillary stones are placed in seemingly random patterns near stone arrangements to extend and diffuse the arrangement into the landscape: 捨石
suzaku	Scarlet Bird; southerly of the Four Guardian Gods: 朱雀
sūsaki shirahama	a promontory of white sand: 洲崎白濱 [洲崎白浜]

T

tabi dokoro	a place visited to avoid a directional taboo; 旅所, alt. *katatagae dokoro* 方違え所
taboo	see *kinki; mono imi*
taiga no yō	a gardening style evoking the image of broad rivers: 大河のやう [大河の様]
taikai no yō	Ocean Style; a garden style evoking seashore images: 大海のやう [大海の様]
tai no ya	a secondary building built to the east or west of the central *shinden* hall in an aristocrat's residence: 對屋 [対屋]
taiseike	a hexagram; a geomantic icon consisting of six lines: 大成卦
taki	waterfall: 瀧
taki no nodo	the water source above a waterfall, literally, "throat of the waterfall": 瀧ののど
tani gawa	Valley Stream; a gardening motif employing

	a narrow stream between hills: 谷川
tatami	rectangular straw floor mats: 畳
tatari	a curse: 祟り
tei	see *niwa*
Ten Stems	see *jikkan*
Thread Fall	see *ito ochi*
three-legged pot	see *mitsukanae*
Tide Land (isle)	see *hi gata*
to	a hinged wooden shutter, either solid or lattice-work, commonly used in Heian-period architecture to separate inner and outer spaces: と [戸], also called *shitomi* 蔀 or *shitomi do* 蔀戸
tōgaku	Chinese music: 唐楽
tori awase	cockfight: 鶏合
trigram	see *shōseike*
tsuka	short posts; for instance, those that hold up the veranda of a building: つか [束], also *tsuka bashira* つかばしら [束柱]
tsuka bashira	see *tsuka*
tsukue gata	Writing Desk Shape; a type of stone grouping: つくゑがた [机形]
tsume ishi	Foundation Stones; small stones set under larger boulders to act as a supportive base: つめ石
tsuridono	Fishing Pavilion; one of the typical names for a garden arbor, not likely to have been used for fishing but rather for moon watching, poetry reading, and as a launching point for pleasure boats: 釣殿
tsutai ochi	Sliding Fall; a waterfall in which water slides down the face of the Waterfall Stone: 傳落 [伝い落]
Turning Stone	see *meguri ishi*

Twelve Branches	see *jūnishi*
Twin Fall	see *mukai ochi*
Twin Halls	see *ni tō no oku*

U

ukon no tachibana	literally, "right-hand citrus"; a citrus tree planted for ceremonial reasons to the right (west) side of the central stairs leading up to the Main Hall of the imperial residence; evergreen, representative of *Yang* element: 右近の橘

V

Valley stream	see *tani gawa*

W

waki ishi	Attendant Stones; in a Buddhist Trinity stone arrangement, two stones (representative of Bodhisattva) placed to the right and left of a larger, central stone (representative of a Buddha); alternatively, Bracketing Stones; in a waterfall arrangement, supportive stones set on either side of a central waterfall stone: 脇石
warawamai	children's dance: 童舞
Water Level	see *mizu bakari*
Water-Splitting Stones	see *mizukiri ishi*
Waterfall Stone	see *mizu ochi no ishi*
Wellspring Pavilion	see *izumidono*
Wetland Style	see *numa ike no yō*
White sandy beach	see *shirasu*
White Tiger	see *byakko*
Writing Desk Shape	see *tsukue gata*

Y

yama	a mountain: 山
yamajima	Mountain Isle: 山嶋
yama kawa no yō	Mountain Torrent Style; a garden style evoking the image of mountain streams: 山河のやう [山河の様]
yarimizu	Garden Stream; a meandering stream often built in Heian-period gardens; the classic form placed the water source in the northeast, allowed it to flow along the eastern edge of the Southern Court, turn west, and flow out of the property at the southwest corner: 遣水
Yi	a theory of geomantic divination based on complex extrapolations of trigrams and hexagrams: Jp. *Eki* 易
Yijing	*Book of Changes;* an ancient Chinese classic detailing *Yi* theory; *I Ching* is the old Wade-Giles pronunciation: Jp. *Ekikyō* 易経
Yin Yang	two mutually opposing yet complementary energies that form the basic units of geomancy: Jp. *in yō* 陰陽, alt. *onmyō*
yoko ishi	Crosswise Stones; those placed in a stream perpendicular to the current in order to modulate the flow of water: 横石
yoko ochi	Sideways Fall; a type of waterfall: 横落
yorishiro	a spirit seat; a natural object that can act as a point of contact with the gods: 依代、憑代
yūgyōjin	Circuit Gods; five gods that govern directional taboos: 遊行神 (Ten'ichijin 天一神 or Nakagami 中神, Taihakujin 太白神, Daishōgun 大将軍, Konjin 金神, and Ōsōjin 王相神)

PERSONAE, Persons mentioned in the book

(Skr) Sanskrit – (Jp) Japanese – (Ch) Chinese – (Eng) English

Anāthapindada (Skr): see Sudatta

Bukong (Ch): author of the *Fudō Giki; Jp.* Fukū, Skr. Amoghavajra: 不空 AD 705-774

Confucius (Eng): see Kongzi

Daoxuan (Ch): author of the *Gion Illustrated Text* (Qiyuan tijing); Tang-dynasty priest; founder of Nanshanlü, the Southern Mountain branch of Vimaya: Jp. Dōsen 道宣 AD 596-667

Dōsen (Jp): see Daoxuan

En'en Ajari (Jp): *ishitatesō*, stone-setting priest mentioned in Sakuteiki (Ajari is a suffix for a priest's name): 延圓阿闍梨[延円阿闍梨] Heian period

Fu Xi (Ch): Legendary patriarch of geomantic thought: Jp. Fukki (Fuggi) 伏義, 伏犧 ancient China; mythical

Fujiwara no Tadahira (Jp): Minister of the Left under Emperor Daigo; transplanted a large *natsume* to his garden: 藤原忠平 AD 880-949

Fujiwara no Yorimichi (Jp): Imperial Regent; Father of Tachibana no Toshitsuna; builder of Kayanoin and Byōdōin: 藤原頼通 992-1074

Fujiwara no Yoshitsune (Jp): sobriquet appears at the end of the Sakuteiki and so was long believed to be its author; courtier and well-known poet; second son of Imperial regent Kujō Kanezane (九条兼実 1149-1207), Yoshitsune also served as regent after his father, but is best known for his contributions to poetry anthologies such as the *Shin Kokinshū* (imperial anthology), and his own personal collection, *Akishino Gessei Shū:* 藤原良経 1169-1206

Fukū (Jp): see Bukong

Gida Taishi (Jp): see Jeta

Gikkodoku (Jp): see Sudatta

Jeta (Skr): original owner of the garden known as Jetavana (Jp. Gion Shōja 祇園精舎) that was re-created as a monastery for Śākyamuni: Eng. Prince Jeta, Jp. Gida Taishi 祇陀太子 sixth or fifth century BC

Kodoku (Jp): see Sudatta Kodoku Chōja (Jp): see Sudatta

Kongzi (Ch): Chinese scholar: attributed writer of detailed commentaries in the Yijing: Jp. Kōshi, Eng. Confucius 孔子 551-479 BC

Kose Hirotaka (Jp): Heian-period aristocrat; descendant of Kose Kanaoka; painter and gardener: 巨勢弘高 late tenth to early eleventh century

Kose Kanaoka (Jp): Heian-period aristocrat, painter, founder of Koze school; reputedly assisted in the design of Shinsen'en, the imperial garden: 巨勢金岡 late ninth century

Kūkai (Jp): Japanese Buddhist priest of the Heian period; received training from 804 to 806 in Tang-dynasty China, then returned to Japan to introduce the Shingon Buddhist sect; also known as Kōbō Daishi: 空海 AD 774-835

Minamoto no Tōru (Jp): Minister of the Left; son of Emperor Saga; owner of a garden in which a scene of Matsushima Bay was evoked by boiling vats of salt water: 源融 822-95

Murasaki Shikibu (Jp): lady-in-waiting at the Heian court; purported author of *The Tale of Genji*, the story of the life and loves of a Heian prince: 紫式部 mid-Heian period

Qin Shi Huandi (Ch): first emperor of the Qin dynasty; infamous for his book-burning persecution of Confucianists: Jp. Jin Shi Kōtei 秦始皇帝 third century BC

Renchū (Jp): *ishitatesō*, stonesetting priest: 蓮仲

Śākyamuni (Skr): the historical Buddha; born Siddhārtha Gautama in northern India: Jp. Shakamuni: 釋迦牟尼 sixth or fifth century BC

Sei Shōnagon (Jp): lady-in-waiting at the Heian court; author of *The Pillow Book,* an insider's look at Heian-period court life: 清少納言 mid-Heian period

Shotoku Taishi (Jp): born Prince Umayado; son of Emperor Yōmei; regent under Empress Suiko; instrumental in introducing Buddhism, as well as administrative systems such as the *kan'i* ranking system, from China: 聖徳太子 AD 574-622

Shudatsu (Jp): see Sudatta

Siddhārtha Gautama (Skr): see Śākyamuni

Sudatta (Skr): wealthy Indian merchant; built the Gion Shōja for the Buddha, Śākyamuni: Jp. Shudatsu, 須達 also referred to as Anāthapindada (Skr), Gikkodoku (Jp) 給孤独; and as Kodoku Chōja (Jp) 孤独長者: 須達多 sixth or fifth century BC

Tachibana no Toshitsuna: purported author of the Sakuteiki: 橘俊綱 AD 1028-94

Wenwang (Ch): first emperor of the Chinese Zhou dynasty (1100-256 BC); contributed to development of Yijing: Jp. Bunō, Eng. King Wen 文王. 1100 BC

Xiao Ji (Ch): Chinese scholar; compiler of the *Five Phase Encyclopedia:* Jp. Shō Kitsu 簫吉 Liang dynasty 梁朝 (502-57)

Zhougong (Ch): son of Wengwan; added interpretive text to *Yijing:* Jp. Shūkō, Eng. Duke of Zhou, 周公 c. 1100 BC

Zou Yan (Ch): introduced principles of *Yin* and *Yang* to the *Yijing;* lived in a part of China called Qi (Jp. Sai 斉) during the Period of Warring States (475-221 BC) and is known in Japan as Sai no Sū En: Jp. Sū En, 鄒衍 305-240 BC

MEASUREMENTS

LENGTH

bu 分	sun 寸	shaku 尺	jō 丈	feet	meters
1.0	0.1	0.01	0.001	0.01	0.003
10.0	1.0	0.1	0.01	0.099	0.03
100.0	10.0	1.0	0.1	0.994	0.303
1000.0	100.0	10.0	1.0	9.942	3.03
100.584	10.058	1.005	0.1	1.0	0.304
330.0	33.0	3.3	0.33	3.280	1.0

AREA

One *chō* is equal to a square area that has sides that are each 400 *shaku* (approximately 120 meters) long.

chō	sq. shaku	sq. feet	acres	sq. meters	hectares
1.0	160,000.0	158,143.7	3.630	14,689.4	1.469
0.0	1.0	0.988	0.0	0.092	0.0
0.0	1.012	1.0	0.0	0.093	0.0
0.275	44,071.3	43,560.0	1.0	4,046.1	0.405
0.0	10.889	10.763	0.0	1.0	0.0
0.681	108,902.5	107,639.0	2.471	10,000.0	1.0

HEIAN PLANTS

This list is not intended as an encyclopedic listing of all plants used in Heian-period gardens but rather reflects those plants mentioned in the Sakuteiki as well as those that the authors came across in research for this book. Those marked with a single asterisk (*) are from *Kyōto no Teien, Iseki ni Mieru Heian Jidai no Teien;* those marked with a double asterisk (**) are from Hida Norio, *Teien Shokusai no Rekishi;* and those with a dagger (†) are found in the Sakuteiki. *Kanji* is as found in the *Gunsho Ruijū* text, with a modern version following in brackets [] if different. English names are based on a variety of sources, and a name in quotes indicates that it is a generic. Botanical names are based on *Nihon no Jumoku and Nihon no Yasō* published by Yamakei Publishers, Tōkyō. The *kanji* names given are modern except for those from the Sakuteiki.

	JAPANESE	KANJI	ENGLISH	BOTANICAL
TREE (evergreen)	*kashi	樫	"Evergreen oak"	*Quercus sp.*
	**mochinoki	黐の木	Bird-lime holly	*Ilex integra*
	**tachibana	橘	Mandarin orange	*Citrus tachibana*
	*yamamomo	山桃	Bayberry	*Myrica rubra*
TREE (coniferous)	*akamatsu	赤松	Japanese red pine	*Pinus densiflora*
	† goyō matsu	五葉松	Japanese white pine	*Pinus parviflora*
	† hinoki	桧, 桧	Japanese cypress	*Chamaecyparis obtusa*
	* inumaki	犬槇	Yew podocarpus	*Podocarpus macrophyllus*
	†**komatsu	小松	"Small pine"	*Pinus sp.*
	*kuromatsu	黒松	Japanese black pine	*Pinus thunbergii*
	† matsu	松	Pine (species generic)	*Pinus sp.*
	*momi	樅	Japanese fir	*Aibes firma*
	*sugi	杉	Japanese cedar	*Cryptomeria japonica*
	*tsuga	栂	Japanese hemlock	*Tsuga sieboldii*
TREE (deciduous)	*akamegashiwa	赤芽槲	Japanese mallotus	*Malotus japonicus*
	*enoki	榎	Japanese hackberry	*Celtis sinensis*
	**hannoki	榛の木	Japanese alder	*Alnus japonica*
	*kaede	楓	Japanese maple	*Acer sp.*
	*kajinoki	梶の木	Unknown	*Broussonetia papyifera*
	† katsura	桂	Katsura tree, Judas tree	*Cercidyphyllum japonicum*
	*mukunoki	椋の木	Asiatic nettle-tree	*Aphananthe aspera*
	*sendan	旃檀	Japanese bead-tree	*Melia azedarach*
	yanagi	柳	Willow	*Salix sp.*
TREE (flowering)	† enju	槐	Japanese pagoda tree	*Sophora japonica*
	† kisasage	楸	Catalpa	*Catalpa ovata*
	*kusagi	臭木	Harlequin glory-bower	*Clerodendron trichotomum*
	*kōbai	紅梅	Red plum	*Prunus mume var.*
	*sakura	桜	Japanese cherry	*Primus sp.*
	† ume	梅	Plum	*Prunus mume*
TREE (fruit)	**biwa	枇杷	Loquat	*Eriobotrya japonica*
	**kaki	柿	Japanese persimmon	*Diospyros kaki*
	**kuri	栗	Japanese chestnut	*Castanea crenata*
	*momo	桃	Peach	*Prunus persica*
	*nashi	梨	Pear	*Pyrus sp.*

	JAPANESE	KANJI	ENGLISH	BOTANICAL
SHRUB	**hagi*	萩	Bushclover	*Lespedeza sp.*
	***natsume*	棗	Jujube	*Ziziphus jujuba*
	sakaki	さかき [榊]	Unknown	*Cleyera japonica*
	† **sanshō*	山椒	Japanese pepper	*Zanthoxylum piperitum*
	satsuki	さつき	Satsuki azalea	*Rhododendron indicum*
BAMBOO	† *kozasa*	こざさ こささ	Grass bamboo	*Sasa sp.*
	***kuredake* (*gochiku*)	呉竹	Henon Bamboo	*Phyllostachys nigra* f. *Henonis* Muroi
	***take*	竹	Bamboo	*Variety unknown*
HERBACEOUS	† *gibōshi*	こぼうし [ぎぼうし]	Plantain lily	*Hosta sp.*
	† *kikyō*	桔梗	Chinese bellflower	*Platycodon grandiflorum*
	† *masuge*	ますげ ますけ	Unknown	*Carex sp.*
	† *ominaeshi*	女郎 女郎花	Unknown	*Patrinia scabiosaefolia*
	***shirokiku*	白菊	White chrysanthemum	*Chrysanthemum sp.*
	† *suge*	すげ	Unknown	*Carex sp.*
	***susuki*	薄	Japanese pampas grass	*Miscanthus sinensis*
	† *waremokau*	われもかう [われもこう]	Burnet	*Sanguisorba officinalis*
	yaburan	やぶらん	Unknown	*Liriope platyphylla*
	† *yamasuge*	やなすげ	Unknown	*Carex sp.*
GROUND COVER	† *koke*	苔	Moss	*Variety unknown*
	shiba	芝	Japanese lawn-grass	*Zoysia japonica*
WATERPLANT	† *ashi*	蘆 あし	"Wetland reed"	*Phragmites communis*
	† *ayame*	菖蒲 あやめ	"Iris"	*Iris sanguinea*
	hasu	蓮	Lotus	*Nelumbo nucifera*
	† *kakitsubata*	杜若 かきつばた	"Iris"	*Iris laevigata*
	† *katsumi* (*makomo*)	かつみ	"Wetland reed"	*Zizania sp.*
VINE	**budō*	葡萄	Grapes	*Vitis sp.*
	**fuji*	藤	Wisteria	*Wisteria sp.*

BIBLIOGRAPHY

Books in Japanese

Abe, Akio, and others. *Nihon Koten Bungaku Zenshū Vol. 12, Genji Monogatari (1)*. Tōkyō: Shōgakkan, 1972.

Abe, Akio, and others. *Nihon Koten Bungaku Zenshū. Vol. 14, Genji Monogatari (3)*. Tōkyō: Shōgakkan, 1972.

Amasaki, Hiromasa, and Jirō Takei. *Teienshi wo Arukuku*. Kyoto: Shōwadō, 1998.

Ashikaga, Kensuke, ed. *Kyōto Rekishi Atorasu*. Tōkyō: Chūōkōron-sha, 1994.

Frank, Bernard. *Kataimi to Katatagae*. Translated by Saitō Hironobu. Tōkyō: Iwanami Shoten, 1989. Originally published as *Etude sur les interdits de direction à l'époque Heian* (Tōkyō: Maison Franco-Japonaise, 1958).

Hida, Norio. *Teien Shokusai no Rekishi: Heian Jidai no Shokusai. Vol. 1-5*. Tōkyō: Nihon Bijutsu Kōgei, 1990-91.

Kawasaki Nobuyuki and Sasahara Kazuo, ed. *Shūkyōshi*. Tōkyō: Yamakawa Shuppansha, 1974.

Komatsu, Shigemi, ed. *Nihon no Emaki. Vol. 18, Ise Monogatari Emaki, Sagoromo Monogatari, Koma Kurabe Gyōkō Emaki, Genji Monogatari Emaki*. Tōkyō: Chūōkōronsha, 1988.

Komatsu, Shigemi, ed. *Nihon no Emaki. Vol. 8, Nenjū Gyōji Emaki*. Tōkyō: Chūōkōronsha, 1987.

Komatsu, Shigemi, ed. *Nihon no Emaki. Vol. 9, Murasaki Shikibu Nikki Ekotoba*. Tōkyō: Chūōkōronsha, 1987.

Komatsu, Shigemi, ed. *Zoku Nihon Emaki Taisei. Vol. 15, Kasuga Gongen Kenki Emaki, (2)*. Tōkyō: Chūōkōronsha, 1982.

Komatsu, Shigemi, ed. *Nihon Emaki Taisei, Vol. 21, Kitano Tenjin Engi.* Tōkyō: Chūōkōronsha, 1978.

Komatsu, Shigemi, ed. *Nihon Emaki Taisei. Vol. 24, Taima Mandala Engi, Chigo Kannon Engi.* Tskyo: Chūōkōronsha, 1979.

Komatsu, Shigemi, ed. *Zoku Nihon no Emaki. Vol. 13, Kasuga Gongen Kenki Emaki, (1).* Tōkyō: Chūōkōronsha, 1995.

Kyō, Gosho no Bunka e no Shōkai. Toky5: Tankō Mukku, 1994.

Kyoto National Museum. *Gazō Fudō Myōō.* Kyoto: Dōbōsha Shuppan, 1981.

Kyōto no Teien: Iseki ni Mieru Heian Jidai no Teien. Kyōtoshi Bunkazai Bukksu. Kyoto: Bunka Kankō Kyoku, 1990.

Kyōtoshi [City of Kyoto]. *Yomigaeru Heiankyō.* Kyoto: Kyōtoshi, 1994.

Mori, Osamu. *Sakuteiki no Sekai.* Tōkyō: Nihon Hōsō Shuppan Kyōkai, 1986.

Murai, Yasuhiko. *Yomigaeru Heiankyō.* Kyoto: Tankōsha, 1995. Nakamura, Shōhachi. *Gogyō Taigi, Vol. 2.* Tōkyō: Meiji Shoin, 1998.

Nakane, Kinsaku. *Niwa: Meitei no Kanshō to Sakutei.* Ōsaka: Hoikusha, 1984.

Takei, Jirō. *Sakuteiki: Gendaigo Taiyaku to Kaisetsu.* Kyoto: Kyoto College of Art, 1995.

Tamura, Tsuyoshi. *Sakuteiki.* Tōkyō: Sagami Shobō, 1964. Uehara, Keiji. *Zōen Daijiten.* Tōkyō: Kajima Shoten, 1994.

Books in English

Forte, Antonio. *Mingtang and Buddhist Utopias in the History of the Astronomical Clock.* Rome: Istituto Italiano per il Medio ed Estremo Oriente, 1988.

Hempel, Rose. *The Golden Age of Japan 194-1192.* Translated by Katherine Watson. New York: Rizzoli, 1983.

Japanese-English Buddhist Dictionary. Rev. ed. Tōkyō: Daitō Shuppansha, 1991.

Mason, Penelope. *History of Japanese Art*. New York: Harry N. Abrams Publishers, 1993.

Matsunaga, Daigan, and Alicia Matsunaga. *Foundation of Japanese Buddhism. Vol. 1, The Aristocratic Age*. Los Angeles and Tōkyō: Buddhist Books International, 1974.

Mizuno, Kogen. *Essentials of Buddhism*. Translated by Gaynor Sekimori. Tōkyō: Kōsei Publishing Co., 1996.

Mizuno, Kōgen. *The Beginnings of Buddhism*. Translated by Richard Gage. Tōkyō: Kōsei Publishing Co., 1980.

Morris, Ivan, trans. *The Pillow Book of Sei Shonagon [Makura no Sōshi]*. London: Penguin Books, 1967.

Morris, Ivan. *The World of the Shining Prince: Court Life in Ancient Japan*. London: Penguin Books, 1997.

Seidensticker, Edward G., trans. *The Gossamer Years [Kagerō Nikki]*. Tōkyō and Rutland, Vermont: Charles E. Tuttle Company, 1964.

Seidensticker, Edward G., trans. *The Tale of Genji [Genji Monogatari]*. Tōkyō and Rutland, Vermont: Charles E. Tuttle Company, 1976.

Shimoyama, Shigemaru, trans. *Sakuteiki: The Book of Garden*. Tōkyō: Town and City Planners, Inc., 1976.

Totman, Conrad. *The Green Archipelago*. Berkeley: University of California Press, 1989.

Tyler, *Royall. Japanese Tales*. New York: Pantheon Books, 1987.

Wilhelm, Richard. *I Ching*. Translated by Cary Baynes. Princeton: Princeton University Press, 1950.

Yamazaki, Masafumi, ed. *Process Architecture. #116, Kyōto: Its Cityscape Traditions and Heritage (*in Japanese and English). Tōkyō: Process Architecture Co., Ltd., 1994.

INDEX

Note: Entries followed by the letter "c" are in captions; those followed by "f" are in footnotes. Bold numbers signify an entire section devoted to the subject.

Entries related to the following subjects can be found under their respective subject headings: Architecture, Buddhism, Garden styles, Geomancy, Island types, People, Plants, Stone groupings, Stone types, Streams, Taboos, and Waterfalls.